Matters of
Light & Depth

Matters of Light & Depth

Creating memorable images
for video, film, & stills
through lighting

by Ross Lowell

Broad Street Books Publishing, Philadelphia

Second printing, February 1994
by Broad Street Books Publishing Inc.

Printed in the United States of America by
the Mazer Corporation, Dayton, Ohio.

Library of Congress Card Number: 92-070096
ISBN 1-879174-03-0

Editing and supervision: Bonnie Schwartz
Graphic design: Ellen Hum
Diagrams: Minerva Tantoco
Printing supervisor: Karen Fasimpaur
Copy editor: Maryanne Furia

Pre-publication reviewers:
Charles Merzbacher, E. Carlton Winckler,
Eric Somers, Tom McDonough,
Gill McDowell.
For material written specifically for this book
or for *LightNews* and excerpted herein, the
author is grateful to: E. Carlton Winckler, Bill
Klages, David Quaid, Ezra Stoller, Tom
Sadowski, Dale Marks, Jon Falk, Jon Fauer,
and Michael Chiusano.
Grateful acknowledgement is made to the
following for permission to reprint copyrighted
material: ASC Press, Hollywood, CA, for
excerpts from *Cinema Workshop*, 4th ed.
(©1983) by Anton Wilson; Farrar, Straus &
Giroux, New York, NY, for excerpts from
A Man With a Camera (©1984) by Nestor
Almendros; Grove Weidenfeld, New York,
NY, for excerpts from *Light Years:
Confessions of a Cinematographer* (©1987)
by Tom McDonough; Prentice-Hall Press/A
Division of Simon & Schuster, Inc., New York,
NY, for excerpts from *Film Lighting: Talks
with Hollywood Cinematographers and
Gaffers* (©1986) by Kris Malkiewicz;
The Society of Television Lighting Directors,
London, England, for material by Paul Beeson
excerpted from *Television Lighting* magazine;
University of California Press, Berkeley, CA,
for excerpts from *Masters of Light:
Conversations with Contemporary
Cinematographers* (©1984 The Regents
of the University of California) by Dennis
Schaefer and Larry Salvato; Wadsworth
Publishing Company, Belmont, CA, for
excerpts from *Electronic Cinematography,
Achieving Photographic Control Over
the Electronic Image* (©1985) by Harry
Mathias and Richard Patterson.

Disclaimer
The information contained herein represents
suggested methods and approaches rather
than absolute solutions to lighting problems.
Due to differences in equipment, energy code
regulations, and other vagaries, readers
should take this information as a starting point
and perform their own tests and experiments
to determine what works best for their pur-
poses. None of the statements in this volume
are to be construed as a warranty or repre-
sentation for which the author or publishers
assume legal responsibility.

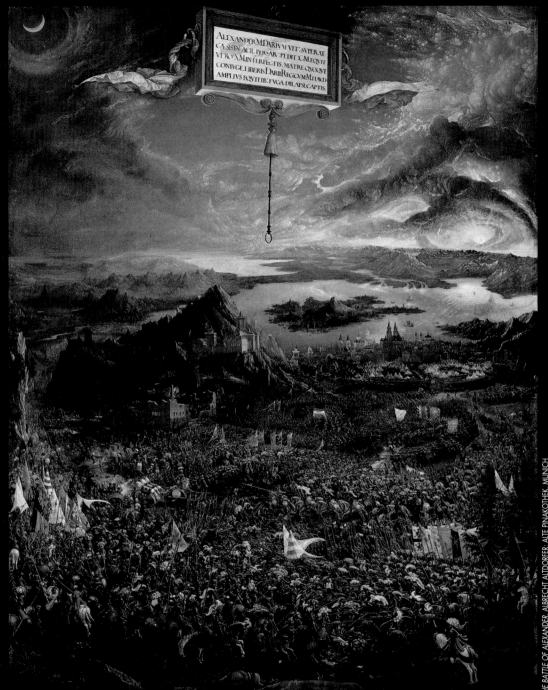

Artists command the forces of light, composition, color, and tone — whether they wield pencils and paint or lenses and cameras. As cinematographer Vittorio Storaro said, "[When]. . . you make a design, shoot a picture, or photograph a movie, it is the representation of all 2,000 years of history, whether you are conscious of it or not." [ML]

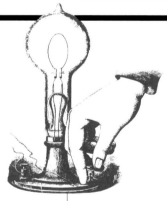

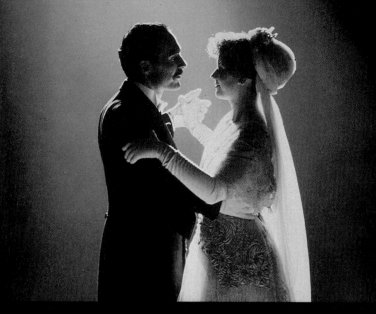

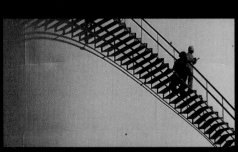

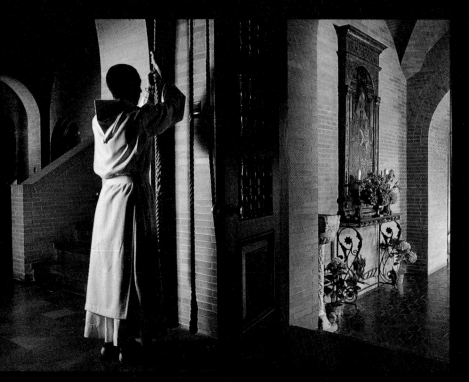

Q. What's the relationship between lighting and composition or lighting and mood?

A. *Intimate.*

Q. How important are the differences between: still, film, and video lighting; studio and location lighting; or interior, exterior, natural, artificial, and available lighting?

A. Important — *sometimes.*

Q. How important is the difference between ordinary illumination and evocative, sensitive, or dramatic lighting?

A. *Crucial* — almost always.

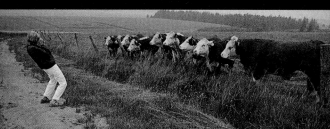

Technical & Practical Abbreviations

amp, ampere amperage
ASC American Society of
 Cinematographers
***B Lights** background light
 and back light
CC Filters color-correction filters
CID, CSI, HMI, & MSR various
 high-intensity discharge (HID) lamps
CRI color rendering index
CU close-up
cyc cyclorama
dB decibel
DP director or photography
EFP electronic field production
EI/ASA exposure index
ENG electronic news gathering
EV exposure value
fc foot candle
FPS frames per second
gel gelatin
HDTV high-definition television
ILM incident light meter
ISO International Standards
 Organization
K degrees Kelvin, or color temperature
kW kilowatt

LD lighting director
lx lux
NTSC National Television System
 Committee
RLM reflected light meter
sync synchronization
TTL through-the-lens meter
UK United Kingdom
UV ultraviolet
v volt
w watt
w/s watts per second, watt-seconds

**= non-conventional term shamelessly
 coined by the author to identify
 a phenomenon or dilemma.
 Examples: Idle-Fixture Phobia;*
 Overkill Fill**

Abbreviations of Quoted Publications

Books
AL *Adventures in Location Lighting*
AMWAC *A Man With a Camera*
CW *Cinema Workshop*
EC *Electronic Cinematography*
FL *Film Lighting*
LY *Light Years*
ML *Masters of Light*

Newsletters & Magazines
LN *LightNews*
TL *Television Lighting*

*See the copyright page and/or
Resources for more information on
these books and publications.*

Symbols

Subject

Camera

Stand

Copy Work
Flag
Object

Reflector
& Reflector
on Stand

Hard Light
& Hard
Light on
Stand

Broad Light
& Broad
Light on
Stand

Soft Light
& Soft Light
on Stand

For early help in making this volume more than a collection of articles from *LightNews*, I want to thank Nathan Sambul and Karen Raugust. Video as well as other portions of this book benefited greatly from the technical and theoretical critiques of Professor Eric Somers and lighting maven E. Carlton Winckler. Professor Charles Merzbacher made brilliant contributions to the content and organization of the book.

Camerapersonality and author *(Light Years)* Tom McDonough proffered priceless praise, prose, and punditry without which *Matters of Light & Depth* would be far more shallow. Gaffer Gill McDowell offered many invaluable comments and quotes. Photographer Dale Marks and soundman Ben Sobin helped to discipline my unruly *Terms of Enlightenment.* Family, friends, and my partner at Lowel-Light, Marvin Seligman, were patient — and even encouraging — while I exorcised my writing and lighting demons. The piece on setting up small studios was proposed by Brian Ellis.

Jon Falk, author of the flash bible *Adventures in Location Lighting,* introduced us to publishers Ed Moran and Marilyn Shapiro of Broad Street Books. Without their enthusiasm and ink, there might still be only one copy of these matters, and without Jon's book, ours would have had to have been much longer.

But for the perspective, perseverance, good taste, and humor of Bonnie Schwartz this work would not have seen the light of day. Ellen Hum graced the interior and exterior of the book with beautiful graphics, while Maryann Furia took countless gratuitous commas from my sentences and sin from my syntax. Serious thanks are due to all those (see *Contributors*) whose quotes and images help shed light on the subject.

Because good craft is contagious, artists like Vermeer, photographers like Eugene Smith, teachers like Slavko Vorkapich, films like *Citizen Kane*, and countless technicians like assistant cameraman Tibor Sands have unwittingly influenced this work.

To all those students who asked difficult questions, thanks for helping me find the words to investigate the wondrous world of light. This book is dedicated to them and to my children, Lisa, Josh, Evan, and Brett, who are the lights of my life. Except for my love of Bach, it is through them that I have discovered everything I know of real importance.

Introduction

Light has a profound influence upon living things. It controls appetites, health, and moods. The changing proportion of light and darkness in each day regulates our biological clock and informs some species when to crawl into a cave, others when to fly across an ocean. Without light, we would have no seasons, no plants, no life, and – most serious of all – no television or movies.

Over the centuries, the connections between *light* and *life*, between *darkness* and *death*, have acted as compelling metaphors in both literature and art. Artists, writers, and philosophers have been fascinated with the subtlety, power, and mystery of light. Modern media and sophisticated technology notwithstanding, today's professionals use their lighting skills to express mood and emotion with results that do not differ substantially from those of the great artists who painted centuries ago.

As the title of this book suggests, lighting can conjure impressions of depth on a purely two-dimensional surface, whether your medium reproduces movement or freezes it.

PHOTOS: AUTHOR

Light reading

Matters of Light & Depth was written for students, the new pro with limited experience, and those of you who, despite considerable experience, still encounter lighting difficulties. It endeavors to show you ways to develop and trust your eye. It discourages you from imposing indifferent lighting formulas onto every subject and setup. It encourages you to be sensitive to light in its myriad manifestations, from the masterpieces you find on museum walls to the haunting beauty of moonlit landscapes. You will discover why lighting planes is preferable to plain lighting and how motivating the source can motivate both yourself and the viewer.

This lighting odyssey stresses the interdependence of all crafts, especially where film and video are concerned, for lighting in these media should be conceived of in concert with composition, movement, editing, story line, and sets. It is often difficult to know whether it is the acting, makeup, sound effects, shadows, or music that make your adrenalin flow, your spirit soar. To the extent that lighting truly serves the subject and the story, it becomes "invisible."

Although most of the material in *Matters of Light & Depth* is original (written specifically for this book), some parts have evolved from lighting workshops and seminars I have taught. Portions that may have first appeared in *LightNews* or other professional publications have been thoroughly revised.

How to use the book

You can start with those parts of the book that are pertinent to your interests and level of experience and save the rest for reference or later needs. A good place to begin might be with the *Terms of Enlightenment*, which provides definitions, ideas, and tips. Some students may wish to begin with *Lights-On Lessons*, consulting with those parts of the book that help them to complete the exercises.

Matters of Light & Depth attempts to illuminate a field that is a confusing and exciting mixture of science, craft, commerce, and sometimes even art. If the book helps you use the light-force wisely and rewardingly it will have fulfilled its purpose.

We are inclined to forget that light rays are invisible; that what we see is their effect on materials around us: dust, vapors, and reflective surfaces.

Tom McDonough
Photography is first of all a record of light. You are alone behind the camera, doubling as artist and scientist, hoping that your light — and it is your light — will bring it all to life. *[LY]*

1

Lights of Passage

Basic Theory & Practice

How to achieve the worst lighting,
overcome Lighter's Block, motivate
sources, perform Light Surgery, finesse
your lighting, frame your subject,
& break the motion barrier.

JAN VREDEMAN DE VRIES

The Best Ways to Achieve the Worst Lighting

Putting things in a negative light

- Use flat front light and burn out the foreground. One way to do that is . . .
- . . . use a light on the camera, full blast, undiffused (as news crews tend to do).
- Switch the traditional key and fill light positions (as beginners invariably do).
- Use a hard light for fill, then another hard one to soften the shadows it adds, and so on.
- Concentrate on the light; ignore the shadows.
- Ignore the subject, planes, mood, and media: light by formula.
- Make sure the lighting overwhelms your story and subject.
- Don't let sources in the scene motivate your lights.
- Light all parts of the room or set uniformly.
- Light all planes to the same brightness.
- Keep lights at equal intensities, distances, and angles: go for lighting symmetry.
- Introduce lots of strong colors — everywhere.
- Always make the background brighter than the subject, or conversely . . .
- . . . let the subject merge with its background.
- Move the subject close to the background.
- Ignore contrast problems.
- Never exceed a 4:1 lighting ratio for broadcast — even with dramatic subjects.
- Trust the lab timer or video engineer to guess what you want — especially with silhouettes.
- Avoid glare at all times.
- Use undiffused hard light on shiny objects.
- Put copy lights close to the camera and always use large sources.
- Try to ignore lighting consistency from shot to shot.
- Light transparent and translucent subjects from the front.
- Choose a room with 8-foot ceilings to turn into a little studio.
- Stick with raw light — only wimps refine the stuff.
- Pretend that lighting and composition are unrelated.
- Pretend that lighting, time, and movement are unrelated.
- Always illuminate moving subjects with moving lights.

- Avoid available light, even when it's beautiful.
- Use all lights available, even when they're not needed.
- Put the mike boom on the same side as the key light.
- Move the zoom stick, not the camera or subject.
- Obey the light meter at all times.
- Ignore color temperature, or conversely . . .
- . . . neutralize all unusual, off-color effects.
- Shoot exterior portraits with direct, overhead sun.
- Never shoot during dawn, sunrise, sunset, or dusk.
- Opt for quantity, not quality.
- Don't scout your own locations — trust a stranger.
- Disregard shooting budgets at all times.
- Ignore safety rules.
- Always follow these rules.

PHOTO: TOM SADOWSKI; SUBJECT: ERROLL LOCKER

Tom Sadowski
Deep down in your heart you know that someday you'll meet face to face with the Grim Gaffer while you are doing a solo tie-in at a fuse box in some old lady's damp basement.

Lighting Planes

Overcoming Lighter's Block
& Mid-Light Crisis

You no longer need to transplant indifferent lighting formulas onto subjects that seem to reject them.

ALBRECHT DÜRER SKETCH

There are only three dilemmas that you are likely to face on every lighting setup: *1)* where to begin — Lighter's Block*; *2)* when to stop — Terminal Trauma*; and *3)* what to do in between — Mid-Light Crisis*. The problem is that there are so many tools, techniques, and terms, so many options and mysteries, that attempting to light even a simple scene can be a paralyzing experience.

Conquering Lighter's Block

One of the best ways to conquer Light Fright is to mentally break down the subject, the set, and the scene into a series of planes. Whether you are shooting dingy factories or talking heads, beer bottles or art treasures, you are actually lighting a collection of surfaces that reflect light differently, or not at all, depending, among other things, upon each surface's angle in relation to a light source and the lens. The way planes reflect light also depends upon whether their finishes are shiny or matte, their contours flat or curved (even convoluted objects can be thought of as having continuously connected planes), their color dark or light, and whether the light source is hard or soft, diffused or not.

Plain and simple

When you think in terms of lighting planes and contours, a lot of positive things begin to happen. You no longer need to transplant indifferent lighting formulas onto subjects that seem to reject them. You anticipate what a hard or soft light will do when positioned at almost any angle in relation to a prop, product, person, background, or foreground. You reduce the time wasted by trial-and-error lighting methods. You may even be able to guess, with some accuracy, what a landscape will look like at a totally different time of day.

Plane talk

One of the rewards of the lighting craft consists of watching the many planes of a scene begin to glow from the light very much as you might have expected. Beginners do not reach this stage of lighting omniscience quickly.

As with other aspects of lighting, there are several learning options. You can pick it up on the job over a period of time. You can study photographs, paintings, and the world around you to see how the various surfaces of various objects of various shapes respond to various light angles. The fastest way to

master the many facets of plane lighting, however, is to undertake a series of exercises for the eye.

Light work

You might start by choosing a room with lots of objects and angles, then stand where you think a light should be. Carefully observe what planes you see: these are the ones the imaginary light would illuminate. If you see too few, too many, or the "wrong" ones, stand elsewhere. When you like what your eyes light on, imagine yourself to be a hard light and then a soft one. Choose your lighting weapon accordingly. Set it up and see how it compares to what you had expected. Then try again from a different side, a different angle, a different height. You will need a ladder.

Soon you will begin to anticipate what a key light or even a back light "sees" while you stand at the camera. Eventually, this will become second nature and the intuitive part of your brain will instinctively play lighting billiards with the various planes isolated by your eye.

Mid-Light Crisis

If the results are appropriate and effective, you can proceed to refine the setup. If the lighting doesn't work and time allows, you may need to start again — Mid-Light Crisis* time. But at least now you have the technique to figure out what should be done.

More than one light?

It is not only the key light that determines which surfaces will be lit. If you use fill light, background light, back light, eye light, or a kicker, some of the same or additional planes will also be illuminated. Sometimes the choice of this additional light is more obvious than other times.

The planes or the forest

It isn't a matter of seeing the planes instead of the forest. The subject, mood, motivation, composition, and purpose of the shot are essential to effective lighting and need to be considered carefully as well. A glaring nose cone on a shuttle model is likely to be more appealing than a glaring nose on the face of a fashion model. Knowing how to achieve one and avoid the other is an important part of the lighting craft.

Not a conventional term, but one coined by the author.

Whether you are shooting landscapes, factories, art treasures, or the human form, you are lighting a series of planes and contours.

How bright or dark each plane and contour appears depends, in part, upon the combined angles of the light, subject, and camera, as well as upon the nature of the surface.

ALBRECHT DÜRER SKETCH

Controlling glare

To control glare, you can move the glaring object, the light, or the camera. You can also use a softer, more diffused light source, a polarizing camera filter (but not on bare metal), or a dulling-type spray (but not on bald heads).

Using glare

Dark subjects and dark backgrounds such as walnut paneling can be rescued from obscurity with a bit of gentle glare from a soft source. The larger the area, the larger the source should be. Such treatment can save even those semi-matte black surfaces from the fate of photographic oblivion.

The law of the planes

Glare light is only one facet of plane lighting, but it is an invaluable one. The law that describes how light behaves on smooth, reflective surfaces states that the angle of reflection equals the angle of incidence in an equal but opposite direction. In other words, light that strikes a surface at 45 degrees from the left is reflected 45 degrees to the right. Surfaces that are not smooth, reflective, and flat are subject to the same law, but the quantity and quality of the glare likely will be different. Experimentation and experience are essential in order to truly understand glare.

Terminal Trauma

Lighting planes can be far more efficient and rewarding than plain lighting. Aside from helping you to overcome Lighter's Block, the technique can ease the agony of Terminal Trauma: knowing when to stop adding "just one more light." The moment to stop is not when the available time and lights have been exhausted, but when you and the planes are reasonably happy and the mood has been achieved.

For more: *Glare* in *The Art & Craft of Lighting Craft & Art; A Thousand Points of Light; Reflections on Reflections* in *Hearing the Light;* and *Exercise #1* in *Lights-On Lessons.*

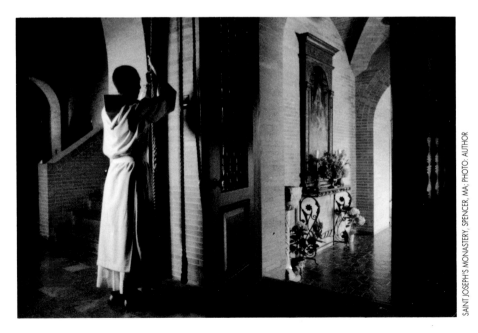

SAINT JOSEPH'S MONASTERY, SPENCER, MA; PHOTO: AUTHOR

Several lights were positioned carefully to emphasize the significant planes, reveal the setting, and suggest depth. (Still from *The Monastery*, filmed for ABC-TV by the author.)

Hard & Soft Light

Key considerations

E. Carlton Winckler
Television lighting utilizes a high percentage of hard lights because of their ability to project their light from convenient locations overhead and at the sides of the playing areas.

Vilmos Zsigmond
I do not like to light with hard sources anymore unless that is the way it is in real life. *[FL]*

Haskell Wexler
To be able to light well in hard light makes the soft lighting a piece of cake, because a soft light is very forgiving. *[FL]*

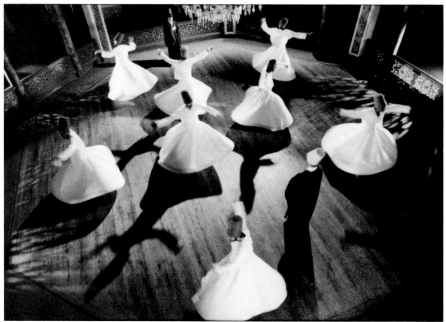

The difference between the quality of hard and soft light is like that between sunlight and overcast sky light. Not only are their effects different, but so are the tools and many of the techniques used to achieve these effects.

The hard back light I used for this sequence dramatized the dancers' shadows and swirling skirts. (Still from *Suleiman the Magnificent*).

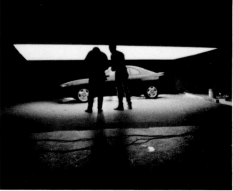

Soft lights that are at least as large as the subject and that are relatively close to it produce a gradual transition from highlight to shadow, yielding a subtle gradation of tones.

Hard Light

History

The sun, which hard lights imitate, provided the illumination for studio "interior" scenes in the early days of film. In fact, it was the temptation of 360 days of sunshine that helped convince producers to abandon the weather of New Jersey and head for Hollywood. In those days, film and lenses were "slow" and required considerable amounts of light to achieve adequate exposures. When artificial lights eventually were used, they were of the powerful, hard-source variety.

With today's "fast" lenses and films and light-sensitive video cameras, much lower levels of illumination are required. Even so, hard lights, which produce higher light levels than equivalent soft sources and throw their beams greater distances, are often good choices, since it is possible to use fewer of these, to use units of lower wattages, or to position the lights at greater distances.

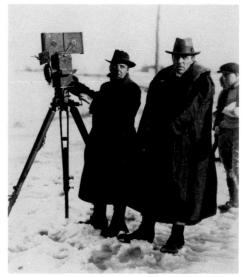

D. W. Griffith and Billy Bitzer shooting *Way Down East*, way back East and way back when.

Quality

Hard-light sources produce intense, small, bright highlights and shadows that tend to be dark and sharp-edged. On contoured surfaces, such as the human face or figure, the gradation or fall-off of light from highlight to shadow is narrow and abrupt. This makes for strong modeling of shapes and for dramatic emphasis on form and outline. Depending upon angle, a hard light may also emphasize texture and surface irregularities, such as those found in coarse fabric and wrinkled faces.

Fixture design

Most hard-light fixtures utilize the direct rays of the lamp in combination with a light-gathering reflector positioned behind the lamp. The relative size, shape, and pattern of the reflector varies with different types of lights. Some, like the fresnel, feature a focusing lens. The fresnel is a lighter weight, optically "stepped" version of a plano-convex lens. The edge of the light beam tapers off in a way that makes it easy to overlap the beams of several lights. Fresnel shadows tend to be cleaner and sharper than the shadows of lensless lights.

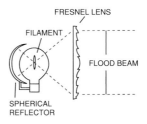

Hard back light does wonderful things for furry, fuzzy objects of every denomination, as well as for fog, mist, steam, and ice.

PHOTO: AUTHOR

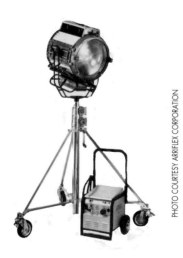

PHOTO COURTESY ARRIFLEX CORPORATION

Focusing

Most professional hard-light fixtures have a focusing mechanism allowing for control of both beam angle and light intensity. The wider the beam (flood), the less the intensity; the smaller the beam (spot), the greater the intensity. Apart from the artistic control this enables, spotting down a source compensates for the light lost when working at great distances from your subject or when you introduce such light-sucking devices as daylight correction or diffusion materials. Flooding out the light makes it possible to balance various sources without moving the light away from the subject, which is often impossible in cramped interiors.

Spill, fill, & contrast

Hard sources spill or scatter light less wantonly than do soft ones. This means that contrast ratios are much greater and the resultant light more dramatic. Unwanted light can be blocked or reduced more easily and more precisely than is the case when using soft sources. This is especially important with back light, which is aimed toward the camera and will create lens flare if not restrained.

When dramatic, dark-shadow, high-contrast lighting is not wanted, fill, bounce, or base light is required. Hard lights that are not heavily diffused or bounced should not be used for fill because they will introduce new shadows. This means that for typical shooting, the more hard light you use, the more soft light you are likely to need.

Size advantages

Because hard lights are considerably smaller than soft lights of comparable wattage, it is much easier to hide them at the edges of a scene or behind a post or desk within your shot. And, for reasons explored in *Bringing Copy Art to Light*, hard or broad lights are preferable for most copy work. Also, transporting them to locations is usually less of an effort compared to lugging conventional soft lights.

Accessories

Aside from flooding the light, you can reduce the output of a hard light by inserting one or more scrims in the front of the fixture. Half scrims and graduated scrims reduce light in just those areas of the scene that need to be darkened. Some of the other accessories available for use with some hard light systems (which generally cannot be used with soft sources) include snoots, glass diffusion, dichroic filters, high-intensity reflectors, and umbrellas.

Soft Light

Light quality

Soft light has a quality that is difficult to put into words, but some of the ones that spring to mind include "gentle," "enveloping," and "voluptuous." Whereas hard light can create drama and emphasize form or modeling, soft light helps to reveal the character of the subject. It does so because the large, soft highlights change gradually into subtle shadows on the curved surfaces of the subject and scene. The transition from white to black, with shades of gray or color in between, is more subtle than a hard-source transition. Also, there are more areas in the softly lit scene where details will not be lost to the extremes of Wash-Out White and Oblivion Black.

Soft versus flat

Soft light is not, necessarily, flat light. "Flat" refers to contrast, but also to the type and direction of the source. Any light positioned close to the camera, whether hard or soft, will produce a fairly flat flavor. Any light, including a soft one, placed at about 45 degrees or more to the side or above the camera/subject axis will result in lighting that is decidedly not flat. However, soft light does tend to be less contrasty than hard light coming from the same angle.

Size and distance

If the light is smaller than the subject or too far away from it, it will not envelop it. If, however, the light is too large and too close, it will devour the subject: there will be little or no shadow to help define the form and the planes, and the highlights will be too large and weak. A 2' x 2' fixture overwhelms a watch, underwhelms a car. Part of choosing the right source includes choosing one that is the right size and placing it at the right distance and angle.

Smaller source

If the source is too large for a small object, a smaller unit should be used. If one is not available, the large source can be "shrunk" by using flags or large cards to block part of it — but not block its ventilation.

PHOTO: AUTHOR

Movement of the light or subject by only a few degrees to the left or right can change the look and mood of the shot drastically. The source I used here is either too close to the subject/lens axis or too large.

Banking

When available soft lights are not large or intense enough for the subject or set, banking two or more soft sources will create a larger and more powerful "single" source. If the units are placed closely together or diffused into an apparently continuous source, they will not cast separate shadows.

Fixture design

To qualify as a true soft source, the light the fixture emits must be reflected and diffused: no direct rays from the lamp should reach the subject. Placing diffusion material in front of the source will increase further the subtlety of the highlights and shadows, which may or may not be desirable for a given subject and mood. The larger the diffusion material and the farther it is placed from the light, the softer will be the illumination.

Working with soft lights

In some ways, it is easier to work with soft lights than hard lights, in other ways more difficult. Initially, it takes less effort to achieve handsome images with soft lights that have been positioned sensitively in relation to the subject. Soft sources give actors considerable leeway in their movements and demand from them less concern about hitting their marks. They must be positioned fairly close to the subject, however, which may be difficult to achieve in large scenes. As a result, soft sources are not commonly used to light large background areas.

Spill problems

Because most soft lights are non-directional, they produce considerable scattered light and spill. Often, this is an asset if they reflect off color-neutral walls and add to the general light level. However, a problem will be created if the washed-out walls appear in the shot or if the spill light reduces the contrast in the scene more than desired.

Soft light barndoors and egg-crate (honeycomb-like) light baffles can limit some of the spill light and help to introduce subtle shading, especially at close range. They also help to control lens flare, but you should not expect the kind of barndoor control that is possible with hard-light sources.

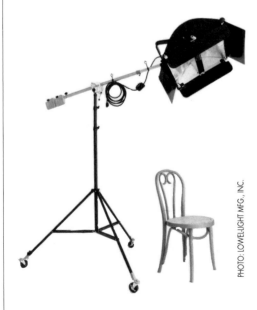

PHOTO: LOWELIGHT MFG., INC.

26

Flags and other materials used to create shadows must be larger and placed closer to the subject (and farther from the light) than is the case when using hard sources. As a result, if you position soft lights too close to the subject they will have to be moved back so that flags and stands will not end up in the frame.

Soft light versus umbrellas

It is relatively simple to convert some hard sources into umbrella lights and, in storage configuration, these are more compact than soft lights. This is likely to be a good choice if the light is not always used as a soft source because you will also be able to use the fixture without the reflective umbrella as a hard or semi-hard light.

On the negative side, the depth of an umbrella tends to be greater than that of a soft light, usurping precious shooting space in "tight" locations. Controlling spill light is more difficult with an umbrella than with a soft light, especially if the latter is equipped with baffles or barndoors. Also, when the reflection of the source can be seen on a reflective subject such as eyes, the rectangular shape of a soft light is less jarring than the more obvious contours of an umbrella. In fact, when source reflections are prominent, some pros attach strips to the front of their soft lights in order to simulate window frames.

Bounce light

For many types of interior scenes, the current source of preference is bounce light. Bounce light provides a subtle, often realistic look that is easy to achieve and work with, especially for actors, since they do not have to hit exact marks to be properly lit. As with all sources, its angle is important: the look of side bounce is drastically different from front and top bounce. Overhead bounce is "safe" in that ceilings are more frequently color-neutral and lighter than walls, "dangerous" in that the light may not be motivated credibly. Also, your subject's eyes likely will require some fill if all of your light is coming from above.

Pros use 4' x 8' panels of reflective material, such as lightweight foamcore, supported on walls and ceilings or in corners. One or more hard sources can be directed onto them and bounced off.

For more: *Exercises #2, 2A, 4, 10,* and *12* in *Lights-On Lessons.*

PHOTO: AUTHOR

Umbrellas allow for quick conversion of hard and broad sources into soft ones. As with so much in light, however, there are tradeoffs.

Mario Tosi
Bounce light looks so natural. . . [The subject] looks like it's not lit. . . If there is a lot of motion, you probably have to use different stages of bounce light: one for the foreground, one for the background, etc. Or if the subject is far away from the camera, you can pinpoint the spot with a hard light. *[ML]*

Broad, Semi-Hard Light

Sometimes, neither hard nor soft light is appropriate. What you may need is a semi-hard, semi-soft source. The easiest way to create one is to take a hard or broad source and add diffusion: glass, gel — whatever won't burn, melt, or discolor. The denser the diffusion and the farther it is away from the light, the softer will be the shadows and the highlights. If you use more than one layer of gel, there should be sufficient space between each layer for efficient cooling and scattering of light to take place. Another way to achieve semi-hard light is to use a soft, silver reflector and bounce the sun or a hard light source off of it.

A photographer who specializes in food photography uses diffusion gel in front of a hard light and pokes a small hole in the center of the gel. This gives each image the voluptuous glow of soft light as well as the sparkle of hard light without requiring the use of two sources. For some pros, part of their fun lies in adapting standard tools of the trade to make them more responsive to their needs.

The type of artificial or natural sources you should choose depends upon a delicate balance of subject, mood, working space, light level required, and amperage available. More often than not, however, your choice will be based upon what equipment is handy and whether or not the sun is shining on the day you want to shoot.

PHOTO: LOWELIGHT MFG., INC.

Hard Light Highlights
- strong, dramatic highlights and shadows
- can be used far from the subject
- usually requires fill to soften shadows and to control contrast

Focusing Hard Lights
- beams can be varied from wide to narrow
- user can control intensity of light

High-Intensity Sources
- very narrow beam for long-throw or high-speed shooting
- some hard lights convert to high-intensity units

Fresnels
- relatively sharp shadows in flood setting
- usually more heat, less light per watt than open-faced units

Ellipsoidal Spot Lights
- extremely sharp, clean shadows
- ideal for projecting patterns onto backgrounds

Soft Light Highlights
- produces gentle, flattering highlights and shadows
- needs to be fairly close to the subject

- tends to spill light and reduce contrast
- requires little or no fill light
- works well as a fill light (no new hard shadows)

Broad Light Highlights
- semi-hard source
- usually non-focusing
- often a hard or broad source converted with any translucent material that won't instantly melt
- good for general lighting as well as for copy work

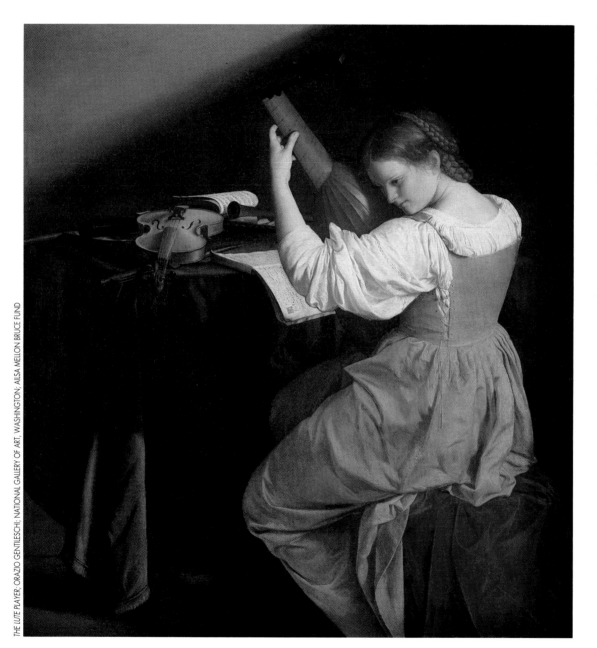

The absence of most high-light reflections suggests that Gentileschi's scene was suffused with soft light from a large window. The dramatically dark background with limited spill, however, evokes the presence of a more directional hard or broad light source.

THE LUTE PLAYER; ORAZIO GENTILESCHI; NATIONAL GALLERY OF ART, WASHINGTON; AILSA MELLON BRUCE FUND

29

On Face Value

People, portraits, problems,
& a little Light Surgery

Successful illumination of the famous, fabulous, and unknown can bring to the surface their inner-light.

The human face, along with its two-dimensional representation, is an endless source of fascination. We are, by nature, people-watchers. Our biological drives to avoid danger, find a mate, feel needed, communicate, and discover our place in the social pecking order are dependent upon the facial expressions and body language of friends, foes, and family.

The role of lighting

Faces that are hidden in darkness can arouse anxiety and fear, so it is not by accident that high-drama lighting makes use of lots of shadows. Comedy, on the other hand, is bright and free of deep shadows.

Successful illumination of people, whether famous, fabulous, or unknown, can help bring to the surface their inner-light, while emphasizing or suppressing character, texture, blemishes, and the illusion of depth.

Function and direction

There are four basic types of lights and six or more secondary types. Each has a name that suggests its function, its direction in relation to the subject, or its importance. The names do not indicate whether the lights are hard or soft, bright or dim, fixed or focusing, open-faced or lensed. However, lights used for fill are generally soft, and back light is frequently hard.

Key light

The key or main light is, by definition, the dominant source. It sets the character and mood of the shot and, if motivated, might suggest a window, desk lamp, or the sun. It is often, but not always, positioned first.

Fill light

Fill helps the film or tape see into dark, shadowy areas. A soft-source fill will not introduce objectionable new shadows. It is generally preferable to position it on the side opposite of the key and usually, but not always, close to the lens. How bright it is in relation to the key will determine the lighting ratio and will therefore influence contrast.

PHOTO: AUTHOR

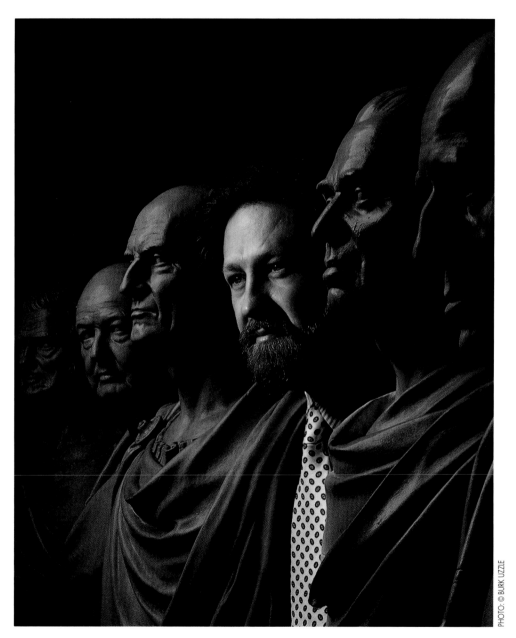

Burk Uzzle's striking study of Harvard Law School dean Robert Clark surrounded by his predecessors exploits contrasting elements: bright areas versus dark areas, warm light versus cool light, and hard light versus soft light. The photographer used his array of lighting tools and techniques to invoke past and present in this composition.

Shooting people outdoors requires a little planning so that the angle and intensity of the light are workable and the background is not washed-out or distracting. When the plane behind the subject is dark or sufficiently out of focus, the background may help to suggest depth and create separation.

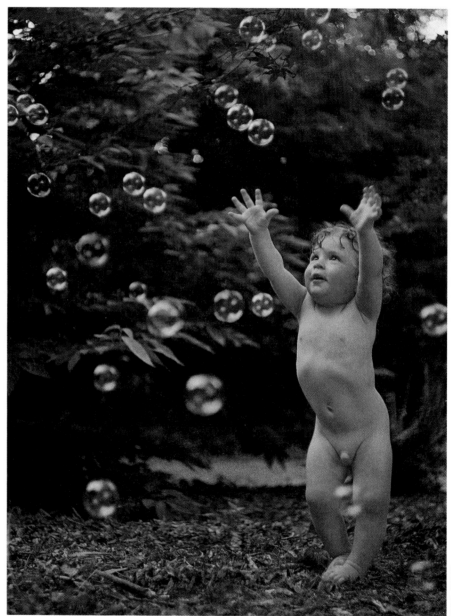

PHOTO: AUTHOR

Back light

Back light illuminates a subject from behind in relation to the camera. The source may be placed dead-center or slightly off to the side and above the subject. However, if you position your back light directly above the subject or set, it is then referred to as top light. Top light is seldom flattering to the face.

Background light

Background light accentuates part or all of the area behind the subject, especially if the key does not do the job. It helps to create separation, as does back light. In video it may be called a set light. On large sets you may need to use several such units. Try not to overlight the background or it will overwhelm the subject. White limbo and intentionally burned-out windows are exceptions.

Kicker

The kicker is a side-back light that adds gentle glow or strong glare to the side of the face, hair, and shoulder. Sometimes it is used for dramatic effect on the dark side of the face instead of fill. The kicker may become a temporary second key whenever the subject turns toward it. Other names for this include liner and, when very subtle, glow light.

Eye light

Eye light provides a limited-area fill or highlight when the key and fill leave one or both eyes dark. A well-diffused or dim source will not add to the overall exposure but can make the eyes — especially moist ones — come to life. Carefully positioned off to one side, its reflections in the whites of the eyes suggest all sorts of potent passions. On the other hand, not seeing a person's eyes can create a menacing or mysterious mood. Seeing an actor's eyes only when he tilts his head up or looks toward someone else can be an effective dramatic technique.

Tyranny of terms

If your only source is a back light, is it really functioning as a key instead? As you move it around toward the front, at what point does it become a kicker or a side light? In practice, it really doesn't matter. What does matter is how it looks and whether it is good for the subject and for the mood. As important as the names may be for communication with other craftspeople, terms should never determine lighting.

Gordon Willis
I had a philosophy which I used. . . in *Godfather II*. . . I didn't give a shit whether I saw their eyes or not. It seemed more appropriate not to see their eyes in some scenes because of what was going on in their heads at certain moments. I had a lot of trouble with that from traditionalists. . . . *[ML]*

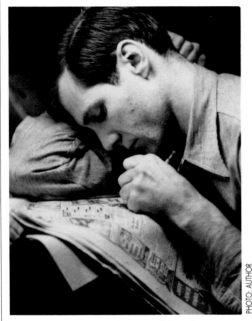

PHOTO: AUTHOR

The angle of the light is only meaningful in relation to the angle of the head. This high-angle source would not have worked as well if the pose had been more conventional.

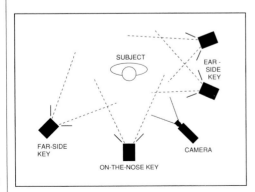

Direction and mood

The key to mood and character revelation is the angle at which the main light strikes the subject in relation to the camera. The following terms describe fundamentally different lighting looks:

Conventional key

A key set 30-to-45 degrees to the side and above the subject is considered traditional for lighting faces. The angle, however, should be set in relation to the facial features of each subject.

Low-angle key

Lighting that comes from below the subject tends to be unnatural or scary. If the same low-angle illumination is motivated by a seen or known source, however, it can be startlingly beautiful and, with the right subject, surprisingly sensuous.

High-angle key

Top light is usually dreary or moody when a subject looks down, spiritual when he tilts his head up.

90 degrees to the side

When a subject is lit from only one side, the results are often stark and dramatic. If both sides are lit equally, the effect is usually dull.

Mostly from behind

Subjects that are lit from behind seem mysterious, otherworldly, romantic, or threatening, depending upon the wardrobe, music, or ad copy.

Far-side key*

In relation to the camera, the main light is set on the far side of a model's nose, beyond the far eye, leaving the camera-side of the face in partial shadow.

Ear-side key*

Occasionally, the main source lights a model from the camera-side of the face, sometimes from the ear-side, leaving the front of the face in partial shadow. This effect is seen more often on canvas than on the screen or tube. The lighting technique is undoubtedly easier to control as a single, static image than as part of a sequence of shots, especially if movement or other subjects are involved.

On-the-nose key*

When the subject's nose is pointed directly at the main light source, his nose shadow will be minimized and so will the texture and blemishes of his face.

Planes

Shooting people and portraits effectively involves a choice of the subject's features. You can start by selecting those areas and planes you wish to call attention to, i.e., the eyes, cheekbones, hair, or side of the face. Your preferences may be based upon those features you find attractive, unusual, or useful to enhance character or mood. Next, find the best place to put the light in order to emphasize those planes and minimize or hide others.

How many lights?

Most of the great portraits and figure studies on canvas and wood appear to have a single source providing all of the illumination for the subject and background. Painters' pallets and contrast ranges are not subject to the technical limitations of tape and film, and artistic license is more lenient than cinematic license. As a result, painters can perform miracles with light by filling and spilling at will. For the photographer, a single source may not always be practical or desirable. Still, even when you use several lights, one source should dominate.

"Problem" faces

Handsome, dramatic people look good regardless of how they are clothed or lit. Subjects with deep-set eyes, prominent noses, double chins, or strongly asymmetrical faces challenge the inexperienced shooter with two questions: "Should I make the subject more attractive?" and, if so, "How?" The answer to the first used to be: yes for good guys and for most women, no for bad guys.

Performing Light Surgery

There are tools and techniques to stretch, compress, improve, or distract from almost every faulty or out-of-fashion feature. For example: a diffused on-the-nose key, positioned just above the lens, minimizes wrinkles, double chins, and large noses, emphasizes cheekbones. Often called Butterfly Lighting, the technique helped to glamorize many generations of movie stars. The human face is one of the few subjects that can be lit effectively from such a dull angle yet still yield an effective image.

James Crabe

. . . [with] aging actresses, you put the key light over the lens, maybe you soften it a little bit, but not too much because you still want. . . . the underside of the chin to go dark. . . . We all know that a real high [angle] key light makes dark [eye] sockets, but in older people sometimes their teeth are withdrawn. . . . If you do not get the light low, you do not see the teeth. . . . These ladies who are camerawise get very nervous when they see a [low] camera. . . . because whenever they look down, their jowls come out and the fold-up double chins. . . . Whereas in the traditional movie two-shot, a man and a woman standing together, the woman is always looking up, the man is always looking down, and he has a little more rugged key light. This is Hollywood lighting. *[FL]*

35

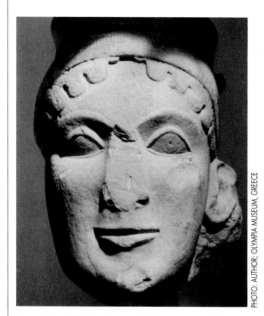

PHOTO: AUTHOR; OLYMPIA MUSEUM, GREECE

It wasn't the Infidels who smashed the noses on Western busts, but ancient photographers desperate to eliminate ugly face shadows.

Front soft light will appear to broaden a narrow face. Side light, top light, and low-angle light tend to emphasize shape, texture, and subtle changes in expression — ideal for young faces, character actors, and strong, silent types. Generous rim light or back light, accompanied by soft, subtle, fairly flat fill, is a safe — if overused — solution for 60-something subjects.

Double chins can be de-emphasized by keeping them in shadow: both lights and camera should be appropriately high. Bald heads and prominent ears are tamed by finessing them with shadows, allowing them to merge partially or fully with the background, and avoiding top light and back light. Strong kickers are unkind to large noses and ears.

Other surgical procedures

When you use a wide-angle lens on a close-up, the subject's nose will appear laughably large, his ears oddly small. Even a "normal" focal-length lens will distort the proportions of the face if the camera is too close. Long lenses are usually preferable, but if too long they will create an impersonal distance between viewer and subject and also flatten the face.

To minimize blemishes, use a diffusion filter or a piece of netting, such as an old-fashioned matte-black stocking over the camera lens. If all else fails, consider emphasizing the setting while keeping the subject small in the frame.

Colored gels, especially amber, gold, or pink ones, will add a welcome, warming aura to black hair and dark skin, which might otherwise end up with a slightly blue or gray cast.

The nose

Lighting faces would be a piece of cake if it were not for noses — even modest-sized ones. Kicker lights can cause glare on the side or tip of a nose. Key lights create dark, unattractive nose shadows on the cheeks and lips unless they are positioned closer to the lens axis than would otherwise make sense. Equally frustrating, prominent nose bridges will shadow the far eye when the main light approaches a dramatic side angle, sometimes even an undramatic one. Unfortunately, the best places to put lights to minimize nose shadows are often the worst places to place them to avoid reflections in the lenses of eyeglasses.

De-lighting eyeglasses

Professional actors seldom wear glasses. If glasses are called for in the script, the lenses are usually flat. Lighting subjects who do wear glasses is a challenge, and the more convex the lenses, the greater the challenge. Positioning the light high or to the side of the subject usually works, unless thick frames block the light from the eyes. Any fill that is used must also be well away from the lens/subject axis. While soft sources glare more gently than hard lights, their large size makes them more difficult to hide.

Tipping the eyeglasses down on the nose slightly may help. If you are lighting for film or video, have the subject move his head around, as he might do in the course of shooting, so that you can anticipate any sustained glare. Fleeting glare is seldom a problem.

Some subjects offer to remove their glasses. Make sure the subject will be comfortable without them, especially if he has to read a prompter or cue cards. Also, consider that there may be pad marks on the nose left by the glasses. I usually ask non-actors who elect to remove their glasses to hold them. It not only explains the marks, it also solves the what-to-do-with-the-hands problem. If your subject has contact lenses and brings them to the shoot, one of your biggest lighting problems will be solved. Some actors have contact lenses in various colors. Tinted contacts tend to minimize squinting, especially useful when shooting outdoors. But there are better remedies.

Squinting

People squint while looking at a candle in a dark room yet seldom squint outdoors, where it can be 6,000 times brighter. Squinting is a response of the eyelids and brow to the conflicting orders the eye's iris receives: "close" to protect the retina from too much direct light and "open" in order to see into the darkness. *Cure One:* Add a lot of light to the book, audience, or wall that your subject must look at — preferably before the problem arises. With non-actors, being able to see who or what is out there also helps overcome camera-fright. *Cure Two:* Reflectors and bright lights should not be used close to the subject's line of sight, especially if he has sensitive or light-colored eyes. *Cure Three:* Reduce the specular nature of the offending source. Diffuse it.

There are "good" reasons why people squint while looking at a candle but not at a sunlit scene, even though it is 6,000 times brighter.

E. Carlton Winckler
When a TV program features a celebrity, the chances are that this person will not appear on the set until a couple of minutes before showtime. So it is normal practice to focus several key [and other] lights on the VIP chair . . . The LD can select the best combination for whatever arises.

Pre-lighting VIPs

At times it is necessary to pre-light executives, celebrities, and politicians who are on tight schedules. One way to increase the chances of having an effective lighting scheme before a subject arrives is to look at photos or tapes of the subject ahead of time. You will also want to determine if he will need any special lighting treatment for such things as long hair (forget the kicker) or no hair (forget the back light).

If you do not trust your subject to wear photographically appropriate clothing, ask him or her to bring along several shirts, jackets, suits, dresses, sweaters, or neckties. Try to avoid extremely dark or light clothing, especially close to the face. Opt, instead, for texture. If a microphone is to be hidden under a tie, select a tie with a lining that will not "excite" the microphone.

Use a sit-in for the pre-light. As soon as the VIP arrives, and before make-up, check out the lighting. You can then finesse the lights while face paint is being applied. Do not approve makeup until you have seen it under your lights. It is often necessary to tone down makeup when it leans toward the theatrical, especially with men, and always for close-ups. If you do not have a makeup artist on the set, keep several shades of face powder handy in case things get hot or the subject gets nervous. Perspiration is seldom a plus.

The Vanity Ploy

If the scene you know you need has not materialized and your celebrity is about to disappear, try the Vanity Ploy. Everyone wants to look and sound his best when he is being "immortalized." Tell your subject, who is rushing off for another appointment, that you have a "perfectly satisfactory" take. The celebrity will sense from your tone of voice that you are not pleased and ask what's wrong. If you hint at a vague something that might be better in his delivery, your subject may not find that next appointment nearly so urgent. The ploy was once used by director Max Lasky with a prima donna dancer who said he would only perform once for the camera. As director of photography David Quaid recounts, the technique enabled all to save face.

Helping non-actors

Before subjecting the anxious non-actor to the camera and microphone, be sure to introduce him to the crew and, time permitting, allow everyone to get to know each other. This way, your subject will see himself as the focus of a shooting crew, not the target of a shooting squad.

Inexperienced "performers" are often nervous, in part because they believe they must get it right the first time. Assure them you have plenty of film or tape and lots of time and that shooting always requires many takes. Clear the room of all non-essential people, particularly those who are overly critical.

Offer suggestions to help the subject feel at ease. For example, insecure subjects tend to immobilize their hands, so let them know you prefer that they gesture. Have suitable beverages available to alleviate dry-throat syndrome. Commend them for what they do well. Don't expect non-actors to be able to memorize long-winded speeches. Break it up. Try improvisation. Sometimes shooting the "rehearsal" will reward you with the most natural take.

When working in film and video, the hardest thing for a non-actor to do while speaking is to look at the lens. Even stage actors can be confounded by those multiple images of themselves reflected in the camera lens. Whenever possible have the subject look at and talk to a well-lit, friendly person positioned near the camera lens.

Confidence and the actor

Actors need to know whether they are in close-up, medium, or wide shot, and whether or not their hands are in the frame. This will enable them to emote in a scale appropriate to the image size. A clenched fist will be lost in an extreme long shot. A clenched jaw may come off as "overacting" in a tight close-up. Although it may be obvious to you, actors cannot always gauge image size by judging camera distance. Actors with film and video experience may only need to know the focal length of the lens you are using. Another way to help actors is to try not to lock them in with your lighting more than absolutely necessary.

For more: *Finessing, Lighting Planes, Method Lighting, The One-Light Approach, Hard & Soft Light, Hearing the Light,* and *Lights-On Lessons #2* through *2C*.

Bill Klages
Going back to the very beginning, when the parameters of the television reproduction system evolved, the only sub-ject matter that the founders felt was constant enough to be a reference was human skin values. I would venture to guess that everyone at that time was obsessed with blond-haired, fair-skinned individuals whose faces had a reflectance value of 30%. Believe it or not, these founders assembled groups of observers whose tabulated preferences indicated an electrical signal amplitude of 70% of the value of maximum picture tube brightness (or "white") was "perfect reproduction" of the human face brightness. How perfect is open to question, since these were the days of black-and-white television. So much for viewer preferences.

Finessing

The fine art of refining raw light,
the black art of casting shadows

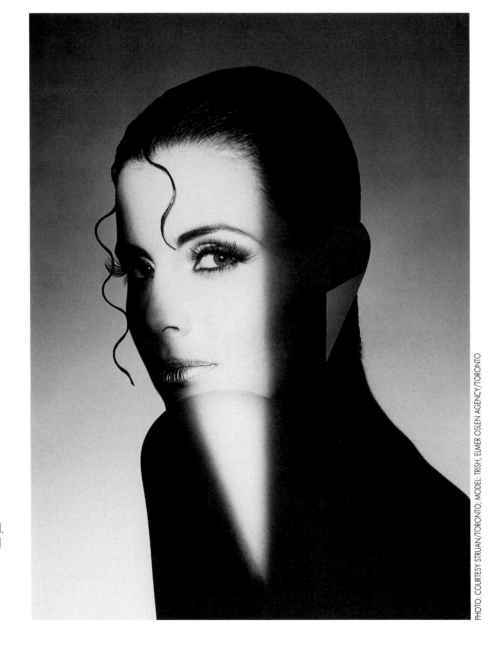

PHOTO: COURTESY STRUAN/TORONTO; MODEL: TRISH, ELMER OSLEN AGENCY/TORONTO

Vertical shadows, whether obvious or subtle, will make
a wide face seem thinner and large ears less pronounced.
Here, instead, the shadows are part of a well-integrated
design full of delightful surprises, such as detail in the
lips and eye despite deep shadowing. Best of all, the
straight-edged shadows are broken by the curves of
the brow, nose, lips, and shoulder with a subtlety that
demands frequent re-examination.

40

T elevision, motion picture, and still lighting, whether on-location or in the studio, can be divided into two halves. The first consists of selecting, placing, and powering lights. The second involves careful polishing. Finessing light is a fine craft — in the hands of some, a crafty art — but it remains an integral part of lighting and composition.

SCULPTURE: MERLE EDELMAN; PHOTO: AUTHOR

A well-cast shadow can reveal a side of your subject — often an exaggerated one — not otherwise seen. One more crafty way to compensate for that missing third dimension.

Objectives

One reason to refine light is to suppress or improve parts of the scene, such as an ungainly face or photographically boring expanse of washed-out walls. A head, for example, will appear to be narrower after vertical shadows are introduced on either side of the face. Another lighting objective is to concentrate audience attention on significant parts of a product, person, or element of the action.

The black art

One of the best ways to create drama and suspense is to subtract light from crucial parts of a scene. The magic ingredient is the viewer's imagination, which flourishes in the dark. Ghosts in unlit attics are more terrifying than in well-illuminated rooms — even without scary music. When one actor strikes another, there is added tension if we first see his shadow fall upon the victim.

Shadow traffic

The city at night, just outside of a window, can be implied evocatively through moving shadows and reflections from automobile headlights on the walls or ceiling of a room. People moving around interiors are cinematically more interesting if they drift in and out of unlit or underlit areas. Moving shadows, such as those caused by clouds racing across the sun, can bring a static landscape to life.

Subtracting light

Highlighting an area, or perhaps just one line you want the audience to see quickly out of a page full of words, can be accomplished by shadowing everything else in the composition. This is the photographic equivalent of the publisher's bold face.

41

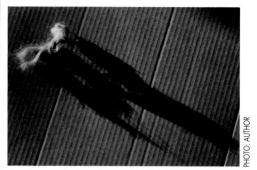

The sharpest shadows are made with a point source, a fresnel-type spot, or an ellipsoidal fixture. Or the sun.

Suppressing unattractive, distracting, or anachronistic portions of a location can be accomplished quickly with straight or curved shadowing devices. How dark or subtle the shadows will be will depend upon the distance the shadow-maker is from both the light and the surface it is projected upon, the type of source used, and how much fill light you employ.

Shadow play

When one shot must say as much as possible about the subject, a well-cast shadow can reveal an aspect not otherwise seen and help to suggest the missing third dimension. Shadows call attention to the form or outline of the object.

Distorting shadows

To create exaggerated or bizarre shadows, the source should be close to the subject and the shadow should fall upon a surface, such as a wall or floor, from an extreme angle, rather than at 90 degrees. Low-angle lights will dramatically enlarge the shadow of a subject. Curved or undulating surfaces will do for shadows what fun-house mirrors do for reflections.

"Fuzzy" shadows

Direct, hard-light sources project multiple overlapping shadows from various parts of the reflector and from the filament of the lamp. Usually, shadow edges will be quite close together and therefore not a problem. However, if shadows are prominent in the scene, their lack of edge-sharpness may be objectionable.

To improve shadow quality:

• Move the light away from the person or object or move the subject closer to the wall or surface upon which the shadow falls.

• Set focusing lights at full flood to cast the cleanest shadows.

• Put a small glass diffuser close to the front of a lensless focusing source and, if necessary, spot the light to compensate for the 40-to-60 percent light lost. The resultant shadow will be cleaner, more unified, and softer.

• Substitute a fresnel or an ellipsoidal fixture for a lensless source.

• Use only the edge of a hard light. Though less bright than the center of the beam, it will produce a cleaner, crisper shadow.

Saving the glow

Keep as much light as possible off subjects that are self-illuminated or that have images projected onto them. Often this means using flags or other devices to shadow the glowing subject. You may have to shoot at night or at dusk. Typical subjects that are harmed by external light include red-hot metal, operating video monitors and computer screens, and front- or rear-projection screens.

Tools and tactics

The tools used to refine raw light include focusing knobs, barndoors, snoots, flags, fingers, dots, nets, scrims, cookies, foil, and a variety of specialized shadowing devices. Outdoors, options include tree branches, butterflies, and wind and fog (real or man-made). Gels and filters of all sorts are standard finessing materials. By understanding and properly using the right tools, you can reduce hot spots and excessive contrast.

Of course, there are many assignments and situations where you find everything happening so fast that fine-tuning the light is not an option. When you do have time, however, finessing the light and "painting with shadows" can transform unimaginative scenes into more felicitous ones.

For more: *On Face Value, The Art & Craft of Lighting Craft & Art, Lights-On Lessons #4C, 6, 9* and *11.*

PHOTO COURTESY ARRIFLEX CORPORATION

Bill Klages
Don't fall into the trap of rushing to purchase the diffusion media that your peer claims is the answer to all our prayers. Instead, be objective. Learn to utilize a limited number of types to accomplish what you have in mind and stick with them whether they are current best sellers or not.

PHOTO COURTESY MATTHEWS CORPORATION

Method Lighting

Motivating sources logically
& dramatically

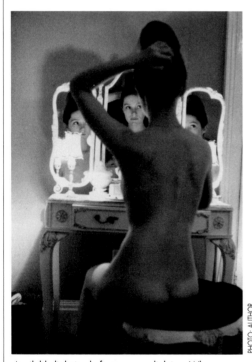

Available light is, de facto, source lighting. When an available source, such as a table lamp or window, is not seen in the shot, your lighting will appear less motivated than when it is seen. This holds true whether or not you add photographic light.

PHOTO: AUTHOR

For many directors of photography, lighting directors, and just plain directors, motivating the light is more than a standard practice, it is a way of light. However, for the new pro, "motivated lighting" is little more than an ambiguous phrase.

The Method

Photographer Dale Marks calls this "Method Lighting." Method Acting was pioneered by Russian actor, director, and producer Konstantin Stanislavsky and practiced by, among others, Marlon Brando. Its premise is that acting should be motivated by the personality and objectives of the character, not by theatrical gestures and affectations.

In the strict version of "Method Lighting," all the light you introduce to a scene comes from, or seems to come from, sources that already exist in the scene, which is why the technique is also referred to as source lighting. The motivating sources may be windows, floor lamps, ceiling lights, candles, flashlights, fires, the sun, sky, or moon.

Example 1

Industrial films and stockholders' annual reports favor factory images of quality-control operations, often featuring someone sitting in front of green-hued, glowing monitors or fluorescent inspection panels. The illuminated screens and panels require no additional light. In fact, the challenge, often, is to keep the light off of them.

If the operator is too dark and you choose to add an edge light or two, the direction, color, and quality of the implied motivating source should not be ignored. In other words, do not use an incandescent spot. If you must, add heavy diffusion and green gel.

Example 2

The hero of a film is in a prison cell illuminated by one window that is high up and far to the screen-left side of the frame. The cameraperson or lighting director will probably reject putting the key light screen-right, or low-left, or even eye-level-left, so as to ensure that the credibility of the scene and the audience's involvement will not be jeopardized.

Using the window as the actual lighting source, or putting the key light exactly where the window is, would seem like ideal motivational methods. However, the limited contrast range of film, and even more so of video, usually rule out these options. Generally, you can't include both the subject that is lit by a real source and the source itself in the same shot. If you do, you would need to reduce the contrast by blocking out some of the hot source that the camera sees, keeping the subject close to the source, or supplementing it with one of your lights. Also, a key that is very high or far to the side will require a lot of fill light — so much so that the single-source effect may be destroyed.

Remembering that your cinematic (or photographic) license allows you — even requires you — to adjust reality in the interests of craft and clarity, you might de-motivate the key light toward the lens and lower it until the hero's eyes glow when he looks up a little. Search for a lighting angle that is not only dramatic and convincing but also workable.

Vilmos Zsigmond
It is very important that people are lit realistically from existing light sources. And if you cheat, you cheat with light sources that you do not see but you feel that they could be there. *[FL]*

Nestor Almendros
I believe that what is functional is beautiful, that functional light is beautiful light. I try to make sure my light is logical rather than aesthetic. *[AMWAC]*

Billy Williams
. . . if you see somebody sitting close to a table lamp, then you want the lamp to be the source. But there are other times when you get into a situation, particularly with a woman, where you want to cheat the source light a little bit. For example, where a woman would logically be sitting in cross light, you may have to cheat more to the front because she doesn't look very good in cross light. If you put a lady in a bad light, you're doing her a disservice and you might be in trouble yourself. *[ML]*

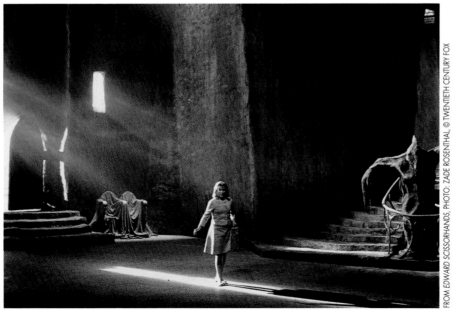

FROM *EDWARD SCISSORHANDS*, PHOTO: ZADE ROSENTHAL, © TWENTIETH CENTURY FOX

A little unrealistic atmosphere in the form of dust or man-made fog can convert back light into apparent rays that connect subject and source for "proof" of motivation.

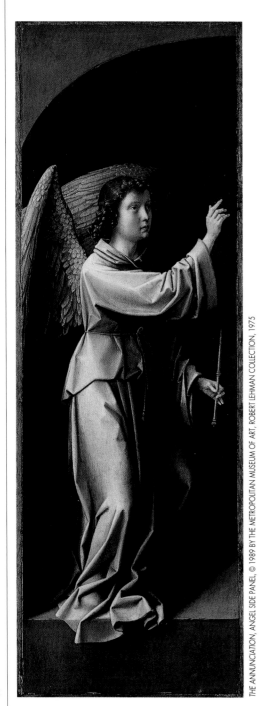

THE ANNUNCIATION, ANGEL SIDE PANEL, © 1989 BY THE METROPOLITAN MUSEUM OF ART, ROBERT LEHMAN COLLECTION, 1975

The next decision would be how to light the background. In the interest of realism, the wall behind the hero should be fairly dark. Lighting it from anywhere but screen-left, where the window is, would be a filmic blunder. You may be tempted to project the prison window bars on the wall. If you are a motivation-lighting purist, you are likely to reject the idea. On the other hand, it would be a good device to suggest the passage of time as the projected pattern changed positions or disappeared in later scenes. If the hero is incarcerated for much of the script, the pattern would provide valuable visual variety. When you cut to a profile shot of the hero (to see a guard entering, for example), the prisoner can, with only a little more unmotivated magic, glow with beautiful shafts of back light, symbolically reminding us of his lost freedom.

Example 3

Sometimes you need to shoot people who, in real life, would be in the dark. Typically, they are sleeping, or in a car at night on a moonless, deserted road, or part of an unlit audience. Too much light, especially front light, and the magic doesn't work. Too little light, or too little separation and, to paraphrase cinematographer/writer Jon Fauer, the forces of darkness triumph. Even pros may have difficulty finding the motivation and justification for any light in such scenes. No wonder beginners are perplexed.

Semi-motivation

Photographic necessity, and, by now, photographic convention, has it that there is always a little moonlight, streetlight, or unexplained ambient light around. That ever-present illumination is least awkward if it comes from the side or back of the subject and set, and most dramatic if it is finessed with judicious shadows so that only a few important areas or objects are lit. You may want to add a minute amount of fill light and a generous amount of

Your cinematic license allows you to adjust reality in the interests of craft and clarity. Gerard David's artistic license permitted him to add some otherwise unmotivated Divine Fill to the far side of the angel's face. He did not, however, let any Divine Fill fall on the background of the scene nor on the body of the figure in order not to destroy the striking sculptural effect. Many religious paintings call upon halos, the Lord's light, and other spiritual emanations to establish a dramatic, motivated source. Secular lighting can be tougher to motivate.

colored gel to suggest moonlight (convention has it blue) and streetlight, store light, or any other light (almost any color goes).

So much for Method Lighting, you say? Not really. Like politics and life in general, lighting requires occasional compromise. There has to be a delicate balance between realism and the unrelenting necessities of the craft.

No motivation

Even if you are convinced of the value and virtue of source lighting there will be plenty of occasions when, for reasons of choice or necessity, you will ignore its urgings. How does lighting motivation apply to fantasy, science-fiction, and fashion lighting? Perhaps not at all. These genres tend to suspend reality or create their own, so lighting may be a matter of style, not credibility.

On news and some documentary assignments, the available light may not be adequate or attractive, but it is definitely motivated. The trick is to avoid overwhelming it. Supplementary lighting can be kept unobtrusive by using the lowest-wattage lamps that will do the job, with enough diffusion to mute shadows and highlights.

Motivating set sources

In designing a set and, to a lesser extent, customizing a location, a lighting director, director of photography, or still photographer does well to become involved in the choice and positioning of prop lights and even of window locations. Establish a low-angle source for scary or mysterious effects, an overhead practical that will swing wildly when hit during a fight scene, or a candle in-hand for dramatic or nostalgic purposes. This is the stuff of which mood manipulation is made.

Motivating yourself

The relative newcomer may see *Method Lighting* as one more demand in an already complex craft. The opposite is true. Along with *Lighting Planes*, *Motivating the Light* is an approach that simplifies the job by giving you a place to start, a way to overcome Lighter's Block*, criteria by which to judge your efforts, and a way to create effective images.

For more: *Cheating* in *Hearing the Light* and *Lights-On Lesson #8*.

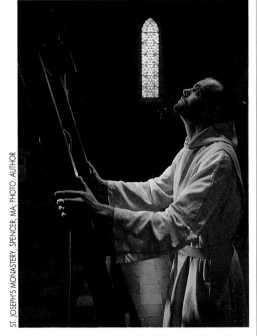

ST. JOSEPH'S MONASTERY, SPENCER, MA; PHOTO: AUTHOR

In its ultimate realization, Method Lighting is the stuff of which mood manipulation and movie magic are made.

Composing, Framing, Zooming, Dollying, & Booming

Composition, camera movement, & lighting are three partners in a two-dimensional dance

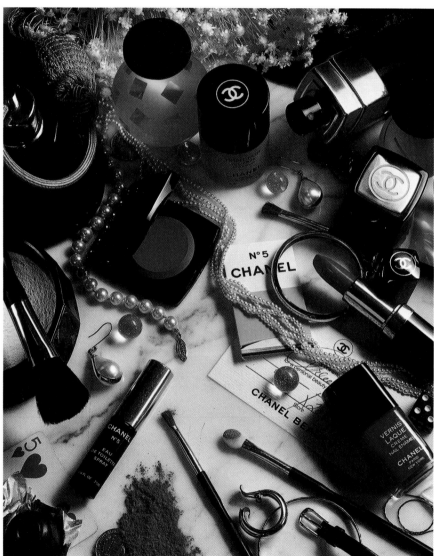

"I often sketch my compositions in advance," says photographer William Whitehurst, "but this one was built up gradually on the groundglass of my 8 x 10 camera." Whitehurst finessed both the composition and his light for almost two days in order to "create channels" for the viewer's eye and reward it with the rich textures and subtle details evident in the composition. For example, notice the variations on the theme of "5." For other elegant compositions, see pages: 5, 29, 31, 40, 58, 166, and 168.

C omposing even "simple" images is a complex matter. It is likely to involve light, shadow, perspective, angle, texture, line, shape, balance, rhythm, and unity. It may also encompass color, symmetry, depth, and distortion, as well as arrangement of subject, furniture, props, and other elements. There are also likely to be cultural, psychological, emotional, and even sexual overtones.

Composition in time

In film and video, composition is in a state of flux whenever the subject or camera moves. It is difficult to control, analyze, or even see the composition when a camera follows the path of a charging cheetah or a handsome actress. Few people will notice much about the background or the graphic dynamics in a scene until the camera and subject come to rest.

As a result, traditional composition lives mostly in the beginning and end of dolly, pan, and zoom shots and when there is no subject motion. And in stills. Movement within the scene and between scenes, whether the transitions are cuts, dissolves, or wipes, can be thought of as compositions in time, albeit often arbitrary and chaotic ones.

The frame

The word composition is seldom heard on the job. Framing, however, is a constant, conscious craft concern. Framing is to composition what illumination is to lighting, what cutting is to editing, and what movies are to films — either a less noble endeavor or a less pompous term.

The preliminary part of framing involves walking around the subject to find the best place from which to shoot, the most representative or dramatic point of view, the most effective juxtaposition of subject and background or possibly foreground. On exterior shoots, light and contrast may prove to be the two decisive considerations.

Framing may also involve the inclusion of foreground objects, such as tree branches, doorways, arches, and people, in order to direct the eye of the viewer, suggest depth, and soften the edges of the frame. Well-chosen, appropriate foregrounds can temporarily "reshape" a horizontal frame into a vertical or circular one.

It is usually a good idea to keep foreground planes relatively dark, especially

When "composing," framing tends to be your first consideration — and often your only one — especially when dealing with active subjects or cameras. Just how tight or loose your framing should be relates to dramatic matters. How much headroom you use depends upon taste and technical problems such as, in the case of film, what your screen proportions are going to be. On some mismatched movie screens people will end up headless. On TV screens, two-shots originally composed for wide screens may end up as one-and-a-third shots. Generally, close-ups will provide the greatest impact.

Our response to what is beautiful is strongly influenced by nature's designs.

when they are out of focus. Dark foregrounds add to the illusion of depth and prevent distraction from the main subject and action. When the main subject is in the foreground or shifts to the foreground, it may be necessary to shift focus accordingly or light to a high enough level to allow for adequate depth of field.

Framing in its fuller sense has to do with subject size, position, and direction in relation to the frame. You should generally leave more room on the side the subject faces than the opposite side. Headroom (the air above the subject's hair) is another important consideration, especially if the project is intended for both the big screen and for television.

In addition to framing, photographers must be attentive to separation, focus, and flare. They must also watch for boom shadows on actors, actors' shadows on other actors, the heads of actors disappearing when they stand up, and microphones appearing inopportunely. All this, not infrequently, in mid-dolly, Steadicam move, pan, and/or zoom.

Mise-en-scene

The combination of framing, composition, and lighting considerations is sometimes referred to as mise-en-scene. Its direct translation is "putting into the scene." Film professor Charles Merzbacher of New York University's Tisch School of the Arts thinks of mise-en-scene as "the total stylistic conception of the film."

Nature's compositions

The human response to what is beautiful is strongly influenced by nature's designs: the elemental contours of landscapes, the lithe lines of animals, the symmetry of flowers and diatoms, the patterns of butterfly wings and snakeskins. The natural world offers endless sources of inspiration for the insatiable appetites of artists.

Aspects of composition

The human response to some aspects of composition and color may transcend cultural limitations. Horizontal compositions, especially those that include the horizon, are more restful than vertical ones. Diagonals suggest the dynamics of a falling tree or cascading avalanche. The cool, receding blues of sky and water and the greens of trees and grass are less aggressive than hot reds and oranges, which are associated with sunsets, fire, and blood. Circles can be more appealing than squares and triangles, perhaps because of the infant's associations with eyes and breasts. Symmetry is so common in nature that it tends

to have a reassuring resonance in paintings and photographs.

Almost no detail is too unimportant to affect your image. The subject's red tie, glaring glasses, or white suit likely will determine where the viewer's eye travels and pauses as surely as would a background of books with legible titles or a cluster of waving bystanders.

Cluttered compositions exhaust the eye in the same way that relentlessly raucous soundtracks deaden the ear. Color should be used judiciously to further the mood and story. The effective use of color, especially strong color, requires as much of a sense of rhythm as does good editing.

Since the objective is commonly to direct attention to the subject — whether it be a person, prop, or product — an important aspect of composition and lighting involves careful selection, elimination, substitution, or shadowing of distracting or anachronistic parts of a scene.

Intimate relations

The question is not which comes first, the composition or the lights. While you or others arrange the scene or still life, or simply find the frame, you probably will be thinking about or executing the lighting, and as you light very likely you will need to fine-tune the composition. Even if you shoot uncontrollable events, eventually you will seek the evocative angle, the unobtrusive background, and the expressive light automatically.

The disciplines of light and composition should be treated as intimate partners, as Siamese twins who cannot sustain life separately. When the lighting is complete and someone substitutes something as "unimportant" as a black cat for a white dog or adds a wide-brimmed hat on an actress lit from overhead, the look of the lighting surely will change. When you project a venetian blind pattern on a wall, soften the highlights and shadows in the shot, or add a blue gel to the back light, you will be affecting the composition as well as the lighting.

Movement and instinct

Movement can hypnotize the beholder. Humans, it would seem, are programmed to respond automatically because, for soldier, pedestrian, and explorer, survival often depends upon early and accurate detection of moving objects. Not surprisingly, movement is at the core of much movie magic. As a consequence, in popular television and film entertainment, car-chase, ski-

Conrad Hall
If things are off-centered or unbalanced compositionally, it's probably producing an emotional effect that a balanced composition is not producing. It's learning how composition affects you emotionally that allows you . . . to use it. *[ML]*

Nestor Almendros
In my opinion, the main qualities a director of photography needs are plastic sensitivity and a solid cultural background. So-called "cinematographic technique" is only of secondary importance, and depends, above all, on one's assistants. *[AMWAC]*

John Bailey
As soon as you move the camera, you lose control over the lighting and . . . composition. . . there's no way to prevent that from happening. For me it's a . . . fair tradeoff, because I love the excitement of moving the camera. *[ML]*

chase, and shark-chase sequences can be counted on to stimulate the eye, the adrenalin, and the box office.

Zooms and zoomitis

Dolly shots are effective in bringing a film or video scene to life and in suggesting depth because, on the screen, the size and perspective of objects in the scene change and move in relation to each other. Zooming changes the overall size of the image, not the relative size and position of objects. Zooms call attention to the mechanical aspects of the medium in much the same way as do jerky pans or unmotivated high-angle shots.

Zoomitis*, an all-too-common professional hazard, is a nervous disorder brought on by the unrestrained use of zoom controls. The symptoms consist of extreme dizziness and near-total disorientation. *Cure:* Zoomenders*. Lighting director/gaffer Gill McDowell suspects that its membership rolls consist of underworked dolly grips.

Lazy lens use

Zooms tend to be used too often, too obviously, and without motivation. Motorized zooms on "inexpensive" video cameras cannot be operated at variable speeds, as, for example, when you need to start slowly, accelerate, and stop slowly. Hand-zooming with them, at this point, is hopeless.

The zoom is also ill-used when your camera is set at an arbitrary distance from the subject and you adjust the focal length to match the required size. With fixed focal-length lenses, you choose one that provides a normal, expanded, or compressed perspective, depending upon subject, style, and other considerations. The zoom lens can also be employed that way if you take the time to move the camera to achieve the desired perspective —not just the zoom control.

Effective zooms

When well-used, the zoom lens is an almost indispensable tool. Here are three ways it can be effectively exploited for video and film shooting:

PHOTO COURTESY CINEMA PRODUCTS CORPORATION

Garrett Brown's Steadicam has given writers, directors, and countless camerapeople virtual wings. Steadicam JR, designed for small video cameras, as well as Brown's amazing Skycam, entitle him to a place in the cameraman/inventor Hall of Fame.

Zoom technique 1

If you are fortunate enough to own or rent a zoom with an extremely smooth or "damped" zoom action, with a lot of practice you can make virtually imperceptible changes in image size, which is impossible with many of the motorized zooms on most video and film cameras.

Extremely slow zooms are invaluable for those long-winded, talking-head scenes. With enough dexterity, you can move from a medium shot to an extremely tight close-up (or the reverse) without anyone's being aware of your having done so. Since the movement is too subtle to notice, the otherwise distracting and artificial look is avoided. Also, at the editing stage you won't be presented with the problem of interrupting an obvious zoom action before it is complete.

Zoom technique 2

The second example is just the opposite: rapid zooming in or out for dramatic effect when the subject or mood calls for it — perhaps a long shot of a rifle or cannon with a bullet-velocity zoom into the muzzle or target at the moment of firing.

Zoom technique 3

The third way you might exploit zooms is to change focal lengths during a continuous shot, such as an interview. It is important to do so, however, during a non-critical moment in the action so that it can be edited out of the final cut.

Bipod camera support

Still, video, and film cameras are often hand-held: used without any support other than that provided by two human legs and arms. The hand-held camera is especially useful when shooting fast-moving news and candid scenes. With this method you can introduce realism and urgency into what might otherwise be static film and video images.

Various shoulder and body braces will help steady the camera, free one or both of your hands, and prolong the onset of backache. However, the longer the lens (which magnifies movement as well as image size) and the longer the shoot, the more important a third leg becomes.

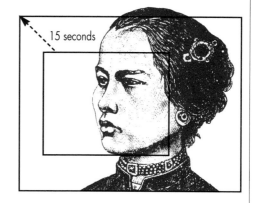

15 seconds

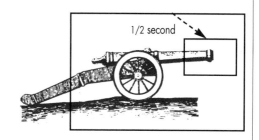

1/2 second

Just how steady a scene made with this type of "dolly" will be depends upon the road, the shock asborbers, and how much air you take out of the tires. In this case, it was about as steady as the burro I was tracking for a series of *Coffee of Colombia* commercials.

The author and assistant cameraman Tibor Sands ride a small camera crane while filming *Suleiman the Magnificent* in Turkey.

Tripods

A good tripod and tripod head (for precise adjustments or panning and tilting) are essential tools for most types of shooting. In addition to making the image steadier, these simple tools make it possible to frame and compose the shot with far more care than when the camera is held by hand.

Dollying and booming

Real subject and camera movements — as opposed to zooms, pans, and tilts — help to draw the audience into the action, separate foreground, middle ground, and background, and bring the scene to life. Whenever possible, camera movement should be planned so that it is motivated by the subject or action and not arbitrarily imposed onto the scene.

A good camera dolly can be pushed slowly and smoothly in any direction. It can also crab: change direction using all four wheels and move in an arc or full circle. The best dollies are equipped with a hydraulic boom arm so that the camera can be lowered or elevated during the shot without jolting starts and stops. Trouble is, the best dollies are difficult to transport (even when you succeed in renting one), but some of the more portable types are adequate for a lot of shooting.

If the ground is uneven, two layers of plywood, offset so that the joints do not line up and leveled with lots of wedges, will be required, unless dolly tracks are available. Note that tracks usually require special dolly wheels. The person propelling and elevating the dolly will need some experience to operate it smoothly.

Cranes allow for more dramatic changes in height while shooting. The ones that two people ride are potentially dangerous if not operated by skilled and experienced people. Never, ever get off of one unless the arm is locked and you have first checked with the operators. Some cranes are more "portable" because they do not support people, but only a remotely operated and viewed camera.

The steady bipod

Steadicams enable a trained and experienced operator to make dolly-like shots where dollies cannot tread, such as up flights of stairs. The Steadicam has changed the way that filmmakers and videographers think about their craft, at least the moving-camera aspects of it.

Alternatives

Wheelchairs and carts with large tires are often convenient alternatives to a dolly when the ground is reasonably smooth. On distant locations and low-budget shoots they may be *the* way to move the camera smoothly. Planes, trains, and automobiles are obvious, but occasionally overlooked, ways to keep things moving.

Riding the rails

Several systems have been designed for supporting a camera (but not an operator) and for allowing it to be moved rather smoothly atop a single or double rail that is supported on tripods. These elevated systems have the advantage of being able to ignore such impediments as bushes, but the length of travel is restricted, even when rail sections are joined together. For carefully planned, limited moves, the system is a blessing.

Lighting for camera movement

The main concern when lighting for dolly shots is the almost inevitable intrusion of the camera shadow on the subject when the dolly is in close. The higher the lights and the lower the camera profile, the less obvious the problem. Elevating the key and mounting a fill light on top of the moving camera may solve the shadow problem without major compromises. However, this "solution" introduces a new probelm: When the camera is in close, its light is too bright, and when it is in the wide position, too dim. A good obie light, called a "basher" by the British, solves the problem. It has a mechanical/optical dimming system so that the intensity of the light can be altered without changing its color.

Thought should be given to the lighting plan in terms of how the dolly movement will affect the look, especially if the camera moves around the subject and that beautiful back light or kicker turns into an ugly, out-of-balance front light.

Interdependence

Lighting, composing, framing, and dollying are such dynamic aspects of the moving-image media that it is easy to forget how they must interact with all the other craft elements. Editing, acting, costumes, sets, props, story, and music are just as important to the results as they are in dance, and need to be choreographed in harmony.

Highlights from the lectures of Slavko Vorkapich
- Composition: the relationship between objects within a frame
- The true nature of motion pictures is motion; many movies are just photoplays
- Moving objects will not seem to move unless the background is differentiated (panning with an airplane in a cloudless sky makes it stand still)
- Actual motion: the subject moves
- Virtual motion: the camera moves
- Observe motions and rhythm in repetitive work like bricklaying or assembly operations
- People blurring in front of the lens, as in a battle scene, heighten tension and action
- Directors should master the organization of movement
- Dots in motion form virtual lines; lines in motion generate virtual planes; planes in motion create virtual volumes
- Static composition: predominantly horizontal and symmetrical, provides emotional relief from, or contrast with, dynamic compositions
- Dynamic composition: provides drama and tension
- Study Goya for composition and use of tone
- The principles in art: repetition, harmony (similarity), gradation (sequence), contrast, unity
- Rhythm is repetition with variation
- "Organization" (as in composition) comes from "organism" — a well-integrated, functioning whole

Video, Film, & Still Lighting

Similarities & differences

It isn't easy for still photographers to break the motion barrier. By the same token, film folk faced with telling their story in stills may suffer loss-of-motion sickness.

Lighting is a rambunctious, sometimes awkward alliance of science, craft, commerce, and art. The most basic aspects of it apply to images, whether they are recorded on precious silver or magnetic particles, reproduced in catalogs or projected onto screens, frozen in time or able to flow with it. Some differences, nonetheless, are significant.

Similarities

Still, motion picture, and video "depth" is illusory. In all three, lighting helps to compensate for loss of the third dimension, when the real world is recreated on the flat print, screen, or tube. Shadows, highlights, side light, and back light are particularly effective in faking depth, as is an image with a dark foreground frame that gradually lightens toward the distance.

All three media are also dependent upon lighting to help create dramatic, romantic, nostalgic, or fantastic moods. In film and video, lighting often gets a helping hand from movement, acting, directing, script, sets, wardrobe, dialogue, sound effects, and music. Also in all three media, lighting establishes a sense of reality when the direction, quality, color, and balance of sources seem to be motivated by the actual or implied ones within the scene.

Differences: breaking the sound barrier

Film and video lighting have been shaped, in part, by sound-recording considerations. In order to eliminate microphone and boom shadows on the face and backgrounds, the key light is generally placed high and cut with a flag just above the subject's head. The background is then lit by a separate source. The mike boom is usually placed on the side opposite of the key. Still photographers as well as film and video professionals who shoot without sound, with microphones minus booms, or with soft key lights are able to ignore such traditional lighting solutions.

Differences: breaking the motion barrier

The most significant difference is that, unlike still images, film and video are concerned with sound, motion, and time. This introduces a series of considerations, problems, and possibilities that still photographers discover as they try to break the motion barrier in an effort to master the moving media. By the same token, film folk faced with telling their story in stills may suffer loss-of-motion sickness.

Differences: how viable is available?

Because interior window illumination may change drastically before a sequence is completed, there are risks when you rely entirely upon such available light. The higher the budget, the more costly the talent, and the larger the crew, the less likely it is that available light will be an available option. However, the use of available daylight on interiors is more practical for the still photographer, since the demands of unchanging light for matching purposes may not be important.

Differences: matching light

The consistency of light quality, contrast, and mood is a major objective (and all too often, a major headache) for the cameraperson or lighting director. Scenes lit one day may be cut with and have to match scenes shot days or weeks later. The vagaries of sun and clouds can create matching problems even from minute to minute.

A variation on the matching theme has to do with reverse angles — the alternative camera perspectives of two subjects who are more or less facing each other. Such lighting demands challenge the still photographer just entering the world of video or film.

Differences: control

A lot can be done after shooting film and video to correct overall color imbalance and slight exposure problems. Film and video camerapeople almost never bracket exposures (variations for safety's sake) the way that still photographers do on some assignments.

Film, and, to a lesser extent, video professionals use a lot of specialized lighting controls such as flags, nets, half scrims, dots, fingers, and special camera filters. These devices help them to finesse and fine-tune the lighting when time, budget, and skills permit by "dodging" the scene in front of the camera, not the enlarger.

Currently, still photographers are gravitating toward movie-type lighting manipulation. Electronic image-splicing has potential for both creativity and mischief.

Bill Klages
The most obvious shortcoming of the television reproduction process is the inability of the television picture tube to reproduce a long scale of brightness. Its dynamic range is very limited. . . . about 30:1. Interestingly, this narrow range is about the value given for the range of reversal film (as Ecktachrome): 5 stops of exposure.

PHOTO: AUTHOR

A small figure on a television screen is only workable if strong contrast exists between the subject and background.

Harry Mathias & Richard Patterson
Most of what has been regarded as proof of the inferiority of video has, in fact, simply been bad lighting. Because of its origins in live broadcast, video production has tended to rely on multiple cameras, and multiple-camera techniques necessarily involve compromises in lighting. [EC]

Differences: film and video

Seeing a color image immediately on a well-adjusted monitor and being able to make both technical and aesthetic changes — which, in turn, can be evaluated immediately — relegates movies and their processing delays to the Dark Ages, in the eyes of some.

The contrast range of video is more limited than that of film, which means that very dark and dramatic film-type lighting will not work as well in video. The drastic difference between film and video screen size also influences lighting and composition.

Small objects and subtle textures on a large motion-picture screen are seldom a problem. A small figure on a typical television set is workable, however, only if strong contrast exists between the subject and background. Fine details and textures need to be lit very carefully, even when they are placed in the foreground of the video scene.

The typically undarkened television viewing room, poorly adjusted set, and all-too-common glare on the tube hinder good image quality. However, contrast and resolution gaps between video and film are shrinking.

Since many films are shot specifically for television — or are eventually shown on television — producers, directors, and camerapeople may temper their lighting and composition in deference to the requirements of the electronic medium. Some television professionals suggest that, in the not too distant future, the aesthetic differences between television and film will lessen, and so too will the economic considerations involved in choosing one medium over the other. It seems clear that film and video lighting, which used to be rather different disciplines, are moving closer together in terms of objectives and techniques, at least for single-camera setups. The gap between "high-definition" video and high-definition film is closing.

Similarities: constant-source and flash

Still photographers can choose between three different types of lighting: available, electronic flash, and constant-source (still photographers refer to this latter category as "hot lights"). With all three, if you are not establishing mood, separating planes, controlling contrast, dealing with glare, and finessing the light, you are not lighting in a serious way.

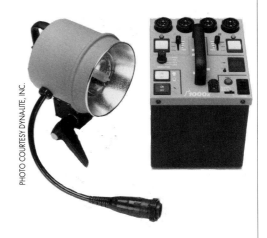

PHOTO COURTESY DYNA-LITE, INC.

Another similarity: many flash units have a built-in (constant-source type) modeling light, which helps the photographer see what the lighting will look like without making test shots. While not very bright, modeling lights can also be used for shooting. In fact, as photographer Jon Falk points out, they can save the shoot: "If the power pack goes toes up but the modeling light still works. . . just load the camera with type B film, use a slow shutter, and shoot."

Differences: constant-source versus flash

Both electronic flash and strobe units emit bursts of light of such short duration that they, not the camera shutter, freeze action. This "thin" slice in time and, when using powerful units, intense illumination, are two of the main advantages of flash. Their daylight color balance and relatively cool operation are also significant advantages.

Video and film require constant-source illumination, whether natural or artificial, for most shooting. Once in a while, special strobe lights are synchronized with film cameras in order to freeze motion, frame by frame, for scientific or other purposes. Strobe is a term usually applied to lighting units that produce a series of closely timed electronic flashes in order to create special effects.

Constant-source lights are generally easy to transport and finesse. You can also judge their intensity, relative to other sources, more easily. Whether the short, dazzling burst of the strobe or the continuous, warm light of incandescents is less distracting to non-professional subjects is a topic that could be hotly debated.

Still subjects may determine source

Still photographers are more likely to want the action-freezing advantages of flash when shooting moving subjects such as fashion models and the ease of evaluation of hot lights when lighting static subjects such as tabletop and architectural studies.

The existing illumination at a location — daylight, tungsten, or a discharge source — may also determine whether you choose flash or constant-source, as well as whether you use color filters or gels. However, color homogeneity should not always be your objective, especially when shooting architecture.

Experienced, well-equipped still professionals will choose the right source for a particular shot or assignment. The choice is usually a matter of balancing technical, aesthetic, and pragmatic considerations. They often combine available with flash or hot lights, and frequently use hot lights together with flash in order to warm up part of the scene or blur the edges of moving subjects.

Still differences: color

The color of electronic flash approximates daylight, about 6,000K. Constant-source lights come in all flavors: unfiltered incandescent ranges from 2,700-to-3,400K, but is, ideally, 3,200K. HMI and similar discharge sources are in the 5,700-to-5,900K range.

Still differences: accessories

In the past, flash fixtures did not have as many light controls and mounting options as did constant-source lights. As still photographers look for more control and lighting effects, flash manufacturers are offering more accessories or making it easier to use the controls available for constant-source lights.

Differences: output terminology

Video illumination is measured in lux, motion pictures in foot candles, and flash in watt-seconds. Just as the number of watts plugged in to the wall, box, or battery does not tell you anything useful about exposure (what comes out of the fixture or actually reaches the subject), so too with watt-seconds. A flash unit's Joule rating allows for more accurate comparisons between various fixtures and manufacturers.

The dual-role photographer

Still photographers are frequently expected to handle video and film assignments as well. At such times, familiarity with constant-source equipment and techniques — especially as they relate to motion — will prove essential.

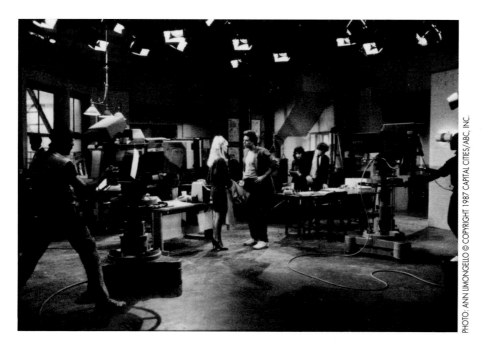

PHOTO: ANN LIMONGELLO © COPYRIGHT 1987 CAPITAL CITIES/ABC, INC.

Video's electronic advantage of immediate playback with immediate improvement of technical and artistic matters relegates moviemaking to the Dark Ages, in the eyes of some. The silver-halide look and film tradition, with its elaborate mystique, makes video a second class medium, in the eyes of others. What unites the media are their shared objectives: to entertain, to enlighten, to delight, and to make money.

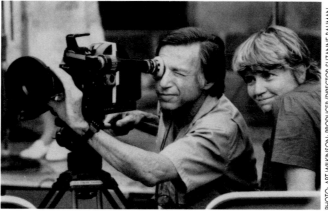

PHOTO: ART WILKINSON; PRODUCER/DIRECTOR SUZANNE BAUMAN AND AUTHOR ON LOCATION

Photographer Bill Hayward describes his available light/flash technique: "I set the camera for a half-second exposure, which allowed most of the model's body to blur against the window background. I limited the flash to the wall area so it 'froze' the model's leg."

PHOTO: © BILL HAYWARD

Dale Marks on flash versus hot lights:

Advantages of flash

- Heat is usually not a problem — makeup is easily maintained; soft boxes and polarizing filters are practical
- Intensity can be varied without changing color temperature
- Because of their power, variable intensity, and daylight color temperature, they are easy to use when shooting interiors with windows or when shooting outdoors
- Sharp images, small apertures, and stopped motion are easily obtained; short flash durations eliminate streaking; slower films can be used with hand-held cameras
- Subject squinting is usually not a problem
- Exposure is sometimes more consistent because it is controlled electronically, not mechanically
- Illustrating "stepped motion" is easy: the shutter is left open while you flash the strobe as the subject moves. With hot lights, the shutter must be cocked and released with each exposure, interrupting the flow and risking image registration

Advantages of hot lights

- Generally less expensive — no powerpack to buy, heads less costly
- More controllable — strobes that focus are scarce, bulky, and expensive. Light control devices are more common with some hot-light systems
- They can be set up faster — no connecting heads to powerpack, no sync cords, no testing of slaves
- More portable — no powerpack to lug, heads are smaller

- No need to carry a Polaroid system for test shots (because of discrepancies between modeling lamps and flash tubes, strobes need Polaroid tests to determine the true ratio of brightness between flash tubes and to determine the true quality of light when using strobes without diffusion)
- No jarring flash — important for inexperienced subjects who are thrown by flashes and for on-location shoots, where flashes could disrupt the activities of those not involved
- Automatically color balance when fill lighting windowless interiors which have existing tungsten lighting
- Make focusing the camera easier, since they are generally brighter than strobe modeling lamps
- Enable time exposure "streaking" (to illustrate motion)
- Facilitate changeover to video shooting

Combining both

Sometimes strobes and hot lights must be mixed together to make a single shot — as when "streaks" trailing behind the frozen image of a fast-moving object are desired. With the camera shutter open and the hot lights on, the streaks are created when the object moves.

The streaks get brighter as the object decelerates. To generate the frozen image, the flash is triggered just before the shutter closes. Strobes usually light the leading side of the object, while hot lights illuminate the trailing side (which prevents the streaks from bleeding too far into the frozen image). Color balancing the two sources is optional.

The experts on TV and video matters:

E. Carlton Winckler
Usually, at the urgings of the engineers, there is a strong tendency to overlight: to use too high a level for the subject. The effective use of depth of field is, I have found, a new subject to them.

E. Carlton Winckler
The advent of HDTV may change many things we have learned about composition and lighting, for we will have a 5:3 aspect instead of a 4:3 aspect. Skillful planning and a lot of imagination will be required of everyone in production during the transition period.

George Spiro Dibie
In lighting for film or video, I trust my eyes. Scopes and waveform monitors do not capture the subtleties of lighting as to mood, time, and emotion.

Anton Wilson
For most dark or flat scenes, the obligatory white reference can be provided by strong back light or rear side light that creates highlights without diluting the dark or flat ambience of the scene . . . A lamp, candle or neon sign will also serve the purpose.

The exact opposite must also be avoided. A face in front of a back-lit window will work on film, but not on tape. . . Here, all the information is in the upper half of the range. The result is that the signal will "float" downward to center itself, with the face going almost black and the window becoming a light gray. In this instance, a black reference is necessary. *[CW]*

Bill Klages
This endless discussion of how to obtain "the film look" with the video camera has been beaten to a pulp. Everyone has his pet solution. Those in the know pursue their work with only one intent: to satisfy their own visualization of the final image.

Anton Wilson
The video term for pushing is "gain." . . . Six decibels of gain is equivalent to a one-stop push, 3dB is a half stop. . . The video equivalent of grain is "noise" and, as with film, the noise level will increase as gain is applied. *[CW]*

Bill Klages
In an effort to keep the camera's electrical noise level at a minimum, the degree of stretch of brightness in the lower end of the scale is very conservative (just the amount determined by our forefathers as proper for the early television picture tubes). The result of this situation is to obstruct the television lighting designer's ability to make shadow areas transparent. This becomes even more difficult in the multiple-camera situation, where ground-level operating area is at a premium and, certainly, non-existent for the placement of lighting fixtures.

Members of the television lighting community engaged in, for example, the lighting of situation comedies go to great lengths to obtain a diffuse fill light that does not completely destroy the picture quality by lowering the contrast level to the actual brightness values of the subjects. This loss of control is the nightmare situation that all conscientious television lighting designers dread.

Bill Klages
Designed into the color system that we use are areas in the color spectrum that cannot be reproduced. . . . Don't be shocked when you have difficulty in obtaining that wonderful lavender you are so fond of. In addition, you may have to add a great deal of red light to change that horrible lemon color to a more pleasing amber. NTSC color has trouble in reproducing certain areas of red/blue and red/green.

Bite the bullet! Unfortunately, the NTSC color broadcast system places the adjustment of the color picture in the hands of the viewer. As a result, the odds that the viewer will ever see your fine selection of colors is very low. You must, however, light for the studio color monitor and still carefully balance your color selection, as well as the scene's contrast, if for only one reason: your own satisfaction.

For more: E. Carlton Winckler's remarks at the end of *How to Avoid a Large Headache Setting Up a Small Studio.*

2

Lighting by Numbers

Technique

You seldom have enough lights
but invariably use too many.

The One-Light Approach

Less is often more

Those who are just beginning to learn about lighting are inclined to believe that the more lights you use, the better the results. Often the opposite is true. A single key light carefully placed in relation to the right subject can produce startlingly dramatic and beautiful images. If the source is large enough, or the area limited enough, and not too much subject movement is involved, the setup can sometimes work for film and video as well as for still photography.

Variations

The first assignment I gave the students of a film lighting class I taught at New York University was to light another student using only one large soft light. It could be placed high, low, or to the side of — but not behind — the subject. The way each student was posed and dressed was almost as important as the angle of the light. In three hours, the students produced 28 Polaroid pictures, each remarkably different. We devoted the next class to analyzing our results. The consensus was that very few of the images would have been improved had additional lights been used.

Ugly angle

One thing students discover rather quickly is that the worst place to position the single source is close to the lens/subject axis. Such placement results in textureless, characterless illumination with washed-out foregrounds, distractingly shadowed or totally black backgrounds, and little sense of depth. Invariably, this is where most amateurs and all too many professionals put their single source.

Those covering fast-moving events such as news and weddings do not have a choice. The light needs to move with the camera and point toward the subject, so mounting it on-board is a practical solution, though not an elegant one. When the source must be camera-mounted, the look of the lighting will improve if it is diffused. This will soften shadows, reduce intensity, and not overwhelm the existing ambient light.

The only thing better than three or four sensitively placed lights is one – if it does the job. Positioning the subject in relation to a single source, whether it is a hard light, a soft light, or, as here, a window, may require more time than setting several lights.

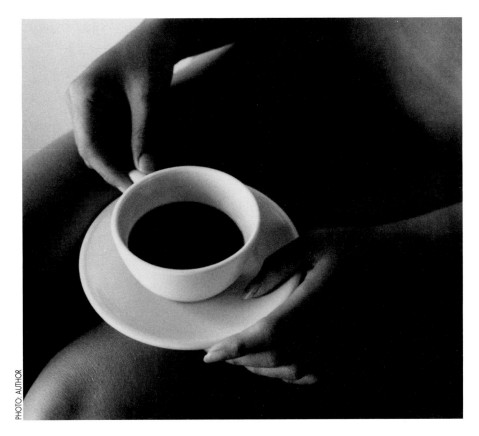

PHOTO: AUTHOR

Dürer's soft window light (see reflections in subject's eyes) and a bit of artistic license help to reveal character, mood, modeling, separation, and texture. Not bad for just one source.

DÜRER: FREDERICK THE WISE, ELECTOR OF SAXONY

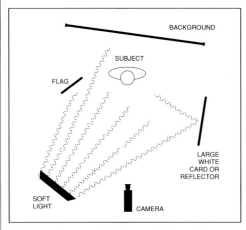

Soft light spill means that little or no fill is needed. To reduce spill — especially on washed-out backgrounds — use doors, flags, or egg crates.

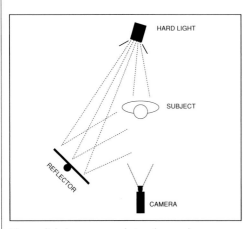

The one-light/two-source technique has much to recommend it, even when there is plenty of power at your disposal. The main drawback: if you move the light, you have to reset the reflector.

Soft touch

When working with only one light that is not camera-mounted, it is advisable to use a relatively large, soft source, preferably one with barndoors or an egg-crate baffle. Egg crates are frames with horizontal and vertical slats that help to reduce spill light. Flags or large cards can be used to control spill and lens flare when using soft lights or umbrella rigs. Flags, barndoors, and egg crates also provide some subtle shading of parts of the subject or background.

Flags can be positioned to reduce subject brightness, thereby allowing more light to fall on the distant, presumably darker, background. This helps to reduce contrast, increase separation, or prevent the background from disappearing completely. Conversely, a flag can also be set to reduce an overly bright wall, perhaps by making it darker toward the edges or top of the frame.

The reason a soft source might be used in preference to a hard one is that a large, diffused source helps to convey the subject's character as a result of the subtle gradation between broad highlights and soft shadows such sources generate. Spill from the soft light can also provide fill illumination that will reduce the contrast ratio, if that is needed.

If contrast is still too great, some subtle fill (front) or kicker (side-back position) can be added by using a large white card, foamcore, or a soft silver reflector placed on a stand and angled to reflect spill light from the single source.

Reflector

A variation on this one-light/two-source setup which I have been using successfully for many years is both simple and effective for relatively close shots. A focusing spot light is set as a back light (above, behind, and possibly to the side of the subject). A stand-mounted small reflector is positioned in front of the subject where you would normally set the key light — perhaps 30-to-45 degrees to the side of the lens/subject axis and above it. The trick is to focus and tilt the light so that most of the beam is concentrated on the reflector, with only the periphery of the light falling on the subject's head and shoulders. After the reflector is aimed at the subject you will notice that the quality of light is neither hard nor completely soft, but is more on the soft side than the hard.

All the angles

There is no one perfect position for the single light which is appropriate for all subjects and moods, yet the exact position of the source is important. Movement of the light or subject by only a few degrees can change the overall look significantly. This does not mean, however, that the subject must be immobilized.

To find the best angle for the light as quickly as possible, it may help to mount it on a small boom with casters so that it can be swung, elevated, and rolled around easily. The boom also makes it easy to keep the stand out of the shot when the light is over the subject or behind it. Whenever possible, the lighting director/cameraperson/photographer should keep an eye on the monitor/finder/eyepiece while someone else moves the light, subject, and furniture.

Experiment

If time allows, try different lighting angles and evaluate the reasons for the success, failure, or mediocrity of each. Later, experience will enable you, with limited wasted motion, to determine where to place the light in order to emphasize significant planes. In the meantime, experiment when the producer, director, client, or subject-with-busy-schedule is not nervously eyeing the clock. Obviously, many subjects, settings, and styles are inappropriate for such single-light treatment.

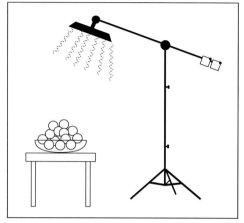

A boom puts your light over your subject and its stand out of your shot. It also makes minute height and angle adjustments easy.

PHOTO: AUTHOR

A single soft light, 45 degrees or more to the side of or above the camera/subject axis, will produce lighting that is decidedly not flat.

69

Two-Light Techniques

Spill, fill, the two Bs, & the two-shots

There are many times when one light cannot reduce contrast, model complex subjects, deal with depth, or separate foreground, middle ground, and background. A second source may solve these problems, though not all of them simultaneously.

Spill and fill

Traditionally, a second light is used to reduce contrast if spill or ambient light is insufficient. It can soften harsh shadows and reveal detail in the otherwise black areas left by the first source — especially if the key is a hard light. If your subject does need fill light, the second source should be soft enough so that it does not introduce any new shadows. How much contrast you want depends mostly on matters of mood, taste, and the medium of reproduction.

The fill light is generally positioned on the opposite side of the key and often, though not always, close to the lens. Other positions may sometimes prove more effective, however. Avoid Overkill Fill*.

The first B Light

If you do not need fill or you are using a white panel to provide subtle fill, there are plenty of other prestigious jobs waiting for a second light. When you are unhappy with the way that the dark edges of your subject disappear into the background, there are two ways to create some separation and feeling of depth with what I call the B Lights* which, unfortunately, are easily confused with one another.

The first B is the background light. This one is always aimed more or less *away* from the camera. It can brighten dark walls, bookcases, or furniture situated *behind* the subject.

For technical and aesthetic reasons, this light should be positioned at a high angle, a side angle, or both. The angle provides modeling, helps to suggest depth, and minimizes unwelcome glare such as that from windows or shiny walls. Lighting backgrounds from an angle also helps to eliminate those nasty subject and microphone boom shadows that background lights otherwise tend to introduce.

Unfortunately, one of the first things the new pro does with a second fixture is to *overlight* the background. Distractingly overlit backgrounds are the signature of shooters who spend most of their time adding light and little time finessing it.

The second B Light

Another way of using that second source for subject separation is by introducing back light, which should be aimed more or less *toward* the camera. Position it above and behind the person or object and direct it toward the subject. Keeping flare out of the lens is generally accomplished by adding an extension to the top barndoor on the back light or, in tough cases, using a flag between the light and camera.

From time to time, lens flare will produce an effect that you, your clients, and the art directors, directors, or producers you work with will love. For the most part, however, like unmotivated multiple shadows, flare is an unwelcome distraction.

Although soft lights provide incomparable back light, they are not often used for this purpose. The problems of mounting, hiding, and controlling these large units — particularly when low ceilings are involved — limit their popularity as back lights.

Both B Lights

The use of either B Light requires plenty of space between the subject and the background to avoid problem shadows and unworkable lighting angles. For these and other reasons you may have to cheat people and furniture away from the background. That is where your cinematic license comes in. If you want to use both B Lights in addition to a key, you will need a reflector (see *The One-Light Approach*) or a third light (see *Magic Numbers*).

Motivation

Key lights and B Lights should be motivated by any apparent sources, such as windows, lamps, candles, or the sun. The direction, color, and intensity of established sources should be respected — within reason.

Frequently, the B Lights are not used because many pros find them too time-consuming to set and finesse properly. Other pros find them difficult to motivate or justify. Some people use them automatically, whether they're helpful or harmful. Bs should be handled carefully — and with a light touch.

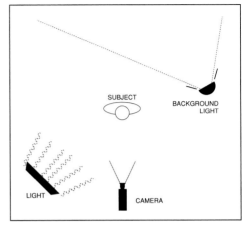

The first thing new pros do with a second fixture is overlight the background.

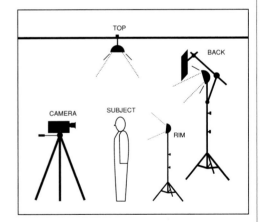

Too high and the back light becomes top light; too low and it turns into rim light or in-the-lens light. A soft-source back light is subtle, but tricky to hang. It is also difficult to block the inevitable flare.

71

Avoid sources at equal heights, equal angles, or equal intensities. Symmetry in lighting is seldom a virtue.

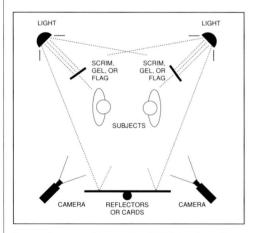

You can key one subject and back light the other with each source. Flags or other light controls can compensate for the ravages of Inverse-Square-Law symptoms. A large reflector can transform spill light into fill light.

Multiple planes

Complex subjects, such as furniture and machinery that have many planes that must be revealed, often require a second light from another angle. Try not to have both sources set at equal heights, equal angles, or equal intensities — or to use two hard lights. Symmetry in lighting is seldom a virtue.

Each plane or surface of a subject should have a different brightness value. For example, the top or side planes might appear lighter than the front planes. If, however, the planes are different colors, this approach may not be necessary.

Bounce

It may be feasible to bounce lights off of white walls, ceilings, or large white cards when high light levels are not required. The angle from which the light is reflected will affect mood and contrast.

Two-subject setups

Another limitation of the one-light approach becomes apparent when photographing two people who are facing one another in an interview or a dramatic situation. Generally, each subject is lit by a separate source from the opposite direction, especially if reverse-angle, over-the-shoulder shots are planned.

Typically, this becomes a four-to-six-light setup. However, two sources may be enough if they are strategically positioned to perform double duty by illuminating the front of one subject while back lighting the hair and clothing of the other person. Barndoors, half scrims, nets, or gels can be used to reduce the back light relative to the front light. Often, background light will not be needed.

Some fill light will be needed. Reflectors or cards may do the job if there is enough spill light that can be recycled onto the subjects. Or, you can save this setup until you graduate to the three-and-four-light stage.

For More: *On Face Value, Finessing, In Praise of Back Light* in *Hearing the Light, Method Lighting, The Art & Craft of Lighting Craft & Art, Bounce Light* in *Hard & Soft Light*, and *Exercises #2B, 2C* and *7* in *Lights-On Lessons*.

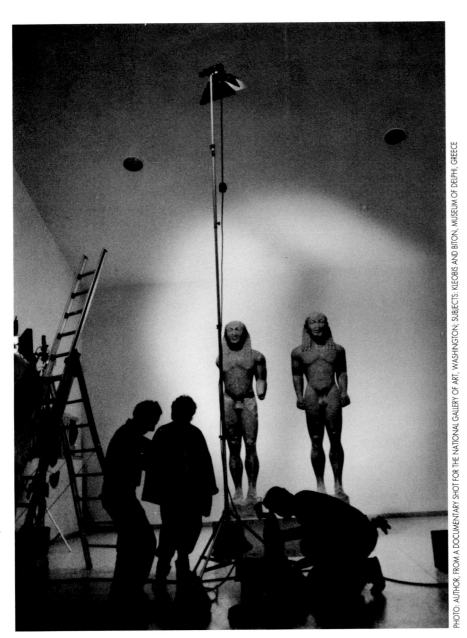

One hard light provided high-angle modeling for these ancient Greek figures, which were shot from a low angle. The second hard light was positioned carefully to disguise the otherwise distracting juncture between wall and ceiling, a technique I call Limbo-Lighting*.

PHOTO: AUTHOR, FROM A DOCUMENTARY SHOT FOR THE NATIONAL GALLERY OF ART, WASHINGTON; SUBJECTS: KLEOBIS AND BITON, MUSEUM OF DELPHI, GREECE

Magic Numbers

Triangles, banks, & the long hall

Question: How much closet space do you need? Answer: Just a little more — no matter how much you have. Similarly, how many lights you need and use depends, all too often, on how many are available. The moment you stop adding "just one more light" may coincide with the moment you run out of fixtures or time. This is not meant to suggest that some sets and situations don't require considerable numbers of lights, or that the pro who uses one source has more willpower than the pro who uses 21. There is, after all, the matter of personal style, as well as the demands of the subject, set, and client.

Three or four?

For typical setups, there may be a magic number: three. Location lighting kits are available with as few as two and as many as six fixtures. Most kits sold, however, contain three or four lights.

The classic triangle

Coincidentally, the "magic number" also matches the minimum number of lights needed to perform the "magic lighting" setup — the classic triangle that provides *modeling* (key), *shadow* and *contrast control* (fill), and *separation* (background light or back light).

Beyond triangles

There are many reasons why four is more magical than three, even if you do not want to use the two B Lights* simultaneously. At times, multiple key lights are required because the areas being shot are so large, or because dramatic effects require them, or because the subject moves around the room and looks in different directions. In such cases, restricting each light's beam spread to separate areas of the scene will help you to avoid unattractive multiple shadows. If this can't be accomplished with barndoors, try flags.

The bank

Instead of separating your lights, you may decide to convert most of your resources into a "single"-source key. To camouflage the individual lights, you can aim their beams through a translucent sheet, into several umbrellas, or off of a white wall or foamcore panel.

Objects

These classic lighting setups, along with their many variations, apply primarily to human subjects, but they can be the starting point for lighting objects of all sorts — unless such objects are transparent or translucent.

For the long hall

In film and video work, camera movement and subject movement often require the use of multiple lights. Take, for example, the common situation of someone walking down a narrow hall toward the camera (camera either stationary or moving with the subject). There are at least three ways to handle this. In a news situation, the light will almost certainly be on top of or behind the camera, yielding distinctly news-type lighting.

For something a little more sublime, you can attach small broad lights to the ceiling at intervals of 5 or so feet. The trick is to hide them and cut lens flare when ceilings are low. With dropped ceilings, it is possible to tuck the lights into the space available when acoustic tile panels are removed, but watch closely for flammable materials, wiring, and automatic sprinkler heads if you do so. The resulting top light this method provides has both drama and realism to recommend it.

A third option: You can locate the lights in doorways so they will "spill out" into the hallway to create areas of light and dark through which the actor walks. This will call attention to both the movement and to the illusion of depth. You may not even need fill if the walls are light enough to bounce a few light beams about.

Block and rehearse

There is no substitute for blocking action when you shoot dramatic or controllable video or film scenes. Blocking consists of determining the positions and movements of the actors and camera. Mark the floor with tape or chalk for starts and stops and strategic places in between. Block before you set up your lights so that there will be less chance that you will have to move them later.

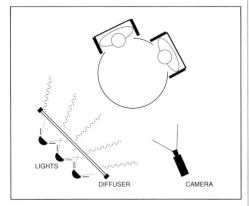

To eliminate multiple shadows or suggest a window source, several lights can be turned into one large light bank by "straining" them through some non-flammable diffusion material. Alternatively, they can be bounced off of a white wall or a portable panel.

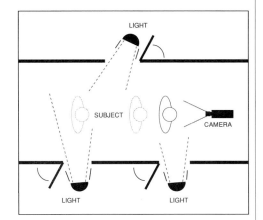

Doorways offer one way to light hallways, but not necessarily the fastest. Try to avoid people "burning-up" as they enter or leave the rooms off the hallway where you have placed your lights.

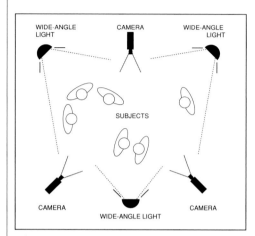

When 360-degree shooting is unavoidable, this scheme can give you consistently acceptable — and sometimes excellent — light all around the room.

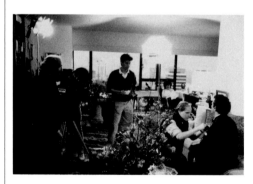

For this foreign TV shoot, a diffused hard source was used to key opera singer Placido Domingo. A soft umbrella provided fill. Both units were positioned left of the camera in order to bolster the window light. Other fixtures may have supplied subject/background separation.

Not practical?

I know, most of what you shoot couldn't possibly be blocked or rehearsed, even if there were time to do so. And much of what is being suggested in this book about carefully positioned lights implies that you have the luxury of lots of time to set up and the knowledge of — and perhaps even some control over — the action. When dealing with many subjects and jobs, this isn't necessarily possible, nor even desirable.

A formula?

When control is out of the question, a workable lighting plan is even more important. Although I don't believe in formula lighting, there is one formula-like setup that ensures relatively high quality while allowing for considerable freedom of subject and camera movement. The setup requires three fairly small wide-angle broad lights. They should be positioned high enough to stay out of the shot, low enough to illuminate the subject's eyes. The units should be fairly equally spaced, such as two in adjacent corners and one on the opposite wall. Select positions that offer pipes or beams for clamping, or use a doortop or wall-mounting device to eliminate stands.

This versatile setup will provide unrestricted 360-degree shooting if the cables are hidden. Wherever the camera is, subjects will have some front light, some side light, and some back light. If exposure allows, add frost-gel diffusion to the lights or bounce them. For this particular setup, three is magic, four is mere illumination.

Cornerstones or millstones?

There was a time when few self-respecting camerapeople would consider a subject properly lit without a *key, fill, back light, background light, kicker, eye light,* and *clothes light*. This type of elaborate lighting has tended to disappear because film and video cameras and lenses have become more sensitive; actors and non-actors have been granted more freedom of movement by many directors; and lighting styles — or, if you will, fashions — have changed. And, oh yes, budgets have generally become smaller, in real dollars.

Peace-of-mind lights

There are a couple of reasons why you may want to have more lights on-hand than you might expect to use on distant locations. To paraphrase cinematographer/writer Jon Fauer, they protect you from the forces of darkness and, I might add, from a sleepless pre-shoot night.

Also, if the client is more impressed with quantity of equipment than quality of work, a few lights just standing around looking ready will convince him or her that the remarkable setup you created was a matter of choice, not necessity.

For more: *Formula Follows Function* and *On Face Value.*

PIETA, MICHELANGELO, VATICAN, ROME; PHOTO: AUTHOR

Two directions of light and a background "halo" revealed many of the planes, faces, and garment folds (and some of the spirituality) of Michelangelo's Pieta. The highly reflective marble and the considerable size of the work dictated my use of a very large and well-diffused bank of lights.

Multi-Light Logistics

The big time

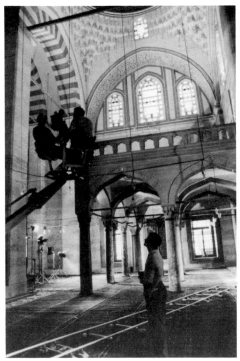

Your lights can often be hidden in the scene by flags and by opaque objects in the dark and distant reaches of super-wide shots.

Sooner or later you are going to be contemplating some sizable locations — an airplane hangar, a museum, a factory — as well as some difficult questions. Should you light on a grand scale? If not, will you suffer the consequences of dull, drab, and dreary images? Is there another choice? What is the bottom line: your budget, your back, or your reputation?

The available alternative
Understandably, the larger the area and the more complicated the lighting logistics, the more attractive available light will seem. But if you don't like the available light or the idea of setting up from scratch, there may be an enlightened compromise: supplement the existing light.

You should first ask yourself a few more questions: Will the color inconsistencies of different sources be acceptable? If not, can you correct them with gels? Will the quality and direction of the light you add contradict the quality, direction, or mood of the available light? Should you keep supplementary illumination at a low enough level so as not to overwhelm the existing ambient light? Will the quality of the window light — or other uncontrollable light source — last until you're finished shooting. If not, can you duplicate it? If you scouted the location in advance, is the light likely to be the same on the day of your shoot?

Low-ceiling woes
Consider, for example, the well-illuminated but poorly lit fluorescent-flooded supermarket, office, or showroom. In deference to photorealism and low budgets, it is often advisable to use the existing overhead illumination and simply add one, or perhaps more, portable fluorescent fixture to provide front or side fill, or maybe a little accent light. If all the tubes are of the same type, it won't be necessary to gel the lights. Color correction filters can be used on the film camera lens, and the white balance on the video camera can be adjusted.

High-ceiling woes
Faced with the towering spaces of some old buildings there are several things you will need: 1) considerable quantities of lights and clamps; 2) the good fortune to have safe places to attach the clamps; 3) tall ladders or scaffolding with casters to reach those places; 4) a crew of helpers not subject to acrophobia; and 5) plenty of time.

Lighting from near eye level is, unfortunately, unworkable. If lights cannot be rigged up high, heavy-duty stands with extending poles are useful, but only if they can be kept out of the shot. This is difficult to do when you reverse camera angles. Carefully manipulated barndoors — better yet, flags — can eliminate overlapping shadows and most lens flare. They can also camouflage lights in the distance when you attempt those inevitable wide-angle shots.

An example of such camouflage technique, born of desperation, dates from the 1950s, when 16mm color film was a sluggish ASA 8 and I had to light and shoot the Steuben Glass Works without any help. Largely lost in the cavernous exhibition space were three giant dark cylinders from which the artisans gathered their molten glass. In addition to the overall lighting, I clamped lots of fixtures to the top of each cylinder and aimed them at the glassblowers below. I then hid the lights behind inconspicuous strips of black cardboard.

Power politics

The quantities of heavy-gauge electrical cable you will need, in addition to a proper power tie-in or generator, are factors that will likely be a problem unless your crew is large and experienced. The office or plant electrician can help save your assignment, if he knows in advance what you will need.

For those grand-scale locations, the type of source you choose — incandescent, fluorescent, metal halide, or (for stills) flash — is mostly a matter of color balance and budget. The quality of light — hard or soft — is seldom a question of aesthetic preference. At a throw of 30-to-40 feet, some 1,000w focusing lights can be spotted enough for adequate exposure, while most soft lights won't even activate the meter.

Fore, middle, and backgrounds

When you have a sizable crew, large high-wattage lights may be appropriate choices. Regardless of the wattage of your fixtures, you should have enough units to light foreground, middle ground, and background adequately and, when possible, separately. Lighting these planes separately enables you to have optimum creative and technical control of the direction and the intensity of the light for each plane. Flags and nets can be mobilized to protect your camera lens from flare, subdue bright or distracting areas, and enrich the image, a practice that could be dubbed "painting with shadows."

The larger the area and the more complicated the lighting logistics, the prettier the available light begins to look.

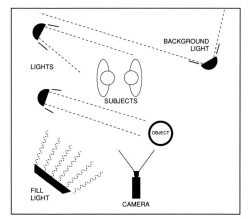

There should be enough units to light foreground, middle ground, and background adequately, and, if possible, separately, but not necessarily evenly. Area lighting is often the best way to handle subject movement.

79

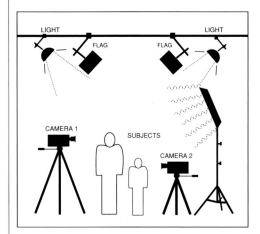

You are not going to want to move those elaborately rigged lights when you reverse your angle 180 degrees. Try to set the lights and flags to work well from either direction.

Reverse angles

Before setting up the lights or even finalizing their positions, consider all the directions in which your camera will be aimed. You are not going to want to move your carefully rigged overhead lights when you reverse 180 degrees. You probably won't have to do so if the lights are high enough — not directly overhead, but at about 45 degrees — and positioned to do double duty. Then, when you change shooting angles, the former front-side lights become back lights, while the back lights transform themselves into full-fledged key lights. Having some ready-to-use soft fill on a stand near the camera is well worth its weight in watts, even if you decide you don't need it.

Lighting with paint

Occasionally, a little makeup in the form of fresh paint, approved by a cooperative client, can perform minor miracles upon dingy industrial apparatus and walls. Instead of "painting with light," you may find yourself "lighting with paint." A thin line of white chalk will separate some dark objects from dark backgrounds, if your camera doesn't move. "Painting with chalk" is another form of retouching prior to shooting.

Tricks of the trade

Your artistic and cinematic license authorizes the practice of many other amp- and face-saving techniques. Lights can be hidden behind columns or machinery. Sun reflectors can be used on interior shots to bounce another source. Dark walls and dark machinery will come to life, with the least number of watts expended, by using very soft glare or edge light. Still photographers can paint with light while the shutter is open.

Undercranking

One often overlooked film option is undercranking (the opposite of slow motion) with the cast moving at an appropriately reduced speed. At 12 frames per second you can steal one valuable stop; at 6 fps, two precious stops. It is remarkable how resourceful you become as amperage, extension cables, and time run out.

Multiple accents

Locations are not the only place that can tax your lighting skills and budget. Even in the studio, when dealing with relatively small sets, you may want to use a few dozen lighting units. These could be low-wattage fixtures carefully set to pick out people, props, or products, leaving the rest of the set relatively dark.

Noise or music

There is always the temptation to introduce arbitrary colors with gels and fancy-but-distracting lighting effects to heighten drama or to command attention. When so inclined, consider whether these additions might violate your subject, mood, or audience's senses.

It is all too easy to confuse effects with effective lighting, startling images with unforgettable ones, and quantity of foot candles with quality of light. Today's fast lenses, fast films, and sensitive video equipment mean that merely recording an image is not the real challenge. Separating planes, implying depth, revealing the character and subtleties of the subject, and establishing a meaningful mood are at the heart of our miraculous craft. This is true whether you use 100 sources or only one. And though you may have enough lights to turn midnight into midday, you should never use more than you need to turn reality into art.

For more: *Lighting with Paint* in *Hearing the Light*, *Color Temperature Matters*, and *Finessing*.

Mario Tosi
The schedule is always hanging over your head and it is a constant battle for the creative person to try to do the best he can under the restrictions of time. *[ML]*

David Quaid
The prime consideration of the lighting cameraman is to "keep it simple," no matter how many units are used. When I turn the set over to the director for shooting and I see lighting units standing unused, I feel I have done my best with the scene. If I turn around to find every single unit used, I get a sinking feeling that the lighting I produced was complicated and somehow impure. *[LN]*

Harry Mathias & Richard Patterson
People may commonly try to shoot video with less lighting equipment than they would use with film, but the truth of the matter is that video requires more lighting than film because it reproduces a more limited contrast ratio. The only way to reduce the contrast ratio in a scene — unless your production manager can call upstairs and order an overcast day — is to use more light to fill the shadow areas. *[EC]*

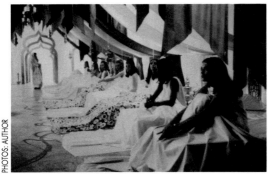

PHOTOS: AUTHOR

Years ago, when film was less sensitive, I shot on a large set that required a feeling of soft, morning light, but also of great depth of field. For this, a Burlington Mills TV commercial, I used about sixteen 4,000w and 8,000w Mole-Richardson soft lights, plus dozens of accent lights.

3

In Broad
Daylight

Tools & Tactics

*The tools & tactics of interior &
exterior lighting differ, but the objectives
& principles are the same.*

Superior Exterior Lighting

The most perfect light source available, earth's sun, is sometimes less than perfectly suited for the outdoor image you may have in mind. All too often, it is too high or too harsh for the subject or mood. Fortunately, there are some techniques that can be used, alone or in combination, to improve upon nature or the nature of exterior light. Some of these methods are best suited for low-budget shoots, others for shoots with large crews.

Shoot anyway

A frequent response to unsympathetic daylight is to shoot with it anyway, especially if your schedule is tight, your angle and area locked-in, or the subject or event cannot wait. At times, what you are shooting is so compelling that the quality of the light seems insignificant. Unattractive exterior light may not even be apparent to the beginner at the time of shooting.

Change the angle

Often the fastest exterior lighting tactic is to change your camera angle. If the subject — whether a person or an object — can be turned in relation to the sun or sky, your lighting options will increase. Back light, side light, front light, top light, and everything in between are yours for the asking — or for the waiting.

Head for shade

When the sun is too high and harsh and you are not in the middle of the Mojave Desert, you may want to move portable subjects into the shade of trees or buildings. Since not all shade is created equal, look for light that has character and directional dominance and that works well with your subject. It is comforting to have a reflector handy to provide a little effervescence in case the shade is too drab or the background too bright, but most of the time you probably won't need it. If you are fortunate enough to find suitable shade near a building with a white or color-neutral wall that reflects the sun, you're all set for light.

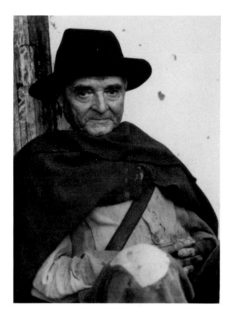

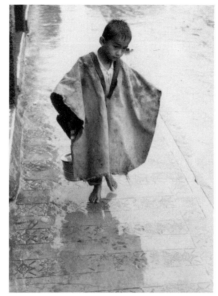

The many subtle shades of shade
The sun can be unkind to people, but shade is the great face saver. Since not all shade is created equal, look for shade that has directional dominance and that works well with your subject. "Good lighting" is sometimes little more than good shading.

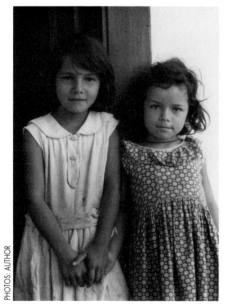

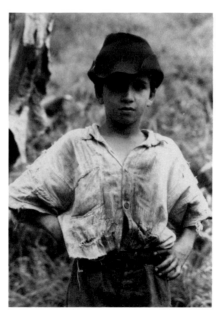

85

Create a little shade

Nothing could be simpler than shading small subjects that should not be moved, such as growing flowers. Attach a translucent or opaque umbrella to a wide-base stand using a clamp that will allow the umbrella to be tilted. Keep a tiny reflector or white card handy.

Change the area

If your subject is portable, moving it and the camera a few yards — or a few miles — may improve the light. On more than one shoot we have raced up a mountain with cast, crew, and props as the sun descended in order to make that crucial "one-last" shot.

Wait

If you are shooting something that is a little more difficult to move, like a building or a landscape, you can always wait for the light to improve — a strategy that works best when you're working with very large budgets or very small crews and very little time pressure. In other words, hardly ever.

It helps to scout before you shoot, or at least to ask some relevant questions about which directions your subjects will face, what the weather expectations might be (in some areas it tends to be sunny in the AM, cloudy or rainy in the PM), and when the sun rises and sets. The best light for your subject, heaven forbid, could be dawn's early light.

Patience makes perfect. On cloudy/windy days and in the tropics, daylight can change dramatically from minute to minute. You have to be ready to grab the shot the moment the sun is gentled by a cloud or, when shooting dramatic landscapes, just as it reaches that one hole in the cloud cover.

Reschedule

If you have arrived on-location without a prior scout, were misled by long-distance "experts," or if the weather is not cooperating, consider some judicious rescheduling. It may be possible to shoot during a more felicitous time of day, such as early morning, late afternoon, sunset, or during the *Magic Hour*.

An ugly landscape or product shot may turn into a beautiful one if you are able to shoot other scenes — perhaps interiors — until the light or weather improves. On some jobs, a sensible strategy is to take a long midday hiatus

while the light is least felicitous, then compensate by adding dusk to your shooting day. In latitudes far from the equator, that might mean quitting after 10:00 PM on a summer night.

Sun calculations

If you can see the sun at noon (or almost anytime) and you know the approximate time of sunrise and sunset, you can calculate where the sun will be at various times of the day. Face south and draw an imaginary arc from left (east) to right (west). The sun is closer to the horizon in the winter than the summer, closer to the horizon the farther away you are from the equator, and closer to the horizon early and late in the day. Dusk lasts longer in the winter, when the sun descends at a greater angle than in the summer.

Use fancy filters

A number of different types of camera filters may prove helpful in taming extremes in exterior lighting conditions: low-contrast filters, polarizing filters, fog filters, and graduated filters of various flavors. A graduated filter in a sliding filter matte box can be used to darken or color a washed-out sky or body of water without affecting the rest of the scene. Keep in mind that you cannot tilt, dolly, zoom, nor let anything cross between filtered and unfiltered areas. The width of the graduated section on the glass filter, the focal length of the lens, and the aperture used will affect your results, so allow enough time to experiment.

Borrow or rent these and other filters and shoot tests, keeping careful notes. I take a case full of filters on jobs and my assistant rents additional ones for special purposes. The tonal manipulation of black-and-white film through the use of color filters is almost a lost art.

In theory, some of these problems can be handled with electronics when shooting videotape. Television wizard E. Carlton Winckler advises adequate preparation and, when appropriate, a scout.

Rely on reflectors

Reflectors make it possible to control high contrast, especially when access to electricity is out of sight. They add sparkle to people, products, and props that are back lit, in deep shade, or that have an excessively bright background.

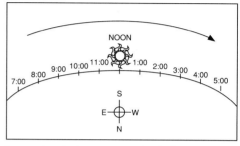

Face south and "draw" an arc in the sky from east to west.

PHOTO: AUTHOR

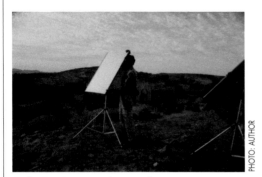

PHOTO: AUTHOR

Gaffer Dan Devaney adjusts a reflector at an ancient Christian burial site in Egypt just before the sun sets.

Unless a low-angle source has been established, such as reflections off water, the reflector should not rest on the ground. A substantial stand and weights will enable you to elevate it fairly safely, as well as tilt and pan it. For film and video, the reflector should be steady and sturdy enough to prevent the flickering caused by wind or unsteady hands. Using reflectors when the wind is strong is impractical and unsafe.

The amount of sunlight a large, good-quality, silver-surface reflector can bounce into a shaded area is impressive. Even a 4' x 8' matte-white panel can provide fill when needed if it is close enough to the subject. "Shiny boards" — mirror-like, aluminum-surfaced reflectors — are primarily used for lighting dark or distant backgrounds, such as tree foliage, where uneven light will not be noticed. They are also effective when you need to redirect a lot of sunlight onto a normal reflector which must be positioned in the shade in order to light the subject from a good angle.

Some photographers use gold reflectors to add a warm glow to their subjects. This effect seems to work best when the color is credibly motivated or when the reflected light is used for back light. Gold reflectors add a healthy glow to pale-complected faces.

Reflectors used without restraint can undermine a scene's realism. Positioned too close to the subject's eye line, they cause squinting; used carelessly, they may blow over and injure someone. Used safely and judiciously, they can save the shot and, compared with some other techniques, the budget.

Use big-time shade and diffusion

Unfortunately, some effective ways to control contrasty, unattractive exterior light involve the use of large equipment and, therefore, large crews. Generally, this is not a problem on many feature films and commercial shoots.

Frames, sometimes as large as 20' x 20', can be assembled on-location and positioned above the scene with stands. The large ones, supported by two stands, are called "overheads"; the ones positioned with one stand and lots of weights are referred to as "butterflies." When a net is attached to the frame, the light that comes through will be reduced but not diffused. When a translucent fabric (sometimes called a silk) is used, the sunlight will be reduced as well as diffused. These "sails" should not be unfurled on very

windy days. After you have controlled the harsh sunlight, reflectors or lights may be needed to redirect the light. For a person doing this for the first time, it may feel a little like playing God.

These frames can also be used to hold a black net behind the subject in order to darken the background. If the frame is far enough behind the subject and the lens is of a relatively long focal length, the texture of the net will likely disappear.

Use lights

Some exteriors are close enough to buildings so that cables can be run from the buildings to power a few lights for fill or kickers: enough for a small setup. Long runs of normal cable will cause a voltage drop that can affect the output and color temperature of the light.

Competing with the sun requires a lot of light — especially if the scene is large — so high-budget productions often have a generator truck that can power enough fixtures to provide fill for the sun and "sunlight" in its absence. The equipment can also be used to turn night into day. The lights of choice for such situations are discharge types, such as HMIs, MSRs, xenon sources, and — though less and less these days — arc lights. These will approximate average daylight and require little or no color correction.

One of the problems you will encounter is that "daylight" at sunrise may be a mere 1,800K, while light from a northwest sky on a clear day in the shade is likely to exceed 20,000K. These, of course, are extreme cases, but often the daylight will be sufficiently out of balance with the film you are using that you will need to employ color-correction gels in front of your lights. At that point, whether or not you decide to filter the film camera or white-balance the video camera will be an aesthetic decision.

For limited-area exterior lighting — particularly on overcast or early-and late-in-the-day shooting — tungsten-halogen sources may be appropriate choices. Except for sunsets and other warm-color effects, these should be corrected with appropriate daylight-blue gels or dichroic filters. The light absorbed or reflected by these hungry-spectrum censors will cost you approximately 1-to-1-1/2 stops.

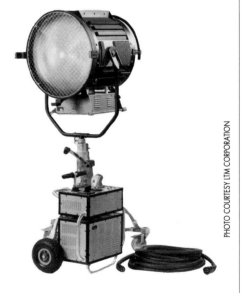

PHOTO COURTESY LTM CORPORATION

HMI and MSR sources approximate the color of average daylight. At sunrise, however, "daylight" may be a mere 1,800K, while light from a northwest sky on a clear day in the shade can exceed 20,000K. Keep color-correction gels handy.

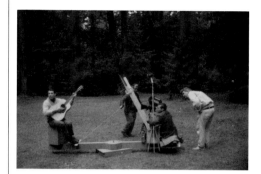

A battery-powered light provides fill as the talent
revolves on one end, the author on the other,
of a rig built by grip Eddie Knott. Producer/director
Yael Woll circles and watches.

PHOTO: AUTHOR

Safety considerations, especially proper grounding of electrical equipment, is even more essential on exterior shoots than interior ones because of the presence of moisture, rain, or snow. Do not let lights become wet unless they were designed for underwater operation.

Using battery lights

For low-budget shoots, especially news and documentaries, 12/14v, 24v, and 30v batteries are common power sources. Car and truck batteries are available worldwide. Two of these, wired in series, will provide 24v for some portable lights. Their considerable weight and relatively short operation before requiring a recharge may complicate location logistics. Still, having them handy may save the day — or the night.

To prevent a significant power and color-temperature drop, ordinary cable should not be run much longer than 5 feet with 12v batteries. Battery-operated lights will result in harsh front lighting only if you are determined to use them at full blast, undiffused, and close to the camera/subject axis.

Silhouettes

Exterior silhouettes can create powerful images by turning complex subjects with distracting detail into simple forms. Keep the subject as dark as possible and position it against a background such as a white, sunlit wall or a bright sky. Care should be taken to underexpose (see: *Meter Matters*) and not let the lab timer or video engineer "save" the shot. Midday is the worst time to attempt a silhouette, dusk and dawn perhaps the best.

Using flashlights

One should never go on-location without some flashlights for countless non-photographic functions. Efficient ones can also be used for some subtle face fill or eye light at close range. Once you fall in love with their admittedly limited potential, you may find yourself designing sequences around them, as I have done on many occasions. Small circles of diffusion and colored gel can be taped onto the front of flashlights to change the quality or Kelvin of the light.

Fog, wind, and rain

The visual impact of fog, wind, and rain should not be underestimated, but finding them when and where you need them are as likely as having a glorious sunset materialize when you want it most. There are various devices that can

provide these magical ingredients on cue, however. Some can be rented from professional dealers but may require experienced operators. Fog and wind require electricity; rain, a generous supply of water.

Aesthetics versus pragmatics

Especially when traveling to distant and difficult locations, it is important to distinguish between "essential" and "really essential" equipment. Although nobody likes to be caught in the position of needing that one piece of equipment they decided not to bring, there is a case to be made for the creativity that necessity often engenders.

For more: *Black and White Tricks* in *Bringing Copy Art to Light, Outside In, Meter Matters,* and *Color Temperature Matters.*

PHOTO: AUTHOR

The "reflector" was a window across the street that provided a theatrical spot of light in perfect balance with fill from the sky. While separation (using one of the B Lights) would have increased the sense of depth, it would have, I believe, hurt the mood.

A Difference of Night & Day

Early & late light, real & fake night

Nature's early and late-day kaleidoscope of light can be nearly supernatural, while day-for-night can be painfully unnatural.

If you were to ask experienced photographers, camerapersons, and video-graphers, "What is your favorite time to shoot exteriors?" chances are unlikely they would respond "noon." Most would praise the beauty of the light during early morning or late afternoon, sunset, and, without a doubt, dusk. In other words, when the sun is low, setting, or has already set, but before the sky is black. Not without good reason.

Early morning, late afternoon

When the sun is near the horizon rather than overhead, the world looks more attractive, more dramatic, and more three-dimensional both in reality and in two-dimensional reproductions. Whether you choose to shoot those special shots or sequences in the early AM or late PM depends, in part, upon the direction that your landscapes and immobile subjects face.

The color temperature of the light will be warm at both ends of the day. The more atmospheric haze and pollution in the air, the more blue will be absorbed and therefore the more beautiful your sunsets are likely to be. Unless you want the color of your images to match shooting done during the middle of the day, resist the temptation to neutralize it with corrective gels or video white balance.

A sun hugging the horizon casts magical, elongated shadows and low-angle highlights. The effect is totally different depending upon whether the sun is behind, to the side of, or in front of the camera, and how much fill you use. Except for when you back light or side light people or products, you will often find that you don't need to use any fill at all. Because the sun's rays travel through additional atmosphere and smog early and late in the day, this additional scattering and diffusion reduces contrast.

Sunrise, sunset

As the sun rises above or descends below the horizon, any clouds in that part of the sky will be dramatically back lit. With enough haze or pollution, the sky may provide a spectacular display of yellows, oranges, and salmons that change all too quickly to pinks, mauves, and purples. Landscapes and subjects are bathed in a kinder, gentler light, and a decidedly more colorful one.

If the sunset evolves into one of those rare 360-degree displays of nature, your subjects will be handsomely illuminated from all sides. More commonly, only one segment of the sky will be dramatic and subjects placed in front of it will be in silhouette or very dark, which might be ideal for certain moods. When details are more important than form, a little front or side fill may be in order and can be provided either by supplemental lights or (if there is a glint of sun left in the sky) a reflector.

The most difficult part may be determining your best exposure. You should open up from what a spot-meter reading of the sky indicates, and close down from what your incident or spot meter would have you believe is the appropriate setting based on a back lit subject reading.

Sunset filters

Some sunset colors may be too timid for your tastes. If you thought to bring along either salmon-colored glass or gel camera filters or not-too-garish sunset filters, this is the time to use them. Graduated neutral-density or color filters, such as salmon-to-clear, are worth a shot, time permitting. How far should you go? "Improving" nature is a great temptation as well as a great danger.

The Magic Hour

After the sun has set, cloudless skies radiate deep blue or purple, enveloping the landscape, seascape, or cityscape in an aura of incomparable subtlety and beauty. For images in every media, this is a time rich with possibilities, a time when it is difficult to mess up, except through timidity and overexposure. Load up the fast film or attach your super-speed lenses and continue shooting until a little after your meter warns you to abandon all hope.

In temperate zones, where many pros do most of their shooting, the *Magic Hour* lasts only about a third of an hour. The consolation is that, if it lasted much longer, the *Magic Hour* might lose some of its magic.

Day-for-night

Nighttime images are sometimes shot during the day for economic, logistical, or (rarely) aesthetic reasons. These situations require a lot of special treatment.

When shooting day-for-night, the best place to have the sun is behind and above the subject or behind and to the side of him. Underexpose 1-1/2-to-2 stops on the wide shots and 1-to-1-1/2 on close-ups. When details are not

Tom McDonough
It was called Magic Hour because it was brief and because its illusory light made heroes of everything — the landscape, the sky, passing strangers. It was the light of most religious paintings, the light of pretty force; it was lullaby light, the light of legendary rearing stallions and of Shane's farewell wave. And since Magic Hour was the only kind of light that could not be mechanically controlled or prolonged or duplicated, it was, for a film crew with exteriors on its schedule, a time of frenzy. *[LY]*

Tom Sadowski
The magic hour is actually the magic 5 or 6 hours in Alaska.

important but silhouettes are, even greater underexposure may be required. Advise the lab not to "save" you.

When you shoot day-for-night with a motion picture camera on a sunny day, you will encounter two problems. First, the lens has to be set at such a small aperture that depth of field is too great to achieve a realistic night effect. Second, you will have too little light to see a clear image in the finder. Neutral-density filters can minimize the first problem, but only very slow films can solve both problems.

Adding some blue to the scene either in the shooting stage or later is standard practice because photographic convention has it that moonlight is cool. By now it is a convention that is more glaring when ignored than observed. Fortunately, it is an artifice that allows for some attractive color manipulation.

Try to eliminate sky that would otherwise expose the photographic deception. This is, understandably, difficult to do, especially on low-angle and wide-angle shots. One tactic is to select locations with dense foliage for backgrounds. If the sky is blue and at right angles to the sun, a polarizing filter will darken it somewhat, but any white clouds are likely to undermine the illusion of night.

Day-for-night, black-and-white
When shooting black-and-white, a deep red filter will darken a blue sky but will also lighten everything in the red/yellow range, including lips and warm flesh tones. For optimal results with both blue skies and flesh tones, a combination filter consisting of a 23A with a 56 is recommended. So are tests.

The human eye's color receptors (cones) do not function at very low light levels, so the world appears to us in shades of black and white. Therefore, minimizing or eliminating color can help to convey the impression of night.

Do shadows from the sun belie "moonlight"? Eliminating shadows is seldom practical, but minimizing them whenever possible is advisable. The moon does cast shadows, but only timed exposures reveal them.

Dusk-for-night
The most successful night look results from dusk shooting. When you underexpose 1-1/2-to-2 stops, everything appears credibly night-like. Distant

Distant buildings, trees, and mountains are not consumed by darkness, but stand out dramatically against a convincingly night-like sky.

buildings, trees, and mountains do not vanish, and the sky is an apparently real deep blue or purple, against which everything stands out dramatically. If your subject needs emphasis, a large spot light — doctored, if you wish, with a light blue "moonlight" gel — can provide back light or whatever light is needed. Dusk-for-night is, happily, a terrific night strategy for both high- and low-budget shoots.

What are the disadvantages of dusk-for-night? You have less control of the dramatic elements than with night-for-night light, and shooting is limited to 15-to-25 minutes in tropical latitudes. If you are thoroughly organized and sufficiently rehearsed, a lot of shooting can be accomplished in that small window of time.

Night-for-night

You will not have a problem with telltale, washed-out skies when you shoot at night, but black skies will make separation of distant objects difficult. There are also such practical considerations as costs, logistics, and the energy levels of the talent and crew to consider.

Some situations are ideally suited for available night light. Filming on downtown streets in many cities requires only high-speed lenses and fast film, or sensitive video "chip" cameras. With few exceptions, the less light you add, the more realistic and effective your images.

Shiny streets

What film professor Charles Merzbacher calls "the secret of wet streets" is a standard, though often overlooked, way to enrich night exteriors, whether or not it is supposed to be raining in your scene. Advance arrangements with the sanitation department for a street sweeping/spraying truck will facilitate matters. On hot nights, when sidewalks are steaming, you will want to shoot quickly or keep the water truck around.

Given enough powerful lighting equipment, generators, experienced crew, and time, it is possible to light up sizable areas in a very sophisticated and dramatic manner. The advantage of night-for-night over day-for-night is artistic control: lighting that can contribute to the mood, the image, or the story.

Setting up for dawn's early light or sunrise could involve working in the dark — in both senses.

AM or PM?

The decision to shoot during dawn rather than during dusk or sunrise as opposed to sunset is likely to be based, in part, upon a single practical matter: setting up for dawn's early light or for sunrise shooting could involve working in the dark — in both senses. It is hard to know, for instance, exactly where the sun will come up without a prior scout. It is also difficult to predict on the night before the shoot what the weather and cloud conditions will be like 8 hours later. If makeup and other time-consuming activities are required, pre-Magic Hour shooting is far more practical than the pre-day variety. The one thing that may be missed if you shoot near water in the late PM is the beauty of ascending morning mist.

Mixing and matching

It is often possible to shoot various parts of a sequence at different times and on different days during nature's kaleidoscope of light without the risk that viewers will ever become aware of the artifice. One strategy is to shoot the long shots — especially if they include sky — during late dusk, and the close-ups using artificial "dusk light" and careful framing, either at night or during the day.

For more: *Superior Exterior Tactics,Color Temperature Matters, Semi-Motivation* in *Method Lighting* (for thoughts on where light is supposed to come from at night); and *Exercise #12* in *Lights-On Lessons.*

Photographer Randy Duchaine embellished this shot with reflections and flare, the former with lots of trucked-in water sprayed on the street, the latter with a little warm breath blown on the lens.

Outside In

Using daylight to shoot interiors

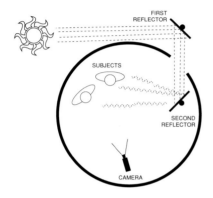

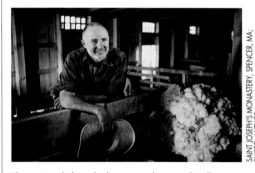

The existing light in the barn was photographically useless, so for this sheep-shearing sequence I added two large reflectors outside. One directed some sun onto the foreground, the other onto the background area. A third, small reflector, positioned camera-right, picked up exterior reflector spill to provide some side fill.

F or centuries, artists like Vermeer have been inspired by soft light streaming through windows and open doorways. Photographers, videographers, and filmmakers are just as enraptured by the source.

Window light or "window light"
Whether the images are shot in the studio or on-location, the "sunlight" you see streaming through windows in ads and movies is often simulated by one or more spot lights aimed through the panes. To suggest daylight without direct sun, a lot of diffusion is added or softer sources used.

Artificial sunlight at its best has several advantages compared with the natural kind. It is unaffected by clouds, can penetrate deeply into a room at a time of day that the real sun cannot, and will have the correct color balance and intensity. Even though it is not available light, it is available day and night, even in windowless studios. All you need is a powerful source and the amps to operate it.

Reflector alternative
There is an alternative to artificial "sunlight" that, despite drawbacks, has a lot to recommend it. Describing this method is most easily done as a case history: In the early 1960s, I was cameraman on the second half of a documentary about Vista volunteers, a film that went on to win an Academy Award. There was extensive sync-sound shooting inside several hogans. These domed, Navajo Indian houses had dirt floors, no electricity, one door, and — sometimes — a window.

Generators and batteries were not practical. It was Arizona in the summer, however, so reflectors were our tools of choice. I had brought two along and improvised two more out of plywood and aluminum foil. One side of the improvised reflector was covered with crinkled and flattened foil, the other with specular (shiny and uncrinkled) foil. I used the mirror-like side to kick as much light into the hogans as possible (film was much less sensitive in those days). Another reflector's non-specular side was used to soften and redirect sunlight from inside.

The hogans that had both a window and a door were relatively easy to light effectively, since there were two sources from which to redirect the stolen sun

beams: one for front-side light, well away from the camera/subject axis; and one which, after bouncing, would yield soft fill or subtle background light. When there wasn't a window, I used the tiny air space around the stovepipe in the roof to sneak in a bit of sun.

The look was so soft, so lush, and so real that I used the technique on many other documentaries and on several commercials, even when there was plenty of electricity at my disposal. Still, I waited for those times when conditions were ideal.

Ideal conditions:

• Sunshine anticipated for the length of the shoot
• Interiors on the ground floor or ones with balconies in sunlight
• Enough windows or doors situated at proper angles to direct sunlight inside
• Outside reflectors on tiltable, lockable stands to reach window height
• Enough time to readjust outside reflectors about every 15 minutes
• Little or no wind
• Inside reflectors stand-mounted to avoid low-angle light
• Willingness to slightly tailor the shoot, if necessary, to the idiosyncrasies of the technique, such as problems with reflector and talent positions

For more: Parts of *Superior Exterior Lighting* and *Color Temperature Matters.*

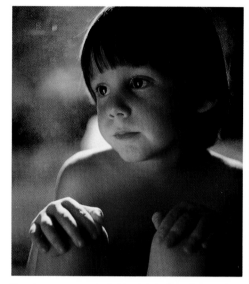

The afternoon sun provided back light through a window and low-angle front light after it was reflected by brown floor tiles.

PHOTOS: AUTHOR

The two hard reflectors that redirected sun through the far window solved the problem of how to light the long corridor dramatically and quickly while maintaining the anonymity of resident juvenile prisoners.

4

Dynamic Lighting of Static Subjects

Technique

With a little art & a lot of artifice, you can bring all those lifeless things to life.

Formula Follows Function

How you light it depends upon whether it's transparent, translucent, or opaque

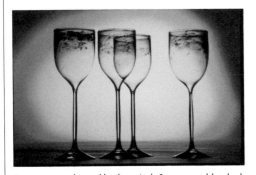

Transparent subjects like these Josh Simpson goblets look best when the only light used is projected onto a plain background. Black edges and no kicks from the glass are valuable perks.

Translucent objects, materials, and vapors come to life through a combination of back light and dark backgrounds.

PHOTOS: AUTHOR

O bjects of industry, craft, art, and nature can be divided into three categories based upon how they respond to light. If objects transmit light and images, they are transparent; if they transmit light but not images, they are translucent; if neither light nor images can be seen through them, they are opaque. Some objects combine two or three of these characteristics. Understanding the basically different techniques needed to make each type glow can help to minimize time-consuming, trial-and-error lighting tactics.

Transparent

Totally transparent objects have an aversion to direct illumination, especially front light. One way to keep them happy is to place them on a cyc, seamless-paper sweep, or other clean background.

A single light should then be projected onto the sweep behind the object. Although a soft light may serve your purposes effectively, a spot light with snoot will throw a controlled circle or, from an angle, an ellipse of light against which your transparent object will appear outlined in simple yet dramatic relief. If the surrounding area is totally dark, this simple lighting setup will eliminate subject glare and add black lines to some edges of a transparent object. For a variation, use a translucent background instead of a sweep, and light it from behind.

Carefully placed black cards or panels will eliminate unwanted reflections on the subject. If you want the subject to glow gently, position white cards or reflectors to the side of or above the subject and, if necessary, bounce light off of them. Some transparent shapes cast striking shadows when top-back lit with a spot light.

Translucent

Translucent objects and vapors, such as smoke, fog, steam, etched glass, and gems, should be lit directly, but primarily — or even entirely — with back light. If the subject is densely translucent, a rim light behind the subject, directly in line with the lens axis, may be effective. If the object is smaller than the source, poke a small hole in a seamless paper sweep or large card and position your light behind the hole.

Dark backgrounds emphasize translucent materials and vapors of all varieties. The darker the better. A little front or side light is necessary if the subject has any surface color, texture, or details that you want to emphasize.

Opaque

Most of the objects you are likely to shoot most of the time will be opaque. The light is partly absorbed and partly reflected by such surfaces. How much of each depends upon how specular or matte and how dark or deeply textured the object's surface is. Very matte and semi-matte surfaces respond well to side-front or top-front light, neither too close to the lens/subject axis nor too far to the side. A good angle to start at is 45 degrees.

Generally, the shinier the surface, the softer the source should be. A specular (mirror-like) surface, such as a chrome waffle iron, will reflect images of walls, cameras, people, and, of course, lights. Such subjects therefore will require special treatment. One technique is to surround the object with large white cards or panels, then add a little top light, which will also spill onto the reflecting surfaces. If you are unable to camouflage the edges of the cards, you may have to resort to the old tent trick: Borrow or make a tent-like structure out of translucent, color-neutral material with as few seams as possible; put the shiny subject inside; cut out a small hole for the camera lens; and flood the tent with light from various directions.

Some objects may ask to be shot outdoors, especially if they cannot be moved inside. If they are specular, shoot them on an overcast day when the sky imitates a translucent tent.

Some opaque subjects respond well to a silhouette-and-subtle-glare treatment that shifts attention from details to shapes.

All three

The real challenge comes when lighting objects that respond to light in more ways than one, like jewelry or cars. It may be necessary to combine two or three lighting directions or techniques, such as back light, background light, and side or front light. Stir in a little fill and you have the traditional movie-lighting recipe.

As with all subjects, the direction and quality of your lighting is dependent upon many considerations, including mood, message, motivation, subject, planes, and aesthetic preferences. When dealing with transparent, translucent, and even opaque objects, the direction of your lighting will determine whether or not they'll glow.

For more: *The Art & Craft of Lighting Craft & Art* and *Exercise #5* in *Lights-On Lessons.*

The Art & Craft of Lighting Craft & Art

Static-subject strategies

T he human face commands attention even if it has been lit and photographed casually. Non-human subjects need a lot of TLC — tender lighting care — to avoid lighting that is harsh, shadows that are ungainly, and backgrounds that overwhelm their subjects. As a result, you may spend more time successfully lighting a beer bottle than a beer drinker.

A clean sweep

Start with a background that does not distract from your subject. If you don't have access to a cyclorama (cyc), use a seamless-paper sweep. As the name suggests, this will provide you with a continuous background from wall to foreground floor: a clean, limbo-like setting against which your subject will be revealed with minimum lighting effort.

Rolls of seamless paper in various colors and shades of gray are usually available through photographic dealers. The largest standard width is about 9 feet. Twelve-foot rolls are available through some suppliers in medium gray and white, although they are not easy to find or to transport. Obviously, the paper must be much wider than the subject or setup. How much wider depends upon working distances, lens focal length (the wider the lens, the wider the paper must be), and how much limbo you need surrounding the subject.

Hang the paper making sure that there is a generous curve where the wall and floor join. Seamless paper wrinkles easily, so use a lot of care while unfurling the roll — and four hands. Choose a tone or color that will not conflict with or overwhelm the subject. Middle gray is generally a good choice for many subjects. Black can be a problem unless you use lots of edge light and back light for separation.

Backdrops

Both abstract and realistic painted backdrops made of canvas-like materials can be rented from various sources in several large cities. (Check trade shows, photo dealers, and source books.) Depending upon the backdrop pattern and your lighting, they will either confuse or enrich the composition.

Separation

If you place your subject at least 6 feet in front of the vertical part of the background and avoid front light, you can eliminate the peculiar shadows that otherwise run up the curve of the seamless paper. The additional space will also enable you to use both background light and back light if you so choose.

Lighting the sweep or backdrop

The way the background is lit may be just as important as your lighting of the subject, especially when photographing transparent objects. Try placing the key and background lights on opposite sides of the camera. The key light is best kept off the background, but this is a "rule" just waiting to be broken.

The natural fall-off of background light can be exaggerated by adding half scrims or open nets in front of the light; another way is to use a snoot in front of a focusing light. The justification for these efforts is the wonderfully three-dimensional look that is created when the shadow side of the subject lines up with the lightest part of the background, and the light side of the subject stands out against the dark portion of the sweep.

Keep lighting simple

Don't use more lights than you need. Each new light may introduce new problems, such as more shadows. Often, a large, white card placed near your subject will reflect enough spill light to fill dark areas without creating new shadows.

Planes

Place the main light source where it will reveal the form, character, and texture of the subject. Move the light around until you like the look of the lighting and the shadowing.

Each plane of three-dimensional objects should have a different brightness. Areas of the subject that are farther away, smaller, or more important should be brighter. Try lighting from above and slightly behind the object so the top surface or side plane is brighter than the front. Use some soft fill if needed.

A fully rolled-out, 12-foot wide white sweep was used here to provide a clean background for a 9-foot gray roll that was only partially extended.

DÜRER DETAIL FROM MELANCOLIA

Objects appear particularly three-dimensional when each plane is lit differently. Planes that are farther away, smaller, or more important often look better when they are brighter.

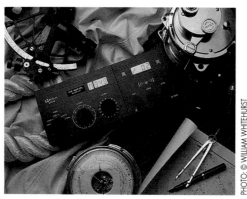

PHOTO: © WILLIAM WHITEHURST

William Whitehurst used a precisely positioned, 3' x 4' soft box to provide both the lustrous key and the gentle glare without which these black and metallic products and props would have appeared dreadfully drab.

Hard light

If you want strong shadows and highlights or pools of light, use a hard light. Hard lights can be dramatic, but their resultant dark shadows often hide important parts of the subject.

Soft light

When in doubt, try a soft light. The gentle highlights and shadows created by large, soft, diffused sources are ideal for semi-glossy surfaces and complex shapes.

Glare

Glare results from the light that strikes a reflective surface at an equal-but-opposite angle from the camera. It can add zest to inanimate objects, such as all of those semi-matte, black metal, leather, and plastic products photographers are charged with rendering beautiful. A little glare helps to delineate surface curvature, texture, and relief.

To create good glare, use well-diffused sources or bounce some hard light off white cards. You will discover quickly where to place the cards or lights to achieve optimal results. To control excessive glare, change the angle of the light or subject, or attach a polarizing filter to the lens and rotate it until your subject glows just right.

Moving lights (for moving media)

Do not move lights while shooting unless the movement can be motivated by the action within the scene. Certain subjects which may lend themselves to lighting symbolism may demand that you break this rule, however. On some art films I have shot, I have asked the gaffer to move a boom-mounted light extremely slowly in an arc around a sculpture. This effect can suggest the passage of time, a sunrise, or a sunset.

Objects of gold and gold leaf are difficult to reveal effectively. A slowly moving, dim, supplementary light can create a mysterious glitter and bring out the gilt in your subject, especially if a gold reflector or gel is used.

Miniature sweeps

Large sheets of plastic material available at some lumber supply stores can be used as straight backgrounds or, if thin enough, can be formed carefully into small sweeps. Two especially useful ones are shiny black and "milky" translucent. The first offers subject reflections plus black limbo. The second, when lit from below and behind, can put all sorts of objects into the state of shadowless limbo that is often sought by some catalog advertisers and television commercial producers.

Hazards

Too much heat can accumulate on a subject if the lights are too close or spotted down too much. This can ruin finishes, fade colors, and embrittle materials. Even modeling lights in strobes, in addition to the dazzling flash, are not conducive to the longevity of tender art and craft. If you can hold your hand comfortably in front of the object, the lights are probably not excessively hot. Still, fading and embrittlement may be a concern. Some institutions, such as the Philadelphia Museum of Art, have printed guidelines on this subject.

As suggested in *Bringing Copy Art to Light*, while some museums and private collectors are acutely aware of the hazards, many all over the world are not. Ironically, preservation is one of the very reasons we are asked to shoot the endangered treasures in the first place.

Heat and reflections

Precious objects that cannot be removed from glass and clear plastic cases are both difficult to shoot and, thanks to the greenhouse effect, vulnerable to dangerous heat buildup. You should keep your light levels low during setup and shooting and off at all other times — even if gallery and museum personnel are not hovering.

Strategically placed black fabric can cut some of the multiple reflections you'll have to contend with in these situations and is therefore considered essential "equipment" on such shoots. Polarizing filters will also help but, since your objective is to keep light levels low, these will do so at a terrible cost: about 2-1/3 stops.

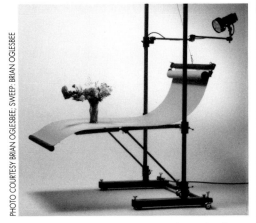

PHOTO COURTESY BRIAN OGLESBEE; SWEEP: BRIAN OGLESBEE

A well-designed, miniature sweep can do wonders for small objects, their backgrounds, and your back.

107

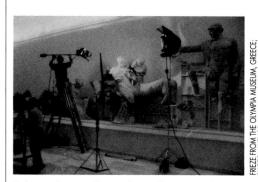

FRIEZE FROM THE OLYMPIA MUSEUM, GREECE;
PHOTO: AUTHOR

Lighting subjects such as sculpture offers several dilemmas: Can you be faithful to both the "piece" you are shooting and the piece being shot? Can you make it dramatic and keep it simple? How can you show the scale of the work without introducing an inappropriate reference?

Sculpture

Sculpture and objects with curved surfaces and complex shapes offer creative challenges. It is difficult to choose their most representative angle, but a well-placed shadow or reflection of the piece in question can reveal yet another facet of the object. When shooting video and film, subtle subject and camera movements can help bring lifeless subjects to life.

Turning (moving media)

Dollying around sculptures and products that need to be revealed three-dimensionally can be complicated. Often, it is simpler and more effective to rotate the object, if it isn't too large. Most turntables are unsuitable, however, since they cannot be turned slowly enough, nor started and stopped smoothly.

One way of solving this problem is to rent a heavy-duty, fluid tripod head designed for use with large motion-picture cameras. Put a wooden doughnut or large-diameter roll of tape on top of it to provide a platform above the tie-down screw. Mounted on a substantial tripod, the head can be operated by anyone with a delicate touch. Starts and stops can be made as smooth-as-silicone. Objects can be matched in terms of position and movement, whether intercut or dissolved together.

Securing a fragile object onto the turntable or fluid head is a serious responsibility. I usually test with a larger, taller, heavier stand-in object turning at a higher speed (for both my own and the museum curator's reassurance). If you carry editor's white cotton gloves, wear them when handling vulnerable objects and you will be sure to make an impression on the curator and not on the art. It is best if museum personnel handle the pieces.

Lighting for turning

Effective lighting of objects that turn is surprisingly simple and wonderfully rewarding. A side-front light, in combination with a splash of light on the background behind the dark side of the turning piece, may be all you need to reveal shape, texture, and subject movement. For some subjects, shapes, and moods, an additional kicker will transform a static piece of art into a remarkably dynamic one. Changing the quantity, quality, direction, or color of the light during the shot is most effective if it has symbolic overtones.

The two-dimensional image can be more compelling than the three-dimensional object if you isolate it from everything else, show it close, and bring it to life through subtle movement and sensitive lighting.

Scale

When human references are deliberately kept out of shots the problem of scale is likely to develop. It may be difficult for the audience to understand whether they are looking at a sculpture that is, for example, 12 feet or 12 inches tall. Moving the object, the camera, or the lights at unusually fast or slow speeds generally will add to the confusion. What is to be done? There's no simple answer. If scale is important, you may have to sacrifice aesthetics and introduce a suitable size-reference.

Outdoors

Keep natural backgrounds clean and simple. It is distracting to have every leaf on every tree sharp. A long lens and large diaphragm setting will minimize depth of field and create a soft, abstract plane behind your subject. Check the shot through the lens set at the stop you are intending to use to monitor the sharpness of each of the various planes. Higher shutter speeds for still subjects, neutral density filters, or less sensitive films can also be used if the backgrounds seem too sharp.

Try to shoot on an overcast day or in the shade. Not all shade is the same. Look for shade that seems to suit your subject. If there isn't a dominant direction to the light, use a reflector or a white wall to provide it.

Which way is up?

When your still, video, or film camera is aimed virtually straight down onto the subject, it is easy to lose track of its top-and-bottom orientation. You may be tempted to place the main light source behind you because it is within easy reach and seems natural. When the image is projected or printed, however, your subject will be lit from the bottom of the frame. This appears unnatural unless a low-angle motivating source has been established. Depending upon your subject and aesthetics, try placing your light at the top, top-corner, or side of the frame, or even above the subject, rather than at the bottom.

PHOTO: AUTHOR

Even if properly lit, a photo may be printed upside down or sideways. Shadows will be peculiar and objects will appear to be losing their battle with gravity.

Occasionally, when shooting stills, subject misorientation occurs despite your best efforts. Look at any catalog that includes abstract objects or small tools and you are likely to see a photo printed upside down or sideways. Not only is the direction of the shadow peculiar, but objects in the shot appear ready to slide off the page. Marking ambiguously oriented prints "this side up" may help. But don't count on it.

Last thoughts

There is no substitute for a good subject or a good eye, a good idea or a good deal of experience. The only thing more important than these, at times, is ingenuity: the art of improvisation.

When the client, crew, equipment, or subject lets you down, it helps to have a Plan B, perhaps based upon the last time you or your associates saved the day and the shoot. Some solutions are so ingenious, it's almost disappointing when problems don't arise.

For more: *Formula Follows Function, Lighting Planes, Hard & Soft Light*, and *Setting Up a Small Studio.*

Shadows and reflections can reveal a facet of your subject that is otherwise lost, along with its third dimension.

PHOTO AND SCULPTURE: AUTHOR

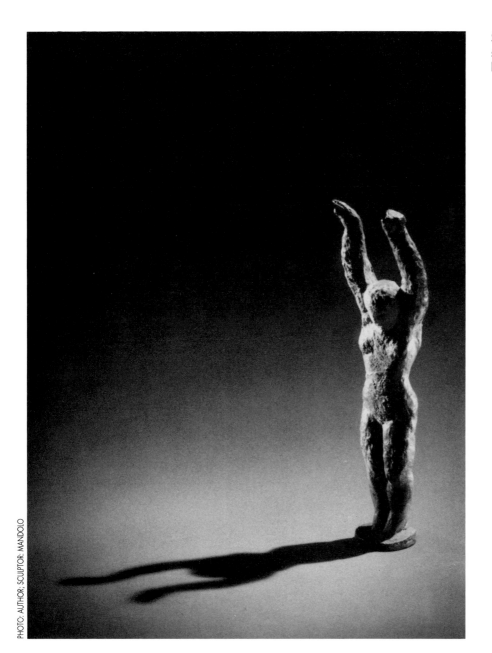

PHOTO: AUTHOR; SCULPTOR: MANDOLO

Sensitive lighting and, when shooting film and video, subtle subject or camera movement can help bring lifeless subjects to life.

Bringing Copy Art to Light

All those more-or-less flat subjects

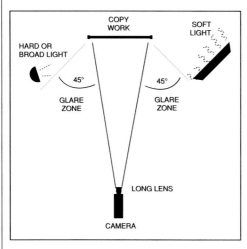

Place the entire light just beyond the glare zone. This 45-degree zone begins with the outside edge, not the center, of the subject, and ends with the inside edge, not the center, of the light. Because a hard light or broad is smaller than a soft light, the entire fixture can be set closer to the glare zone.

S hooting paintings, prints, and other two-dimensional subjects is almost effortless — when you don't have to deal with texture, wrinkles, warp, glass, glare, and fancy frames.

Centering

The first step in shooting most copy art is to center the camera in relation to the work. This will eliminate perspective distortion or keystoning, and reduce the problem of glare. If you are not working on a copy stand and not shooting something with a delicate surface, try my mirror trick. Put a very small mirror at the exact center of the subject, where corner-to-corner strings intersect. Then move the camera until you see your lens centered in the mirror.

Shooting blind

When photographing subjects protected by plastic or glass that cannot be removed, count on seeing nasty reflections of walls, windows, people, and cameras. The most effective way to eliminate these reflections is to use a very large panel of jet-black fabric stretched between two stands or, for faster setups and moves, hung from a pole attached to one large stand that is equipped with casters and weights. The hole you cut in the center should be just large enough for the camera lens. Keep spill light off the camera area and keep everyone, including yourself, behind the shooting blind.

Beyond glare

The greater the camera distance from the piece being shot, the easier it is to control glare and distortion. That means you should use a long focal length lens whenever possible. Lights should be set so that their inside edge is just beyond the glare-angle zone, or at least 45 degrees beyond the outside edge, not the center, of the piece. If the "flat" surface is somewhat textured, warped, or wavy, the angle must be even greater to avoid light reflections.

Hard lights and broads

Some people like to use soft lights on copy art. Soft sources will minimize texture, which can be a problem when photographing a surface of heavily applied oil paints. Soft, on the other hand, means big, and big means glare. The smaller the light, the easier it is to keep all of it in the glare-free zone and at a workable angle.

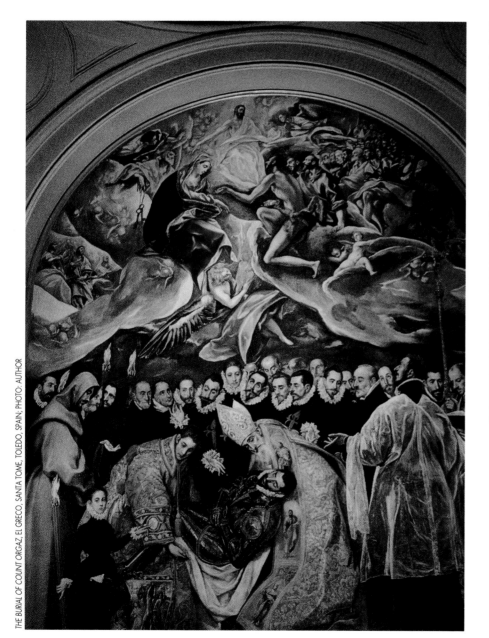

El Greco's masterpiece, *The Burial of Count Orgaz*, was a lighting challenge because there was no way to place fixtures on the left, right, nor top without introducing disastrous glare. I positioned four 1,000w lights below the painting and partially spotted the ones aimed at the top to compensate for fall-off. Flags cut off most of the light from walls and ceiling.

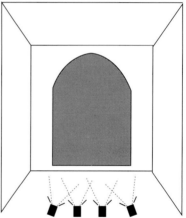

113

Hard lights are not only smaller than soft lights, but also subject to less light fall-off from one side of the work to the other. When utilizing focusing hard lights, half-scrims and graduated scrims can be added to compensate for some of the fall-off; spotting the fixtures will compensate for light losses due to the scrims. Another advantage of hard light is the ease with which you can control spill. When you copy large works in confined spaces, however, small broad lights are often a good choice because of their wide and generally even coverage.

Polarizing filters

Polarizing camera filters are effective in reducing glare on most surfaces, at a cost of about 2-1/3 stops. Greater glare control is possible if polarizing gels are also used in front of the lights, but this carries with it an additional exposure sacrifice. Even if this isn't enough to discourage still photographers who can use slow shutter speeds to compensate, another problem may do so. Due to their fragility, at this point, polarizing gels cannot be positioned close to constant-source incandescent lights without destroying them. Minimum distance is at least 1 foot, more for certain lights or focus settings.

How many lights?

One light, sufficiently bright and far enough away, may be adequate for smaller works. But if even coverage or adequate exposure is a problem, a second unit should be placed on the opposite side of the first. Large works, such as murals and tapestries, require at least four lights and considerable lighting space to achieve even coverage. When the proportions of the subject or the proximity of the surrounding walls demand, lights may have to be placed above or below the work — sometimes both.

Even more even

To help balance the light intensities from each side, some pros like to hold a pencil-like object perpendicular to the work to see if the shadows are equally dark. If not, they adjust the lights until they are.

The same incident light meter you use to measure exposure can tell you if the light level is the same over your entire copy area, an important step even if you decide to try the pencil trick. Extremely light areas of the subject can be finessed with subtle shadowing.

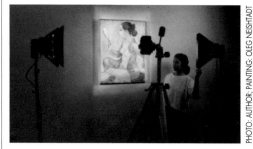

PHOTO: AUTHOR; PAINTING: OLEG NEISHTADT

Graphic artist Ellen Hum, who designed *Matters of Light & Depth*, demonstrates the art of barndooring light off of white walls.

Texture tactics

Symmetrically arranged lights of equal intensities minimize or eliminate texture. Most of the time, texture is too subtle to reproduce photographically and not necessary to the successful image. Capturing texture may be important when dealing with such subjects as small oil paintings, coarsely woven fabrics, or tapestries. To emphasize texture, use a hard light from one side. If fill light or fall-off compensation is required, the light on the opposite side of the subject should be a softer, less intense source to avoid the visual confusion that results from texture shadows coming from two sides.

Ellipsoidal spot lights may be the fastest, though not always the most available, fix for lighting works of art.

Framing frames

If your composition is to include the deep frames surrounding so many paintings, your perfectly positioned, glare-free lights will cast perfectly ugly shadows of the frame on both the canvas and the walls. Removing the frame is seldom an option — but worth investigating.

To reduce frame-frustration, position a flag in front of each light to create a subtle-edged shadow on both near sides of the painting. The loss of light near the frame area must be compensated for by the light on the painting's far side, and the overlap must be carefully blended. It takes time to do this properly, so, as an alternative, this may be the appropriate occasion to try those soft lights or umbrella lights you were hoping to use all along.

Washed-out-wall woes

There is another challenge when lighting art on walls. Most walls are white or, at least, light. Reducing contrast or creating a dramatic setting for the art requires a lot of flags, nets (to reduce, but not totally block, the light), and stands with gobos or clamps to support and position these tools.

Leko or ellipsoidal spot lights (usually associated with theatrical lighting) may solve, or at least reduce, both this problem and the previous one. Check color temperature.

Black-and-white tricks

One advantage of shooting black-and-white film is that you can play with a collection of camera filters that will, for example, minimize stains on old prints and increase contrast on certain low-contrast art. The "secret" is that color filters absorb and suppress the opposite color, and "pass" their own colors.

115

There are times when you shoot copy art that the emphasis should not be on the "copy" but on the "art," when your lighting should be anything but even, and when shadows should be introduced to embellish the image or to focus the viewer's attention. Photographer William Whitehurst placed several glass blocks in front of the only light used to illuminate this composition "to add a little emotion." He also employed a dozen miniature reflectors (white, silver, gold, and mirrorored) to fine-tune the fill.

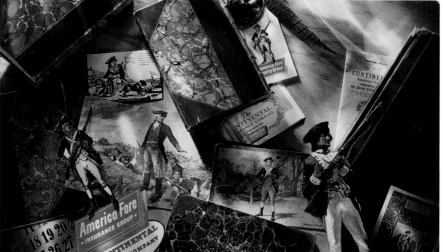

PHOTO: © WILLIAM WHITEHURST

How transparent, translucent, or both a piece of stained glass is will determine the quantity of back light and background light you should use to light it for photography.

DETAIL OF INTERIOR GLASS PANEL BY TOLAND SANDS; PHOTO: AUTHOR

A pure red filter therefore will lighten reds, oranges, and yellows, but darken blues and greens. Yellowed paper can be photographically rejuvenated and its contrast increased with a strong yellow filter, but any yellow, orange, or yellow-green subject matter will also be lightened and perhaps lost. Test shots, or at least safety shots, are recommended.

The not-so-straight approach

Sometimes you may not want an accurate, straightforward representation of the original, but an evocative or impressionistic image for some special use. In that case, start by ignoring everything I have said about copy art technique.

Perhaps you should shoot at an angle to the book or painting, allowing part of it to go out of focus. Instead of perfectly even lighting, consider introducing shadows over the bright or unimportant areas. You may be able to "justify" the inclusion of a hand, the back of a head, or perhaps a person's shadow or reflection to provide movement and indicate size. Almost anything goes — as long as it goes well.

Objectives

Your copy is not likely to surpass the original in terms of color, subtlety, detail, or texture. However, it can isolate and emphasize portions of a work or enable an audience to see otherwise inaccessible art. After all, how many people have seen the ancient art of Lascaux on the actual cave walls? At that site, ironically, the very presence of warm visitors toting fungus on their feet and professional photographers carrying lights on their cameras has apparently caused more damage to this priceless heritage in a few years than occurred during the tens of thousands of years previous to the paintings' rediscovery.

Art Hazard Highlights

When lighting paintings, fabrics, parchment, and other vulnerable materials, you may hasten their demise in any number of ways. Heat, light (especially UV), and handling (including fingerprints and falling lighting equipment) are just a few. While museum technicians and directors are usually very protective, some are unaware of the hazards to their art. All too often, technical and logistical problems make us lose sight of the long-term objective: to preserve the originals.

117

5

Shedding Light

Practical Matters

A thousand points of light & 999 pointers on meters, color temperature, kits, lamps, & small studios.

ALBRECHT DÜRER

A Thousand Points of Light

Old & new ways to see the light

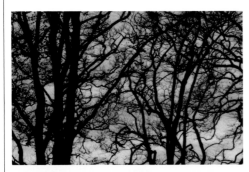

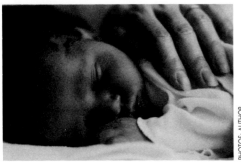

O
ddly enough, one way that new pros can begin to understand the elusive subject of light is through the craft's elaborate mumbo jumbo, but only when the jargon is arranged into meaningful categories. The following collection of classifications represents, for me, a balance between over-simplification on the one hand and exhaustion on the other. Don't be intimidated by the quantity of categories. Disregard all but the most useful ones for the time being. You can return to others when you need them. Standardized terms simplify communications among craftspeople. They should not dictate your lighting techniques, though, lest you begin to work by formula instead of by feeling.

Attributes of a light source

Every source has attributes that affect the nature of light emitted, exposure, mood, and overall lighting look. The experts do not necessarily agree upon such lists. Here is one version:

- Quality — hard, soft, or in between;
- Intensity — amount of light;
- Direction — in relation to subject/lens axis;
- Color — color of light emitted;
- Beam Pattern — shape and shadow patterns;
- Size — effective area of light emitted;
- Distance — from source to subject or light meter.

Both size and distance affect the other five attributes. Example: the larger and closer the source — everything else being equal — the softer its effective quality.

Aims or objectives of lighting

While the minimum aim of lighting is to provide exposure, there are also some elevated aims such as:

- to enhance mood, atmosphere and drama;
- to separate planes;
- to imply depth;
- to reveal character and texture;
- to complement composition;

- to direct attention toward;
- to convey time of day and year;
- to reward and, occasionally, to bedazzle the beholder.

The light's job

A light's function during a particular scene ends up being its job description, its temporary purpose in light. Typical job categories:

- modeling and mood: key light;
- subject contrast control: fill light;
- separation and pizzazz: back light;
- separation and set lighting: background light;
- modeling and character enhancement: kicker;
- accenting an area: eye light, clothes light, accent light.

Jobs sometimes overlap and change. A kicker may become a key in the next setup, or even in the same setup, if the camera dollies around the subject.

Direction of light

The angle formed between the light/subject axis and camera/subject axis largely determines subject modeling and scene mood. Examples:

- The key light is frequently positioned 15-to-45 degrees horizontally and vertically off the lens/subject axis;
- The camera-top light is (unavoidably!) about 0 degrees horizontal, 5 degrees vertical;
- True rim light is 180 degrees horizontal and vertical — in other words, right down the lens barrel.

There are other ways to indicate light angles. On the job, pros tend to use descriptions such as 3/4 back, top, side, and kicker, indicating the approximate angle of the light yet allowing for fine-tuning.

The light's job and angle tell you little about its personality and power.

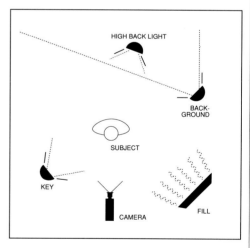

This classic lighting setup was once considered a sacred formula. Now, it is only one among many possible variations. The one you choose should depend upon your subject, mood, media, contrast range, individual style, and — sometimes most significantly — time limitations.

Type of illumination

The following dichotomies represent not only light extremes but often passionate controversies in the worlds of cinematic and photographic aesthetics:

• natural light versus artificial light;

• available light versus photographic light;

• constant-source (hot light in still jargon) versus electronic flash.

Nature of the fixture

"Type of source" is another way of referring to quality of light:

• soft light;

• broad light or semi-hard light;

• hard light.

The nature of the fixture should not dictate its job. Still, since soft lights are rarely used for back light and hard lights rarely used for fill, built-in assumptions about which lights are appropriate for which jobs and which angles are not surprising to find.

Make or manufacturer:

• Arri, Desisti, Ianiro, Lee Colortran, Lowel, LTM, Mole-Richardson, and Strand, to name a few, and many electronic flash companies.

(Note: sometimes a product name evolves into a generic name.)

Wattage:

• A fixture may accept a range of lamps. Example: the same fixture sometimes may accept lamps of 500, 750, or 1,000 watts — often safely;

• What goes in doesn't all come out. The intensity and incident reading will depend upon the type of source, efficiency of design, distance, etc. — not just upon wattage;

• The wattage reference may have several nicknames. Example: A 2,000w focusing fresnel spot light can be called a 2k, a deuce, or a junior. Some of the jargon depends on geography.

Nature of the subject

How objects respond to light determines, in part, the best way to light them effectively. Examples:

- transparent, translucent, or opaque;
- specular (mirror-like), semi-matte, or dull matte;
- smooth or textured.

Movement will also influence the way you light. Examples:

- static subjects;
- minimum subject movement;
- dynamic subject action;
- camera movement.

Nature of the media

How the image is ultimately viewed and the size of the screen, tube, or print it will appear on should influence how you light it, especially with reference to contrast. Some of the categories:

- stills, video, or motion pictures;
- color or black-and-white;
- image viewed by reflected light (prints) or by transmitted light (movies and slides);
- high-definition/resolution or low-definition;
- two-dimensional or, rarely, three-dimensional.

Nature of the shoot

The type of shoot does not necessarily determine the lighting but, due to practical considerations such as crew size and budget or as a result of tradition, it will probably influence your approach and choice of equipment:

- studio, tabletop, or location;
- interior or exterior;
- static camera or moving camera;
- hand-held, tripod-mounted, or rigged camera;
- industrial, documentary, feature, news, wedding, food, fashion, wildlife, architecture, portraits, or copy work, among others.

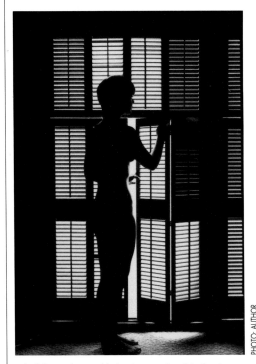

PHOTO: AUTHOR

Of all the attributes of light, direction (angle) often has the greatest impact on mood.

Mood

Good lighting helps to establish the mood of a shot or sequence. A few of the most obvious moods include: drama, mystery, comedy, romance, and horror. Advice to the contrary notwithstanding, there is no right way or only way to light for each mood. Still, mystery and horror are not likely to be lit high-key since imagination flourishes in the dark. Comedy is seldom seen with somber or high-contrast lighting. There are many other conventions in mood lighting but they should not be thought of as sacrosanct formulas.

Style

Style relates to a traditional lighting look as well as to that hard-to-define quality that may distinguish the work of one lighting craftsperson from another. A few of the extremes:

- realistic and motivated versus fantastic;
- subtle versus bold;
- high-key versus low-key;
- dynamic use of color versus muted color.

Lighting approaches

The two techniques I consider especially important to this craft because they can make the process simpler and the results more effective are lighting planes and motivating the light. There will be many occasions when one or both of these approaches must be ignored, however.

A new look at old angles

Where you put a light has many ramifications, such as: drama, modeling, texture, glare, flare, flat light, and squinting. It is important to remember that all subjects and scenes are different. Subject reflectivity, the height of your lights and camera, and the color of the surroundings, among other aspects of the shoot, will affect your results. See diagram on opposite page.

Interdependence

Lighting is often talked about as though it were an independent phenomenon. The opposite is true. Lighting affects, is affected by, and should relate to every other element in the final image. Consider:

- composition, set, wardrobe, and any movement;
- the role of the lab or video engineer.

Final warning

Just because a light may have an important-sounding name or function doesn't mean you have to use it. A lot of fine images were and will be recorded without a good eye light, or even a good light, for that matter. Not too many fine images were created without a good eye, though. So make sure the categories and terms serve, ultimately, to help you develop that good eye and enable you to communicate better.

For more: *On Face Value*; *Video, Film & Still Lighting*; and *Lighting with Paint*.

Tom McDonough

First thing, turn out all the lights in the room. Go sit in front of the mirror. Take your flashlight. Hold it at heart level and aim it straight up, toward your face. Switch it on. What movie are you in? *Frankenstein*, right, or *Bride of Frankenstein*. Now take your flashlight and hold it directly over your head, aimed down. What movie are you in? *The Godfather*. Very good. Light a cigarette, blow a lot of smoke around. Hold the flashlight behind your head, aimed forward. . . . What movie are you in now? *Casablanca*, *Close Encounters of the Third Kind*, or *Alien*. Excellent. Hold the flashlight at arm's length, aim it at your eyes. Don't blink. You got it. The evening news. *[LY]*

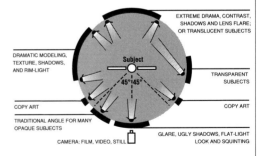

Drama, modeling, textrure, glare, flare, flat light, and squinting: where you put the light has many ramifications.

For definitions see: *Terms of Enlightenment*. For a fuller exploration of this diagram, see: *On Face Value* and *Dynamic Lighting of Static Subjects*.

Meter Matters

Light reading on reading the light

Good exposure can be as simple as pointing and shooting — if the camera has automatic exposure control and you have a little light and a little luck. At the other extreme, you can undertake a serious study of exposure determination and contrast manipulation, starting with film sensitivity, f-stops, shutter speeds, the Zone System, and reciprocity and its failures.

These and other professional rites of passage may take years to master. However, there is a middle course: Even if your camera is blessed with automatic everything, learn to use meters creatively, i.e., know when and how to outsmart them. From time to time you will need to outsmart them, not only for proper exposure but also for interpretive exposure.

Two types of light meters

There are two different types of light meters in common usage today: incident and reflected. Each has its advantages and limitations. Both types "assume" subjects have surfaces that average out to middle gray — 18 percent reflection — or the equivalent in color. With both types of meters exposure is only a starting point. When using both, you will also have to set the film or video camera sensitivity (exception: through-the-lens meters in combination with bar-coded film cartridges). Good meters of both types are expensive but, considering what they do for you and your image, they're still a real bargain. Many pros use two or three different meters aside from the one built into their eyes.

Perhaps the most confusing part of meter usage is that the exposure corrections required when dealing with a scene that is either very dark or very light are totally opposite depending upon whether you are using an incident light meter (ILM) or a reflected light meter (RLM).

Incident light meter (ILM) readings

Incident light meters read the light that reaches the subject or scene. They ignore how bright or dark, shiny or dull, various surfaces are. (Extremely bright surroundings can fool them slightly.) Most incident meters have a translucent hemisphere or half ping-pong ball-like dome that collects light from every direction except from behind. Full front light will contribute the most to the total reading, back light the least.

Experience and a good eye can turn a dumb meter into a sophisticated tool. Two meters can tell you almost everything you need to know about lighting and contrast — except whether they're any good.

The light-gathering hemisphere should be aimed at the camera from immediately in front of or to the side of the subject; in any case, from a spot that is typical of the light level in use. When the scene is lit primarily with back light or side light, the meter can be angled between the camera and the main source in order to avoid overexposure. Precisely where you aim it is a matter of whether you want to expose for the highlights or the shadows. Tests and experience help.

Some pros prefer to read the key light instead of, or in addition to, a general reading. For that you need the flat light-gathering disk available with Spectra meters.

Sometimes readings need to be made in several parts of a set, especially if an actor moves from area to area. When shooting exteriors lit only by the sun or overcast sky, one ILM reading from the camera position should suffice.

Incident light meter "misreadings"

Not all scenes conform to the 18 percent reflection assumption programmed into meters. Since ILMs are blind to subject brightness, they won't correct for, or even inform you, about the exceptions. As a result, unusually dark scenes and subjects likely will be underexposed and very light ones washed out.

What is called for is some firm but sensitive human intervention. If you add too much exposure to dark scenes blacks will turn into grays and light areas will lose all detail. If you subtract too much exposure from unusually bright scenes the whites may end up as grays and dark gray areas will be black. The appropriate compensation is generally between 1/3-to-1-1/3 stops in either direction, but that's a wide range. How much you decide to compensate will ulitmately depend upon how light or dark the scene is, how you want it to look, and how much experience you have to draw upon.

For those of you who shoot stills, exposure bracketing serves as an insurance policy, regardless of which type of meter you are using. Silhouetted images require a 2-to-3 stop smaller (and, therefore, larger number) stop than the ILM indicates. ILMs are not useful when it comes to brightness (i.e., contrast) ratio determination.

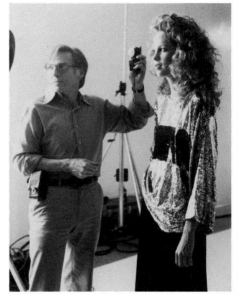

When back light or side light predominate, the meter's "ping-pong ball" can be aimed at a point midway between the camera and that source.

Anton Wilson
To determine the foot candles necessary for a T-2.8 aperture at 1/50th of a second . . . take the number 10,000 and divide it by the EI. The result is the foot candles necessary for a T-2.8 exposure at that EI.
For any stop other than T-2.8, merely double the result for each stop above T-2.8 or halve the result for each stop under. *[CW]*

Vilmos Zsigmond
In many paintings people's faces are not . . . in full light. You remember it and you say, I will underexpose, but it is not really underexposing, it is underlighting selectively. . . . Whatever I wish to appear dark, I will light dark. But still, it is perfectly exposed. *[FL]*

As with MDs, a second opinion is advisable. Split the difference between an RLM and an ILM to limit your exposure to error.

Reflected light meter (RLM) readings

The RLM is designed to read that fraction of the incident illumination that is reflected from the scene. Like the ILM, it is most content when scenes are 18 percent middle grayish, or "5" in the Zone System. When this is the case and your meter is carefully aimed at a representative portion of the subject, the resultant exposure is likely to be safe, though not necessarily inspired.

The portable 18 percent solution

If you are comfortable with an RLM but nervous about whether or not the subject brightness is average, there is a technique you should try instead of, or in addition to, the standard procedure. Substitute for the scene a Kodak gray card that reflects 18 percent of the incident light when positioned at the subject and aimed midway between the main light source and the camera. This hybrid method ignores subject and scene brightness and therefore "recommends" an exposure very similar to that of an ILM. It is also subject to the same "misreadings," however, and therefore may require exposure intervention.

Second opinions

Just as a second opinion from a reliable MD is often advisable, so it is with RLMs whenever scenes are obviously not of the 18 percent variety. Take two readings: an RLM of the subject and an RLM of a gray card or an RLM of the subject and an ILM. Then split the difference. This sounds like a crude compromise but it tends to be a reasonably dependable method and limits exposure error and confusion.

RLM spot meters

Spot meters are specialized reflected light meters. The area of the subject they read is limited to a narrow angle of about 1 degree. They can do this either from up close or from a distance. The spot meter has a viewing system that enables you to determine and see what it reads. This eliminates many uncertainties, including inadvertent glare and meter shadows that often affect the accuracy of conventional RLMs.

Reading a small spot is a big help when shooting distant, moving, or unapproachable subjects, such as the inside of a furnace. Spot meters are also the best way to check the brightest and darkest areas when determining your brightness ratio (also called contrast ratio).

Because they read only a spot, these instruments will not average out a scene successfully for general exposure purposes unless you are reading a middle-gray card or area. Last caution: spot meters, which are otherwise almost infallible, can be tricked by bright areas, such as sky, just outside of the inner circle being read.

Through-the-lens meters (TTLM)

In-the-camera meters read reflected light. Good TTLMs can perform sophisticated and accurate readings of virtually everything — except your mind. The most useful ones let you choose between spot and wide-angle readings and automatically compensate for variations in film sensitivity with bar-coded film cartridges. Also, most filters added to the front of the lens will be compensated for automatically.

TTLM readings are generally "weighted" in favor of the center of the image where, presumably, the subject will be. If your composition is a bit more daring, you can center the camera on the subject, determine the exposure, lock it in, or set the lens stop manually and recompose off-center. It may be necessary to move closer to the subject or zoom in for a reading in order to eliminate large excessively bright or dark areas. Using a gray card or bracketing exposures is advisable, when practical, for tricky subjects.

PHOTO COURTESY OF MINOLTA CORPORATION

Spot meters are the best way to check the brightest and darkest areas and read a distant or inaccessible object. They can read everything quite accurately — except your mind.

Bill Klages
Practiced television lighting designers do a great deal of squinting to aid in "reading" brightness. You might suspect that a spot brightness meter is an answer to predictable results. The subject matter to be televised is always too complex, however, and the method much too slow to have any practical value. These meters are useful only in determining the brightness of large areas . . . before cameras are available.

Reflected light meter "misreadings"

Reflected light meters "overreact" to scenes that contain large areas that are very dark or very light. They will compromise the effect of high-key or low-key images by trying to "middle gray" both. You will need to open up 1/2-to-1-1/2 stops after reading unusually bright scenes such as snowscapes, and to stop down for dark scenes.

Another concern to be aware of is that it is difficult to know precisely what area is being read by a conventional RLM, so poor aim, bright sky, back light, the intrusion of your own shadow, and glare threaten accuracy, even when you use a gray card. This is seldom a problem when using TTLMs or spot meters.

The constant-stop strategy

Many pros are able to judge the consistency of light levels from one setup to the next without a meter and therefore may not "read" very often, especially when they are shooting for long periods of time within the same interior. These people may light various setups to a predetermined stop which is decided upon based on how much or how little depth of field is desired, how cool the surroundings need to be, and what their "lucky numbers" are. Between T-2.2 and T-4.5 is fairly common for interior shoots. Maintaining a consistent exposure on exteriors is more difficult and probably requires the use of neutral-density camera filters.

ILM, RLM, TTLM, or spot meter?

Motion picture pros tend to rely on incident readings and their experience to achieve basic exposure. Many also arm themselves with a spot meter, which may either leave its holster frequently or only during crises of confidence. Still photographers once used reflected meters a lot, both with and without a gray card. Lately, however, refinements such as highlight- and shadow-averaging and darkest-area or lightest-area readings (with automatic compensation) are possible, lessening the need for reflected light readings.

Crucial contrast readings

Meters are not only used to determine exposure but also to check and control lighting contrast and subject contrast. Excessive contrast for a particular medium or emulsion will result in images that lack detail in important light or dark areas and, all too often, in both. The information that a well-wielded

Gordon Willis
You want to maintain [the same f-stop] from cut to cut because, if you just start arbitrarily dialing stops to compensate for lighting that you haven't properly set, the movie is going to start jumping around. You're going to have depth of field problems cutting from one person to another, one scene to another. . . . They'll move from soft to contrasty and back to soft. [ML]

meter provides also can be used to make assessments about the contrast desired for purposes of creating mood and drama.

Meters are needed primarily because the human eye is a poor judge of lighting and subject contrast. The eye's ability to see detail in the darkest and lightest portions of a room or landscape is far greater than the capabilities of film or videotape. Part of the reason is that the eye's iris closes quickly when looking at bright areas and opens slowly when confronted with dark subjects in shadowed areas. The inexperienced eye is, as a result, easily deceived. Many professionals, nonetheless, use their eye in addition to or instead of a meter to judge whether the contrast is appropriate for the mood and is within the reproduction capabilities of the medium. They only do so, however, after they have disciplined their eye and have suffered some unwelcome surprises.

Those working in video have at their disposal the advantage of immediate feedback to appraise results, especially when working with a well-adjusted video playback or waveform monitor. For stills, Polaroid film provides a comparably quick look at "truth in contrast." If you are using the Polaroid for test purposes, be aware that allowances will have to be made to correct for contrast-range discrepancies between the Polaroid film and the emulsion you intend to actually shoot with.

Contrast viewing glass

In the 1960s, no self-respecting cinematographer appeared on the job without a contrast glass, worn necklace fashion on the chest. Though seldom used, it was part of the occult paraphernalia that justified our high status and salaries. Actually, the little device is a big help, especially to the new pro. It enables him to approximate quickly the disastrous effects that contrast may wreak on the look of the scene after the image has suffered the indignities of reproduction, printing, and projection.

Two different ratios

Just as there are basically two different kinds of meter readings, incident and reflected, there are two basic types of contrast readings, lighting ratio and brightness (or contrast) ratio.

Bill Klages
The best way to judge the contrast of the television image is to turn the color off in the picture monitor. This removes the effect of color contrast on the image and readily reveals the brightness differences between all the picture elements.

Lighting ratios

The lighting ratio involves only incident light; it ignores all information about the subject and set tones and brightness. It is essentially a comparison between the key light plus fill (if the fill adds to the key level) and fill only. These readings are made with an incident light meter. If the first measurement is 200 foot candles and the second is 50, then your lighting ratio is 4:1, or a 2-stop difference. Maximum lighting ratios depend upon the media and ultimate use of the image. Ideal ratios also depend upon such matters as subject, mood, and style.

In TV, a timid ratio is 2:1, a dramatic one 8:1, a maximum ratio about 16:1 (4 stops). Since the lighting ratio is based upon incident readings, it ignores subject brightness extremes. For that you need. . .

Brightness ratio or contrast ratio

Because lighting-ratio readings tell you nothing about how dark that navy blue suit is and how white that hat or pale face is, your film or tape may not be able to reproduce successfully both in the same shot — regardless of how "safe" the lighting ratio and exposure setting are. This is most likely to be the case if the blue suit is in shadow and the white hat in full light.

A brightness ratio requires two reflected light meter readings of the scene: the lightest significant area (in terms of size or importance) and the darkest one. Comparing the two provides the ratio. These readings will be made, especially where small areas are involved, most reliably with a spot meter. The spot-meter setting currently available on some still cameras will work as well.

Each medium or method of reproduction has different brightness-ratio limits. Movie theaters can project an image with a range as high as 125:1 (a bit more than 7 stops) that still offers detail in the highlights and shadows. Currently, the maximum recommended range for broadcast TV is usually about 30:1 (5 stops), although some experts have suggested a slightly higher range. Because of this difference in the contrast ratio between the two media, more lighting care is required for video than for film, which is not always the practice.

As with lighting ratios, maximum does not mean ideal. How much contrast you want, or end up with, may be a formula derived from a complex balance of personal taste, your dramatic and stylistic intentions, and reality.

Ratio relationships

Lighting ratio and brightness/contrast affect each other. High lighting ratios may turn an otherwise normal-contrast subject into one that exceeds the reproduction capabilities of your medium. A scene containing unusually dark and light subjects may reproduce as contrasty, despite low key-to-fill ratios.

When high-key or low-key looks are sought, both the choice of lighting ratios and subject brightnesses need to be considered carefully and controlled precisely, along with such other production aspects as wardrobe, makeup, and sets.

The meter versus the eye

Many professionals do not bother with brightness-ratio readings, especially when they're pressed for time and when they judge the subject to contain average tones: neither too contrasty nor too flat. They may also eventually reach the point where they can trust their eye to supply such critical information. Even if a meter is used, it is only a starting point and will not make aesthetic or stylistic decisions. You will do that.

Caleb Deschanel
. . . I usually figure that the whitest white is about 4 stops overexposed and the blackest black is somewhere around 3-to-3-1/2 stops underexposed, depending of course on the background. I can take someone and underexpose his face 2 stops and put him against the black background and you would see his face really well. I could then light the background to 4 stops over, and have the front of his face exposed exactly the same way, and you would hardly be able to see any detail in his face because your eye cuts down that front detail. . . . It is part of the nature of contrast. If you show absolute black on the screen it is milky. . . . Whereas, if I put a spot of white light in the middle of the black, that black will appear much blacker. *[FL]*

PHOTO: AUTHOR

Your meter doesn't know whether you want a normally exposed subject with burned-out sky or a well-exposed sky with a silhouetted foreground. Without lights or reflectors you'll need to make that choice and adjust your lens aperture accordingly.

Finessing the iris: video and film

When shooting video and film, you can sometimes change exposure during the take, and thereby "extend" your potential range. When a camera pans, tilts, or dollies from one area to another there may be drastically different brightness levels involved. An example would be tilting from dark trees (assume an exposure of f-5) to a sky of white clouds (requiring a minimum stop of f-16). With careful timing and practice, you will be able to alter the lens stop as the camera moves without having the change be obvious.

Automatic exposure controls on video cameras, unfortunately, respond too quickly to changes in brightness. This tends to be very distracting to viewers. It is largely for this reason that most pros do not use this seemingly miraculous option for production work. They opt, instead, for manual manipulation once the exposure has been determined.

Motivated exposure shifts

"Motivated stop changes" could provide the same kind of subjective reality that motivated light sources do. Since the human eye adjusts to sudden darkness extremely slowly, why shouldn't the camera lens do the same? As the camera moves from a bright exterior into a relatively dark interior, imagine the suspense that could be created if the lens iris accommodates (opens up) very gradually. All the audience would see would be a few highlights. Mysterious sounds might add to the drama.

More readings?

There are many more exposure matters. Don't stop reading here. Video practitioners who use light meters less than their film brethren but who would like more control over their exposure fate should see the section devoted to light meters in Harry Mathias' and Richard Patterson's book *Electronic Cinematography*.

Kris Malkiewicz's *Cinematography* (second edition), contains an excellent section on the subject. Gordon Willis addresses the same subject briefly but compellingly in *Masters of Light*. Alan Ritsko's *Lighting for Location Motion Pictures* contains a thorough exploration of exposure and meter use. See: *Resources* for more information on all of these books.

Envision a scene in which an actor moves from a sunlit exterior to a black interior where only a window and a few highlights can be discerned. Perhaps mysterious sounds add to the drama. Gradually, the room gets lighter (in the same way that the human eye adjusts to darkness). It is accomplished not with dimmers but by adjusting the lens iris.

Exposure Terms
See: *Terms of Enlightenment* for definitions and tips.

- Automatic Exposure
- Averaging
- Bracketing
- Brightness Ratio, Contrast Ratio
- Dark Adaptation
- DIN Standard, ISO
- EI/ASA, Exposure Index
- 18 Percent Assumption*, Middle Gray, Zone 5
- EV, Exposure Value
- Exposure
- Exposure Latitude
- Filter Factor
- Foot Candle (fc)
- Gray Card
- Gray Scale, Chip Chart
- Incident Light
- Incident Light Meter, ILM
- Intensity, Light Output, Light Level
- Interpretive Exposure

- Lighting Ratio
- Lux
- Meter Reading
- Middle Gray
- Overexposure
- Reciprocity Law
- Reciprocity Law Failure
- Reflected Light Meter, RLM
- Shutter Speed
- Spot Meter
- Stop, f-stop, T-stop, Diaphragm, Aperture
- Through-the-Lens Metering, TTLM
- Underexposure
- Zone System

E. Carlton Winckler
With an expert cameraman it is possible to turn off the automatic exposure circuits on cameras and to rely on the cameraman to use his judgement on exposure, but on long sequences with no live video operator at hand and a less than meticulously rehearsed show it is generally unwise to do so, as things in the control room can get a bit frantic and the cameraman can be distracted.

Color Temperature Matters

*The bane of beginners,
the boon of the brave*

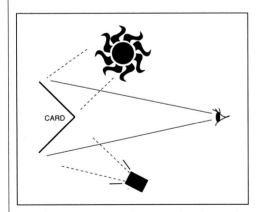

No color temperature meter? Compare the relative Kelvin of two equally intense sources by limiting each to only one side of a folded white card. Avoid glare. Thanks to the eye's chromatic adaptation and short color memory, only side-by-side comparisons are useful.

Lord Kelvin, a British physicist, mathematician, and inventor, devised a way to measure the relative amount of red and blue in a light source by comparing it to the color of a "black body" when heated to various temperatures. The resultant measurement is called degrees Kelvin, Kelvin, or K.

Kelvin limitations

Lord Kelvin's system tells us much of what we need to know about candles, tungsten lamps, and, to a lesser extent, daylight. Even so, it leaves out important information about the color of certain filters and those not-just-red-and-blue light sources, such as sodium, fluorescent, and mercury vapor. Such sources are found commonly on location shoots.

Color temperature metering

Glowing black bodies and meters with two color sensors are helpless in the face of sources that contain green and magenta. These require a meter with three-color sensors. In most situations you will find portable three-color meters adequate, but even these often fail to provide all of the photographically gruesome details you might need when working with exotic, kinky-spectrum sources.

Many pros do not ordinarily use a color temperature meter. Actually, a relatively accurate color comparison of two sources is possible without a meter: just use your eye and a white card, as shown on the left.

Non-white balance solutions

If you take a reading of one or more of your lights, compute the results, and determine there is a serious color mismatch in relation to your film, there are several options open to you. One is to ignore the meter's findings because you like the color shift, you do not have the correction gels required, or you plan to have the lab correct the palette later.

An obvious strategy when color mismatch is a concern is to turn off the offending sources and use only your lights. Or, if practical, you may decide to look for a different place to shoot the scene. If you have a collection of tough, fade-resistant, light correction gels or some color-correction (CC) camera filters you can perform color surgery upon one or more of the sources, the lens, or both.

Color Rendering Index (CRI)

The color rendering index or CRI ascribed to sources such as HMI and MSR evaluates the accuracy of the light source as compared to a standard source. The higher the CRI number, the better.

Video virtues

Video cameras and tape are not finicky about moderate color imbalance. Their electronic white balance for all three primary colors can improve, although not fully correct, exotic sources. If two or more sources have inconsistent color output, it may be necessary to gel some of the more serious offenders and only then proceed to white balance.

Seeing color problems on a high-quality monitor and being able to make both technical and aesthetic changes immediately is a great advantage of video, especially when you compare it to the next-day "playback" film technology requires. Even so, it helps to have a pre-calibrated monitor with SMPTE-C phosphors, even on location.

Film factors

Most motion-picture labs and darkroom technicians can manipulate the color of a shot or scene — often drastically — but cannot alter specific areas within the scene that were lit by sources of different color temperatures. Laboratory timers and technicians are unable to guess what you had in mind and will aim for printing results that are average and safe. If you want to preserve any special color effects, be sure to let these people know.

The color purple, among others

The human eye can detect a difference of about 50 degrees Kelvin in the 3,200K range. In the daylight range of 5,500K, however, a difference of less than 200 degrees is difficult to discern by eye. Daylight color films are balanced for 5,500K — a summer-like, midday combination of clear sun and sky with no large, off-color reflecting surfaces. Winter, early and late day, overcast skies, and other "abnormal" light conditions can either be seen as a problem or an opportunity, depending upon technical and stylistic considerations.

ALTDORFER, DETAIL OF *THE BATTLE OF ALEXANDER*, ALTE PINAKOTHEK, MUNICH

Altdorfer represents on canvas the dramatic color extremes inherent in atypical daylight. Such extremes explain why subjects shot close to sunrise and sunset look red or golden while those photographed during dusk or in the shade appear unusually blue.

PHOTO: AUTHOR

White bathrooms are soft boxes just waiting to happen. Here, the ceiling-bounced light was 3,200K, but the film was balanced for daylight and I had no time to filter the light or the lens. This reproduction was intentionally left uncorrected.

Film types

Tungsten films are balanced for 3,200K (and sometimes, though rarely, 3,400K). Used with 3,200K lamps, everyone should be happy — assuming walls, ceiling, lens, lab, projection lamps, and viewing lights do not introduce a color shift. Tungsten film balanced for 3,200K can be shot in daylight by using an 85 salmon-colored filter to absorb excess blue. An 80A blue filter can be used when you expose daylight film with tungsten sources. One disadvantage of these filters is serious loss of light.

The indoor/outdoor trap

If you think only in terms of "indoor" and "outdoor" films, you may be unpleasantly surprised with your results. It is not the door that should determine your choice of film and filters, but the color of the light. When you illuminate your subject with daylight flooding through a window, your film should be balanced for daylight, not for the "indoors."

If the only light you are using comes from the sky (no direct sun), the Kelvin may exceed 20,000 degrees. In these cases, additional counter-blue measures in the form of warming filters will be called for.

When shooting night exteriors with tungsten (3,200K) sources, don't load the camera with "outdoor" film unless you decide that a salmon-colored look is what you want. Think instead in terms of tungsten and daylight films, tungsten and daylight sources, and any filters needed to transform or finesse these.

Mixing sources

Mixing window light and tungsten in the same scene needs a little planning. The blue window illumination is often so bright that it ends up white in your image. If it retains a blue cast, it usually looks fine and suggests distance and depth. If much of it spills inside, you must decide whether or not you like the effect. In my experience, it generally works better as back light than front light.

Color correcting the windows with large rolls of gel consumes a lot of time and is somewhat expensive. Also, window gels tend to wrinkle if they're not properly attached, creating peculiar reflections in your shot. Adding daylight-blue gels or dichroics to the lights is usually faster, but these will cut your light output by about half.

Still photographers who use electronic flash suffer only minor daylight-balance problems. HMI sources have the advantage of being efficient and cool (more light, less heat) and require little or no filtration to match daylight. These are expensive and require a ballast, but are widely used nonetheless. HMIs have replaced more cumbersome arc lights for many exterior film shoots.

PHOTO: ©1991 RANDY DUCHAINE

Randy Duchaine decided to shoot these subjects using the not-quite-white light of existing overhead fluorescent fixtures. He added a 30 green gel to his bounced flash unit and a 30 magenta filter to his camera lens so that his daylight film and flash were both fluorescent balanced.

PHOTO: AUTHOR

The strong green/blue and weak red/orange "makeup" of most fluorescent tubes either can be a photographic nightmare or blessing, depending upon the effect you are trying to achieve.

139

Lamps and K

The color temperature of lamps varies slightly even when rated at 3,200K. In most situations, plus or minus 50 degrees will not be detectable, even on film. A difference of even 200K can be tolerated in the following situations: when employing back light; when using fixtures that are color-gelled; or when shooting in the higher Kelvin ranges, such as daylight. Videotape is more tolerant than film and transparancies. Try not to mix distinctly different color sources on the same subject if their disparity will be obvious and objectionable.

Unrealistic and super-realistic color

The new pro is, understandably, concerned about achieving accurate color and not allowing the electronics, the film, the lights, the lab, or all of the job pressures to produce a green sky or a blue face. There are occasions, though, when special color effects, including distortion, are desired.

Some, if not all, of the "peculiar" color effects in your scene should be welcome. For example, it would be odd to look at a scene "lit" by candlelight

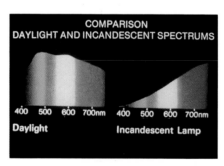
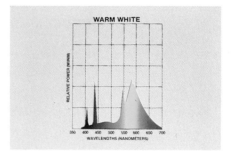
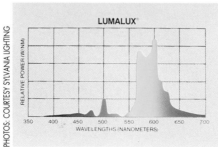
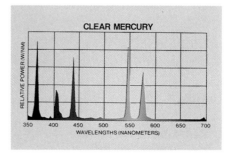

The spectral distributions of light sources vary widely. Typical daylight has a continuous spectrum that is strong in the blue range. Incandescent sources, such as tungsten-halogen, have continuous spectrums dominated by red/yellow. The not-so-smooth spectrum of the fluorescent lamp is relatively green/blue. Unfortunately for industrial and architectural shooting, sources such as sodium and mercury have discontinuous spectrums (serious frequency gaps) that no amount of gel will fix fully.

without there being an overall amber glow. And what is a landscape if haze doesn't add a little blue atmosphere to the distant planes?

When you want to exaggerate or distort color you can do so by filtering the lights, the lens, or both. A lot of creative color manipulation is possible after the shoot as well, but mostly in the realm of overall color shift rather than local-area control.

Be careful when you shoot video to avoid neutralizing special off-color effects at the time you white balance. Use an unfiltered source instead of your filtered lights during the white balance procedure in order to trick the electronics. Then, if you are using automatic white balance, turn it off, along with the unfiltered light, before you shoot.

At the end of the rainbow
Like so many other aspects of lighting, color temperature problems and solutions involve considerations of technique, taste, style, and fashion. To put it another way, if it doesn't have to match or look average, and it isn't ugly, go for it.

For more: *Method Lighting* and *A Difference of Night & Day*.

Color and color temperature terms
See: *Terms of Enlightenment* for definitions and tips.

- Absorption
- Achromatic
- Automatic White Balance
- Chromatic Adaptation
- Color Blind
- Color Conversion
- Color Correction
- Color-Correction Filters
- Color Reference
- Color Temperature Meter
- Color Temperature, Kelvin, K
- Coloring Light
- Color Shift, Color Distortion
- Complementary Colors
- Cool

- Daylight Film
- Dichroic
- Discontinuous Spectrum
- 85 Filter
- Fluorescent Filter
- Gain
- Gel (Gelatin), Media
- Gray Scale
- Haze, Ultraviolet, Sky Light Filters
- Hue
- Lily
- Mired
- Primary Colors, Secondary Colors
- Saturation
- Spectrum
- Warm, Warming Filter
- White Balance
- White Light
- Window Gel

Color Highlights

Some *approximate* color temperatures: fires, candles, and sunrise — 1,900K; household lamps — 2,400-to-2,900K; photographic tungsten lamps — mostly 3,200K; HMI — 5,400-to-5,900K; flash — 5,600-to-6,000K; shade or north sky (minus direct sun) — 9,000-to-25,000K (which accounts for those shady blue faces).

Tom McDonough
Pink light . . . is lush, sweet, forgiving; it fills in the wrinkles. The blue-green end of the spectrum casts a clinical pallor and does grim things to your zits. In the concentration camp sequences of *Sophie's Choice*, Almendros favors the blue side of the spectrum, rendering Streep as close to ghastly as a Madonna can get. *[LY]*

Billy Williams
. . . when I photographed *Women in Love* . . . I deliberately used very warm firelight and candlelight effects, day-for-night that was very blue-green . . . so that you cut from an interior that was absolutely golden to a blue-green exterior in the forest. I think to use color like that makes it much more exciting for an audience. *[ML]*

John Bailey
. . . I don't pay much attention to color temperature at all. In fact I use a lot of gels to alter it. *[ML]*

Anton Wilson
The only way a red object can appear red is if red light is included in the original light source. . . Thus the color balance of the light source will determine, to a large extent, the color of the objects on the film. *[CW]*

141

Choosing & Losing Lighting Kits

Before you rent or buy a lighting kit, there are a few questions you need to answer. And, after you get it, there are a few ways to keep it going.

How many lights do you need?
- Two-to-four lights is typical for small areas, one or two subjects, and most copy work.
- Four-to-six lights for medium-to-large areas.
- Seven or more for very large areas, special setups, or lighting several areas simultaneously.

Do you prefer hard or soft light?
- If in doubt, see: *Hard & Soft Light*.
- Consider a kit that gives you both options.

What about watts?
- The total kit "wattage" does not tell the full story. Some types of lights are more efficient than others, e.g., they'll offer higher foot candle readings or larger area coverage.
- Hard lights offer greater output per watt than soft lights.
- You may want to test the output before choosing.

Which is more important, speed or control?
- For fast action setups where finesse is not practical, choose a kit without the caboodle, i.e., a basic one.
- Where subtlety or dramatic effects are important or where difficult mounting problems exist, more elaborate kits are advisable.

What about size?
- Must it fit in a small car trunk with everything else?
- Should it be airline carry-onable? Airline shippable?
- Remember, as my friend Ben Sobin once said, "Just because it has a handle, doesn't mean it's portable."

One large or two small kits?

- Usually, several small cases are more of a nuisance than one large one.
- When airlines charge by the piece for excess baggage on overseas flights a lot of little cases will cost more than a few large ones. However, some rope and tape, plus a little ingenuity, will lower the charges, often by a few hundred dollars, even as it raises a few behind-the-counter eyebrows.
- There is an advantage to owning two different size-and-assortment kits rather than a single large one. This gives you three options, depending upon the needs of each job: a small kit, a medium-size kit, or both.

Need to balance daylight? Fluorescent light?

- Choose a kit with lots of gel frames and plan to use daylight-correction gel filters; or choose a kit with lights that accept dichroic filters.
- To supplement existing fluorescent illumination, consider using a fluorescent light kit.

Care to customize a kit?

- Some kits have room for additional equipment: umbrellas, flags, clamps, and possibly even another light and stand.

Build your own kit?

Some manufacturers of professional equipment make it easy for you to create a kit to suit your exact needs. Order an empty case and only the equipment you need. Don't buy more than you expect to use right away since supplementing the kit at a later date is easy, whereas carrying useless stuff isn't.

Organize and identify kits

It is surprising how often cases have to be packed and unpacked and moved in and out of airports, motels, station wagons, and locations. Professionals spend a lot of time organizing their equipment into a minimum number of cases while trying to ensure that they don't sacrifice lighting options. Since several cases may appear identical on the outside, you can use marking pens and tape placed where it won't rub off to help find the extension cables (the heavy case), the fixtures (the light case), the clamps (the noisy case), or the expensive lamps (the damaged case).

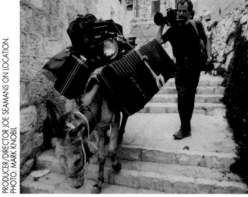

PRODUCER/DIRECTOR JOE SEAMANS ON LOCATION.
PHOTO: MARK KNOBIL

In choosing a kit, one consideration is whether it is likely to be transported by plane, train, auto, or none of the above.

Expensive-looking cases disappear faster and clear customs slower than beat-up cases, regardless of what they have inside.

Don't lose them

One way to spot your cases and luggage quickly on crowded conveyor belts or to help airline personnel locate wayward cases is to add bold stripes with white or colored tape. Avoid expensive-looking cases: these seem to disappear faster and clear customs slower than worn ones — regardless of what they have inside.

Reduce pilfering from cases that look as though they might contain easy-to-sell cameras by running tape around the entire case and latches. Besides discouraging the curious, this will indicate to you if someone has, in fact, looked inside. Any case that arrives significantly later than the others cries out for you to inspect it for missing items. Avoid using locks because keys and combinations are invariably somewhere else when you need them most.

The crucial "extras"

One case should contain distant-location survival gear. Every professional has his own list of essential stuff. The stronger the pro and the more help available, the heavier the package is likely to be. Content examples: basic tools for maintaining equipment (including Phillips-head screwdrivers, Allen wrenches, and Vise-grips); some spare screws, nuts, washers, and knobs (to replace lost, broken, and stripped ones); aluminum foil (to protect surfaces from hot lights, never to wrap operating lights); grounded three-way outlets that plug into heavy-gauge extension cords; a test light and voltage meter; wooden wedges (for leveling props, tables, high hats, etc.); dulling-type spray; white cards (to reflect light or write out cues for the talent); various kinds of tape; and basic makeup (at least face powder) and a razor (for the afternoon whiskers of VIPs). Do not leave home without a few lightweight C-clamps of various sizes to hold all sorts of things together. On exterior shoots, consider using both an umbrella (to protect against hot-sun and wet-rain conditions) and a repellent stick or spray (for protection against bugs and other natural nuisances).

For more: *Hard & Soft Light, Lighting by Numbers,* and *How to Avoid a Large Headache Setting Up a Small Studio.*

Gaffer Gil McDowell explains what happens as he gradually adds stuff to his light kits: "They change from fly-away to drive-away to truck-away kits. Then I need another fly-away. And so it goes."

145

Halogen Lamp, Socket, & Finger Matters

Most modern fixtures without a ballast use tungsten-halogen lamps. These are also known as quartz lamps.

- Tungsten-halogen lamps have a tungsten filament coil set in a regenerative halogen gas atmosphere that prevents premature lamp blackening. It does this by removing the tungsten that otherwise coats the envelope and depositing it back on the filament. As a result, the lamp size is smaller, useful lamp life greater, and color temperature more stable compared to conventional tungsten lamps.
- The color temperature of tungsten-halogen lamps is seldom higher than 3,200K, so they require some correction to match daylight.
- As with all lamp types, rated color temperature is approximate. If color is critical, check each source with a reliable color temperature meter and correct, if necessary, with gels.
- 12- and 30-volt lamp filaments are very compact and generally more rugged than equivalent higher voltage filaments. They are also capable of greater focusing ranges from spot to flood.
- Read lamp and fixture instructions, especially safety warnings. No instructions around? Ask the manufacturer for duplicates.
- Use a protective glass or screen on open-faced fixtures. What one lamp manufacturer has called "non-passive lamp failure" is extremely rare, but if it happens it can involve hot flying glass and filament particles capable of causing serious damage to people and property.
- Line voltage (or battery voltage) should not exceed lamp voltage because: 1) overvolting will shorten lamp life and raise color temperature; and 2) serious overvolting may shatter some lamps, endangering your subject, set, and equanimity.
- Lamps other than low-voltage ones should be internally fused for safety.
- Always unplug a fixture before relamping it to avoid, in case the switch is left on, the nasty odor of scorched fingers.
- Do not touch even a cool lamp envelope with bare hands, and clean with alcohol if touched. Body oil can etch the envelope, shorten lamp life, and cause violent failure.
- Install and remove double-ended lamps very carefully, with one hand at each end, to avoid damaging fragile porcelain tips.

- Operate a fixture in the recommended positions only (see fixture instructions). Using some fixtures upside down, sideways, or aimed straight down can shorten lamp life and possibly damage the fixture.
- Never block a fixture's ventilation with foil or other materials.
- Avoid turning fixtures on and off frequently because current surges shorten lamp life. Try to use a card, not the switch, when "flashing" a light to study its effect on the scene.
- Two-pin lamps must be inserted fully into their sockets to prevent damage to lamps and sockets. This may be the greatest, but most preventable, cause of socket failure.
- Replace sockets if their contacts are loose or pitted, otherwise the life of future lamps used in the socket will be shortened.
- Avoid excessive vibration and fast spot/flood changes when lamps are on.
- "Average" manufacturer's lamp-life ratings mean: 50 percent fail before their rated life, 50 percent fail after their rated life. Actual in-fixture lamp life may be shorter — especially if handled unkindly.
- Not all lamps are created equal. A typically short life of several identical lamps often indicates a defective run. Test a different manufacturer's lamps in the same fixture.
- Reliability of lamps may vary from one manufacturer to another, from one lamp type to another, and, rarely, from run to run. What is one to do? Some fixture makers or professionals may be willing to recommend to you specific makes of lamps which perform well in specific fixtures.
- In situations where it is not practical to interrupt shooting, it may be advisable to install new lamps in all fixtures before shooting.
- You may want to attach a tag to each fixture and record the particular lamp's wattage, voltage, and expended life to avoid some of the problems listed above. This will also make it less likely that you or your helpers will plug 12 or 30 volters into 120v outlets, or 120v lamps into 240v outlets.
- Whenever possible, allow lamps and fixtures to cool before lowering, moving, or wrapping the fixtures. Pros generally wrap and pack cables and accessories while fixtures cool off.

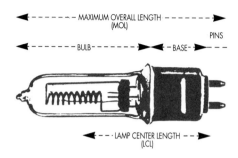

MAXIMUM OVERALL LENGTH (MOL)

PINS

BULB — BASE

LAMP CENTER LENGTH (LCL)

Lamp Definition Highlights
Bulb
- The "glass" part only of a photo Lamp.

Lamp
- Fits into a light and glows white-hot when turned on. Caution: if anyone calls it a Bulb, their *Cinematic License* will be revoked.

Lamp Life
- The number of hours at which half of the test lamps fail. Tip: shock, vibration, frequent on-off cycles, overvolting, power surges, obstructed ventilation, defective lamps, and other such longevity-threats are not factored in.

Also see: *Discharge Lamps, Filament, HMI, MSR, Tungsten,* and *Tungsten Halogen* in *Terms of Enlightenment.*

Surprisingly, the probability of damage to lamps from removal and re-insertion is greater than that from typical travel shock when left in the fixtures.

How to Avoid a Large Headache Setting Up a Small Studio

There is no perfect studio. As in choosing a car, you must decide what is most important: appearance, power, maintenance, or how many bodies and objects you can squeeze in.

Conference spaces

Sometimes the "studio" is only an executive's office or boardroom set up for occasional shooting of speeches and conferences. If the ceiling is low and lights can be more or less permanently mounted, choose small, focusing, 250-to-650 watt fixtures. These can be attached to a dropped ceiling grid with scissor-mounts or to walls by means of special plates. Aim the fixtures to cover a desk or chairs all around a conference table.

If the ceiling is high enough, three additional spots can be tucked into corners of the room to provide a little back light when needed. Diffusion will improve the quality of highlights and shadows. Unless the walls are very dark or distant, lighting them is not necessary, especially if you use those back lights to outline your subjects. If overhead fluorescents are to be left on (make tests both ways) they should be color corrected with appropriate tubes or gels.

There are still some things to do: hide cables, deal with windows and reflections, and silence squeaky chairs — for starters.

Video and film studios

Look for a space with: high ceilings; plenty of power; good acoustics (if you anticipate recording); smooth, level floors (if camera dollies are going to be used); and as many niceties as you can manage. Settle for anything but the basement. Difficult-access, small-door shooting areas invariably attract un-wieldy products, props, and camera dollies.

Still studios

For studios that will be used strictly for still shoots (or film/video insert stages where sound will not be recorded), you do not have to worry about poor interior acoustics or trains, planes, and automobiles, nor, in summer, about the noise of the air conditioner. Also, if you light stills primarily with electronic flash, your power requirements will be lessened, but many photographers end up doing their share of video jobs, too.

Difficult-access, small-door shooting areas invariably attract unwieldy products, props, and camera dollies.

148

Vertical space

The typical space you will be expected to transform into an all-purpose studio is a large office or small storeroom with, gulp, an 8-1/2-foot ceiling. It will be difficult to light even small "tabletop" setups unless they are on the floor because lights and accessories may hang several feet below the ceiling. Even 11-foot rooms will require ingenuity if your subjects stand.

If you expect to light groups of people and products using large, soft sources from above or wide-angle lenses from below, you and your images will suffer without 14 or more feet of vertical space. The longer and wider the shooting area, the higher the ceiling must be to avoid seeing overhead lights or the flare that they produce.

When you have to work with low ceilings, here are a few tricks and realities worth remembering. Remove any dropped ceiling panels. Mount shallow, lightweight broad lights overhead. Aim them at aluminized Mylar attached to non-flammable ceilings. The angle of the reflected light should not be overhead top light but, ideally, low enough to light the subject's eyes. Spill light will be difficult to control.

Because of the low ceiling the people you shoot should be seated and the camera positioned slightly high and angled down — a good point of view for most products, a not-so-good one for most executives.

Noise

If you expect to use the studio for sound sequences as well as for silent inserts, listen carefully at different times of the day when machinery, elevators, lawn mowers, and dogs are most active. Air conditioning vents and fluorescents that can't be turned off independently in your area will be a problem.

Echo-like reverberation requires some acoustic wall materials. For a less expensive fix than this, hang furniture-mover's pads on walls out of camera view and throw a few on the floor near the microphone. When you shoot the chairman-of-the-board in your inelegantly padded set he will recognize that you are not squandering corporate funds on frills.

Grids

Grids are ceiling-hung structures that support lights, cables, connectors, and shadow-casting devices. Normally, they are made of pipes. Special track systems available through some professional dealers enable you to move your lights from left to right and forward or back with little effort.

The grid should cover the entire shooting area. Be sure to provide generous clearance around automatic sprinkler heads. The consequences of extreme heat buildup are guaranteed to dampen everyone's enthusiasm.

Safety

Grids must be solidly secured overhead and tested. Clamps, lights, and other potential widow-makers must be secured to the grid with safety cables. Do not mount lights on sprinkler lines or when anyone is underneath the lights.

Power

You will need places to plug in lights all around the shooting area, high up and low down. Heavy-duty, ground-level switches for all overhead lights are a must. The cost of good, quiet dimming devices may be amortized by reductions in air conditioning costs, lamps expended, and time saved applying makeup to control perspiration.

Windows

It is worth the effort required to block the lustrous light coming through a bank of north-facing windows when it is *not* needed. Windows, on the other hand, can add sound and reverse-angle problems to your shoots.

Limbo

Building a real cyclorama to create visual eternity requires a specialist. Ready-made cycs that can be assembled in your studio are available through some professional photographic dealers. Cycs are expensive and require painting whenever you want to change their color. Seamless paper sweeps are a good alternative.

There are several useful devices that can suspend the rolls of background paper sweeps from the top of the studio, allowing you to crank out a sweep the minute you decide on a suitable shade or color. When in doubt try Thunder Gray. Miniature sweeps and flat tables with translucent tops will provide shadowless product shots when lit from underneath.

Lighting equipment

A very small studio needs only about five carefully chosen fixtures to start off with. Others can be added later. A combination of soft lights (not umbrella lights) and focusing spot lights is probably the best way to outfit both the grid and floor. The spot lights can be open-faced or fresnel-type, depending upon your preference. A maximum of 1,000-to-2,000 watts per fixture is usually sufficient for small studios unless high-speed, heavy-diffusion, slow-emulsion requirements demand more powerful units.

If your equipment budget is limited, you may want to choose some of your lights and light controls based on their ability to travel happily to location in kit configuration.

Other essentials

Barndoors, scrims, snoots, gels of all flavors, a variety of diffusers, and a choice of different wattage lamps for each light are more useful than one more fixture. Do not forget flags and other finessing devices. A boom will save precious time positioning top and back lights precisely, without having stands seriously compromising the sides of the frame.

No studio is complete without a small collection of elevating and leveling contraptions: apple boxes, step-up blocks, and wedges. Sandbags or stand weights will be useful. Lighting and grip equipment catalogs are full of tempting toys. A good strategy is to rent the gear to make sure you need it before you exhaust your budget and shelf space.

Big panels

Wooden or foamcore 4' x 8' panels that can be wheeled about the studio are simple to construct and quite useful. They should be white on one side, black on the other. These baffles can be used to reflect or block quantities of light or to add light or dark edges to reflective subjects.

Product lighting

Your grid makes it simple to hang several soft lights close together to provide a large top-back source that can make even dull products attractive. For smaller objects and setups, turn off one or more of the units.

Rent questionable stuff first to make sure you like and need it before you exhaust your budget and shelf space.

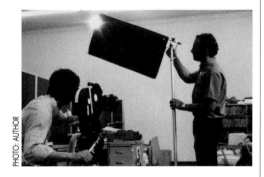

PHOTO: AUTHOR

People lighting

If your grid-mounted lights are too high or difficult to work with, keep some stand-mounted and boom-mounted lights ready to use for fill, accents, and kickers. You can solve the inevitable subject-squinting problem before it arises by projecting light onto the area your subjects will normally face.

The assistant

Adequate storage cabinets, shelves, and wall pegs are important. So is a good assistant who can move mountains, schedules, and lights. Or bring you the aspirin when all else fails.

For more: *On Face Value, Lighting by Numbers,* and *Dynamic Lighting of Static Subjects.*

And now for something a little larger...

E. Carlton Winckler

- The large majority of TV stations have a small corps of skilled engineers (usually unionized, while the remainder of the staff is non-union) who operate all the electronic equipment and set up cameras and audio, but who may not be on hand for the rest of the operation. The balance of the staff, who may be graduates of universities or trade schools, are trained in directing, decor, lighting, makeup, etc. Mixed in are a few handymen or apprentices, often with real talent and imagination. All of these people pitch in and do all of the jobs necessary to put out programming. Much of the time they turn out product of which a major network would be proud.

 Of all the jobs in the above operation, the hardest is doing the lighting, as that seems to have the least factual information and to be subject to the most complaints from engineers.

- I am always surprised at the large number of TV studios that do not have light stands in their inventory. Stands are extremely valuable when you need to add a source quickly — like at one minute to air.

- TV studios, even low-ceiling ones, are normally wired with a raceway running along every other lateral grid bar. Each raceway should contain at least one 50-amp outlet, preferably two, among the normal complement of 20-amp outlets, to permit the use of a 5k fresnel or soft light source. At least the key and fill lights should be mounted on extension hangers for quick adjustment of height for facial-shadow control.

- Dimmers or no dimmers? The answer is an emphatic YES. Whether the system should be the European one-light/one-dimmer or the American one of plugging several lights into one high-wattage dimmer is a matter of taste. I vote for the one-to-one system.

- Most news shows have a weatherman who uses Chroma Key to show his maps and inserts of moving clouds. It is an excellent system of matting. The trouble is the supposed difficulty with the lighting requirements — the belief that the blue or green plate has to be lit very brightly and evenly. For the best results, the light level on the plate never needs to be higher than the key light on the action and is usually best at around half of the key level.

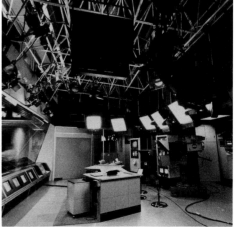

153

6

Hearing the Light

Light Philosophy

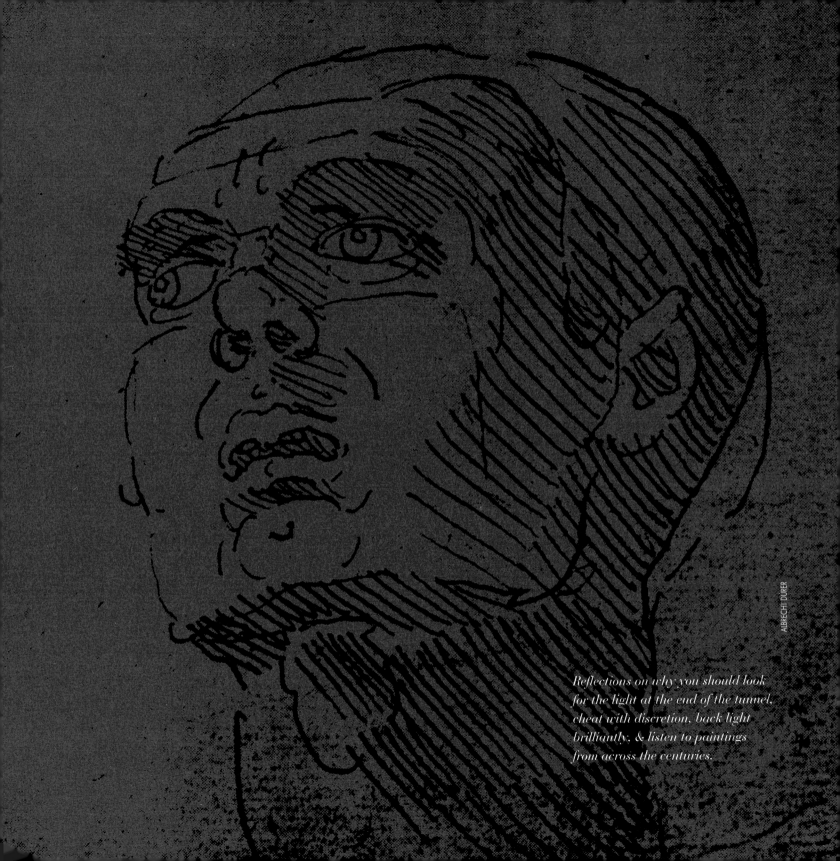

Reflections on why you should look for the light at the end of the tunnel, cheat with discretion, back light brilliantly, & listen to paintings from across the centuries.

ALBRECHT DÜRER

Light at the End of the Tunnel

Paul Beeson
Lighting is really common sense and personal observation. This is applied to a few rules of photography which cannot be broken and to others which I tend to bend a little. *[TL]*

Beginners are characteristically blessed with enthusiasm, optimism, and naivete. Their state of elation and apparent freedom is due, in part, to their ignorance of all the rules and restrictions, in part to a "damn the craft, full speed ahead" attitude. Disasters abound. Despite their ignorance, or perhaps because of it, neophytes occasionally achieve fresh and wondrous images. It is undoubtedly at such moments of accidental success that the amateur decides to turn pro, or at least to study the subject.

There are inspiring teachers who know how to liberate the spark within their students and fan it into a flame able to penetrate the darkness but, alas, they are rare. Afraid of making mistakes and unable to see the bigger picture, the student's work, at best, is bland or imitative and the light at the end of the tunnel remains discouragingly faint.

There comes a time, eventually, when the student has absorbed many of the rules and techniques and has put them into a meaningful perspective. This is the time when the journeyman or journeywoman steps out of the tunnel ready to use the rules when helpful and violate them when necessary.

The student's creative "graduation" is not necessarily an academic graduation. Craft is complex, confidence tenuous, and professional working relationships challenging. Schooling may begin in earnest only with the first job.

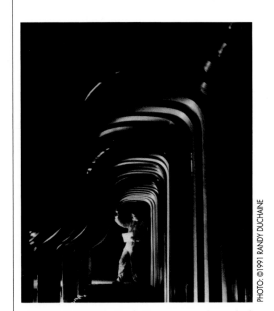

PHOTO: ©1991 RANDY DUCHAINE

Dramatic pictures are only on rare occasions the result of enough luck to compensate for craft ignorance. Far more often, compelling images are the product of an experienced pro consciously violating the rules.

Honest Cheating

"Cheating" has a largely technical significance in the lighting-shooting craft. It involves minor adjustments of the physical world to improve or distort the photographic one. Common examples: raising a table on blocks to bring it closer to an actor's face in order to tighten the composition; asking the subject to look more toward the lens or away from another subject than might seem natural, and moving people and furniture away from walls to reduce shadow-on-background problems and make it easier to use back light.

Pros almost always "cheat the angle" of the main light source in relation to the position of the window or table lamp that is supposed to be providing the illumination. Other not-totally-realistic lighting conventions: brightly lit, keyhole-framed eyes; blue moonlight; studio-lit chrome appliances that glow as if shot under an overcast sky.

What makes most cheating possible is the same thing that makes lighting challenging: absence of real depth. What makes cheating troublesome is the ease with which one can slip into dishonest cheating. It is one thing to elevate a short actor or glamorize an actress. However, doesn't one cross an ethical line when one misrepresents a product or politician through image manipulation? Nowhere on a cinematic license does it say: "If you don't, someone else will."

Tom McDonough
What movies mainly do is warp the shape and time of things in the world. Since they do this in a way that we regard as realistic — photo-representationally, narratively — we are soothed by the distortion. . . . Cinematography, the actual making of moving images, is the basic tool of this magic. [LY]

In Praise of Back Light

Striking ski films and beautiful nature photography have something in common: in both, the sun is usually behind the subject, not the camera. Such back light is ideal for flying snow, furry fauna, and soaring birds. It also performs minor miracles on fog, mist, steam, rain, and blond hair. For ages it has been the light of choice for mysterious, supernatural, and romantic images.

Inside dream palaces all over the world, the once ubiquitous Hollywood back light turned screen sinners into saints, and aging sirens into ingenues. It also played a major role in preventing subjects from disappearing into backgrounds at a time when photographic reality existed only in shades of gray — often the same shades.

A lot has changed since Hollywood's hallowed and haloed heyday. For one thing, we now have better separation of planes as a result of the invention of color film. For another, a sophisticated audience has emerged that is easily put off by artificiality.

For a time, the favorite still and TV commercial look was the single-source, semi-side light. Photographers felt back light was incompatible with this look. Now, this is just one of the many ways used to reveal subjects. Ceiling-bounce illumination, which dominated feature lighting for a while, has lost much of its popularity. Other kinds of "honest" lighting have come and, temporarily at least, gone.

Currently, old Hollywood-style hard lighting, including nostalgic doses of back light, is in fashion with some still pros. Ironically, many cinematographers bounce light off large panels to achieve a window-like source that is even softer than the one still photographers favored. Back light, no less than hemlines, can be subject to the whims of fashion.

Regardless of whether back light is in or out of fashion, don't use it — or reject it — automatically. Always consider whether this inherently dramatic resource is appropriate for a particular set or mood and is likely to reveal the subject compellingly. If you do use it, be warned: the stuff can be highly addictive.

PHOTO: AUTHOR

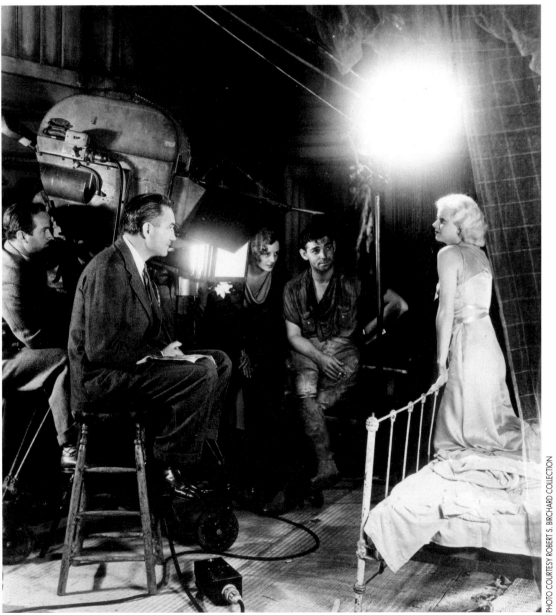

The back light for this still was a key light for the movie camera. The low-angle fill was as close to the lens as a source can be. Counterclockwise: Jean Harlow, Clark Gable, Mary Astor, director of photography Harold Rosson (ASC), and director Victor Fleming shooting MGM's *Red Dust* (1932).

159

Lighting with Paint

The craft to which this book is dedicated is sometimes referred to as "painting with light," a phrase that resounds with equal amounts of poetic allusion and harmless delusion. The phrases "painting with light" and "sculpting with light" both suggest the gratuitous glorification of a craft that does not need a Fine Art analogy to refine it. At its best it is already an elevated craft, a scientific art, an artful science, a demanding technology, a big business, a lighthearted romp, and an ongoing experiment in magic. In another sense, though, the phrase is significant.

While each of the arts draws inspiration from the others, perhaps none is hungrier for creative infusions than photography, especially cinematography. The influence of literature, drama, music, dance, and the graphic arts upon motion pictures and other photographic arts is difficult to overestimate. I am also intrigued with the many overlapping artistic concerns shared by filmmaking and architecture.

Historically as well as in the present, film is indebted to the graphic arts in several ways. Feature films sometimes evoke the aura of an era through the images and style of a Classic painter. The success of the transformation from one medium to another depends, in part, upon respectful allusion rather than slavish imitation. The various visual elements such as wardrobe, props, composition, color, and lighting can help to transport the audience back to another time. Even if references to painters of the past elude much of the audience, no harm is done; the set designer and other film collaborators undoubtedly had some fun.

There is, however, a more significant way in which the filmmaker, videographer, and photographer of today can benefit from artists of all ages. Museums, galleries, and art books enable the new pro to explore the diverse ways artists have portrayed the world and its inhabitants. Painters deal with many of the same challenges you do, or you will: how light reveals form and texture; how it relates to color, composition, and mood; and how it can help to compensate for the loss of one out of three dimensions.

Phrases like "painting, sculpting, and writing with light," serve to remind the new pro that photographic lighting and composition need all of the other arts to keep them fresh.

Most Classic paintings are lit from the viewer's left, I believe, at least in part because right-handed artists preferred to work with light that would not shadow their brush strokes. Photographers who have looked at a lot of art may find keying from the left slightly more natural than from the right.

161

Masters of light and depth

Johannes Vermeer's voluptuously soft side light, rich detail, and strong, dark foreground figure transform this simple scene into a compelling one, even when reproduced in black-and-white. The following is a short list of other artists whose sensibilities may help your own work. Some can be studied in this book, others in museums and art books:

Caravaggio
Robert Campin
Pieter Claesz and Willem Claesz
Jacques Louis David
Edgar Degas
Gerrit Dou
Albrecht Dürer
Thomas Eakins
M.C. Escher
Orazio Gentileschi
Edward Hopper
J.A.D. Ingres
Rembrandt van Rijn
Titian
George de La Tour
Joseph Turner

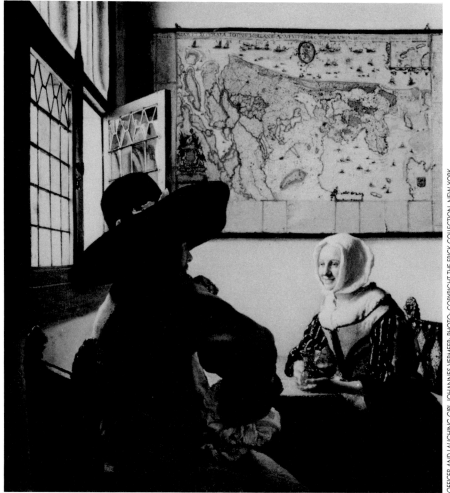

OFFICER AND LAUGHING GIRL, JOHANNES VERMEER; PHOTO: COPYRIGHT THE FRICK COLLECTION, NEW YORK

Reflections on Reflections

The late, great photographer Ernst Haas once cautioned his students: "Beware of reflections, they can make you too quickly a genius."

The magical way reflections enrich images has been exploited by artists — geniuses or not — throughout the ages. Whether the reflection is the essential theme of the picture or only a small accent in a large frame, it is likely to dominate the image and steal the scene.

The most graceful reflections are attached to whatever created them. But the most fascinating ones are separated from their mates and often fragmented or distorted.

There is a far more common type of reflection. Just as every subject is defined by the nature of every light that strikes it, every light is defined by the way in which it is reflected by a subject. This symbiosis is at the heart of the lighting craft.

DETAIL OF THREE SPHERES II; © 1946 M.C. ESCHER/CORDON ART, BAARN, HOLLAND

Escher's mirror sphere not only reflects his studio, himself, and two other spheres, it also reflects his fascination with light and reflections.

163

The way a candle flame flickers in a girl's eyes, window light glows on a vase, or sunlight dances on water can be both revealing and rewarding. Water kicks back sunlight quite differently depending on whether its surface is calm, wind-whipped, or radiating concentric ripples from a fallen twig.

A girl's moist eyes not only reflect light differently than dry ones, they also reflect her feelings of sadness or joy. Some actors blink a lot just before a take in order to enhance their "performance." Whether or not it works may depend upon the eye light's highlights.

Still water and flat, polished metal mirror the original image as though it were an identical twin. Matte planes eat up incident light; they also mute and scatter it. Concave, convex, and colored surfaces alter the flavor of each source that plays upon them.

Reflections are a good test of a painter's skills as well as his attitude about "truth in lighting." For the photographer, reflections are an inevitable and sometimes unwelcome byproduct of his lighting efforts. He can, however, exert great control over the nature of his reflections through the use of such tools as diffusion and polarizing filters.

Reflections of all sorts are a vital part of images of all sizes in which artists of all media try to capture or transform their surroundings.

M.C. Escher's apparent fantasy is actually a precise revelation of an important optical principle: whether or not you see what's beneath the surface of the water, floating on the surface, or reflected off of the surface depends upon your angle of view. Water, as is the case with clear glass, becomes an efficient mirror as your viewing angle decreases. Several of Escher's other studies may also be valuable assets for your bank of visual resources.

Silk, satin, and suede reflect light differently than does jewelry, and not at all like hair, eyes, and skin. How skin reflects light depends upon the source's size, distance, and hard/soft quality. It also depends upon matters of makeup, perspiration, and passion, "details" the sensitive image-maker doesn't ignore. Whether he mutes them or accentuates them is another matter.

PORTRAIT OF PRINCESSE DE BROGLIE, J.A.D. INGRES; ©1980 BY THE METROPOLITAN MUSEUM OF ART, ROBERT LEHMAN COLLECTION, 1975

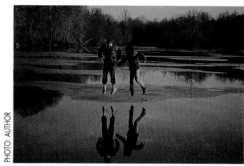

PHOTO: AUTHOR

The symmetry supplied by connected or almost connected reflections can enrich an otherwise ordinary image.

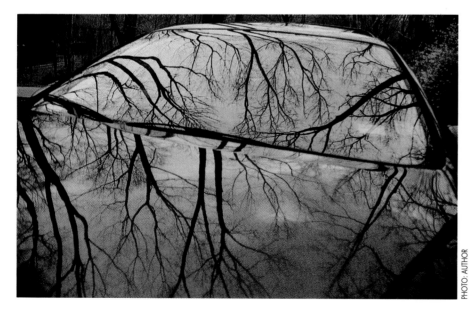

PHOTO: AUTHOR

The human eye and brain are constantly engaged in unconscious detective work to resolve visual mysteries. One clue to this "abstract" snapshot is the clear versus fuzzy reflections from the two different reflecting materials. The other clue is the subject's contours, which are made more understandable by the distortions of the reflected objects.

167

This sensous yet subtle study by a follower of David is full of mysteries: Why is the window pane broken? What is the lady sketching on the pad — an ingenious prop that serves to caress her face with well-motivated, low-angle, reflected sunlight? And why don't we know who painted it? The creator's anonymity and sensitivity to subject, mood, setting, composition, and light provide "proof" that differences in tools and techniques among the various visual arts and artists matter less than the creative forces that ultimately unite them.

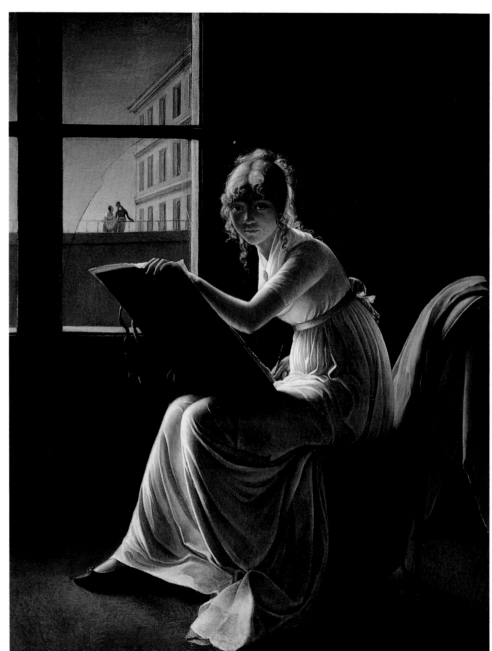

MADEMOISELLE CHARLOTTE DU VAL D'OGNES; ©1981 BY THE METROPOLITAN MUSEUM OF ART, BEQUEST OF ISAAC D. FLETCHER, 1917. MR. AND MRS. ISAAC D. FLETCHER COLLECTION

Hearing the Light

Sometimes you are so busy battling the demons of obscurity, bureaucracy, and technology that you have little energy left for creativity. As artists and craftspeople, you need time to become sensitive to your subjects and to hear your own inner voice.

Mohammed (with whom I studied stone wall construction) counseled his students to listen patiently to the rocks in the pile until they told us where they wanted to be placed. More than one renowned sculptor has suggested that within every marble block lies a hidden form willing to whisper to the sensitive artist/midwife how it should be born.

Whether inspiration comes from your subjects or from your unconscious, its arrival is more likely if you are prepared. Preparation includes understanding how light "works" and having resourceful helpers, reliable tools, thorough plans, and enough confidence to take advantage of the fortuitous. Then, just before you light and compose, you need to steal some quiet moments in order to discover where the subject wants to be placed, how it wishes to be born, how it must come to light.

Whether you shoot architectural models or fashion models, temples or teapots, those few moments of communion with your subject can also make you more sensitive to the potential poetry and power of your medium. They can prepare you to recognize those all-too-rare moments when a scene or a subject is so eloquent that you are deeply moved, even as you work to capture it. This is the moment that makes it all worthwhile, especially if the scene's magic survives the many transformations your image will be subjected to before viewers can share it.

PHOTO: AUTHOR

Effective images and sequences depend upon preparation, skill, and a little sensitivity to the subject. This scene is from an interview I filmed of Nehru shortly before his death.

Ezra Stoller
One's antennae must always be out for that unanticipated image which can end up being the freshest and most explicit of all. But to leave the whole thing to chance means disaster . . . *[LN]*

7

Lights-On Lessons & Resources

*Exercises for the eye & a guide to
selected publications & videotapes.*

Lights-On Lessons

Lighting exercises for beginners

Exercise #1

Objectives: To learn the crucial craft of lighting planes; the use of dominance in lighting; the subtle but important effects of diffusion, source size, and distance upon highlights and shadows. Note: black-and-white film is preferable to color for this one.

One of the best ways to develop your lighting skills if you are a student or beginner is through calisthenics: exercises that are meant to build not the muscles of your body but the sensitivity of your eye.

Purpose

Try some of these hands-on, lights-on explorations, preferably ones that deal with those techniques with which you are least familiar. Preserve them on film, either still or movie, or on videotape. The more notes you make about exactly what you have done, the more helpful the project will be to you. Number the notes and record the numbers with a card or slate that is included in each shot (unless you use Polaroid film, in which case simply clip your notes onto each picture.) Use a gray-scale card. Take your time. Explore some of the nearly infinite variables.

Lighting tools needed

One soft light; two focusing hard lights; one broad light; three or four stands; one small boom; and several small flags or black cards. Also: diffusing gels; color gels; shadowing strips; one small reflector; one or two large white cards; and clamps to hold the cards on stands.

Camera tools needed

Camera; tripod; matte box or sun-shade; polarizing filter; and, for Exercise #4B, black-and-white filters.

Exercise #1

Exercise: Place a wooden or cardboard box that you can get from a liquor store onto a piece of seamless paper or onto the floor. Orient it and your camera so that your lens sees its top and two of its sides. For this exercise, the front plane should appear to be the largest area, the top the next largest, and the side plane the smallest. Use only one broad or hard light, positioned about 5 feet from the box. Ask your helper or fellow student to move the light until each plane of the box has a different level of brightness as determined by your eye or a spot meter. *Variations:* If you have positioned the light near the camera lens, repeat the exercise placing the light above and to the side of the box. This time, use diffusion material in front of the light, first close to it, then about 16 inches away from it, and then again about 3 feet away. Be sure to compensate

for the light that will be absorbed by the diffusion material and scattered throughout the room as you move the fixture farther from the subject. Finally, move the light as well as the diffusion closer and farther away from the subject to see the varying effects this will have. *Suggestion:* If you made the front of the box brightest, try to make it darker than the other two planes. See: *Lighting Planes.*

Exercise #2

Exercise: Find a subject who likes the limelight enough to sit on a stool for an indefinite period of time. Light him with a large, soft source mounted on a stand, ideally one with casters. Get a helper to raise, lower, and wheel the light about. Position it at many different angles: above, below, and to the side of the subject; near the lens; and so on. *Limitations:* Do not put the light behind the subject for this exercise. Use no other lights, not even for fill. Keep the background simple. *Suggestions:* Let a little light spill on the background to create separation if needed. Change poses and possibly wardrobe to suit the lighting. See: *The One-Light Approach.*

Exercise #2A

Exercise: Continue one of the setups from Exercise #2 in which the light is positioned approximately 45 degrees to the side of or above the subject. This time substitute a hard light.

Exercise #2B

Exercise: Continue using the setup from Exercise #2A. Shoot a series of new shots using varying amounts of fill light to control contrast and add detail to the dark side of the face and body. Maximum lighting ratio should be 32:1, the minimum, 2:1. See *Lighting Ratio* in *Terms of Enlightenment. Limitations:* The fill light must be a soft source or a large well-diffused broad to avoid additional shadows. Place the source close to the lens for this exercise.

Exercise #2C

Exercise: Continue using that pose and lighting setup from Exercise #2B that had a ratio of about 8:1. Keep the same ratio, but move the fill farther and farther away from the subject/lens axis until it becomes a kicker, an angle that would be considered well beyond that of side light. *Variations:* Substitute a small reflector and, later, a large white card, for your fill light. *Suggestions:* If

Exercise #2
Objectives: To grasp how effective one well-placed light can be; to prove how different the look is when the light or subject's head angle is moved only a few degrees.

Exercise #2A
Objective: To compare the look of hard light versus soft light.

Exercise #2B
Objectives: To deal with fill and contrast control.

Exercise #2C
Objectives: To become aware of how the position and nature of fill affect the overall look of your lighting.

Exercise #3

Objectives: To discover ways to exploit glare light and ways to tame it.

Exercise #4

Objectives: To begin to discover how good food lighting differs from good people lighting; how the light/subject angle affects mood, modeling, texture, glare, and just about everything else.

you find the spill from the key light inadequate, add a little direct light to your reflecting surface.

Exercise #3

Exercise: Place a semi-reflective appliance, such as a plastic-bodied vacuum cleaner along with its hose and attachments, on a fairly dark carpet. Before you do any serious lighting, compose the shot through a camera aimed down at about 45 degrees. Recompose, if necessary, after lighting. Use a fairly large soft source positioned above and behind the subject to generate what would be considered something between back light and top light. While you look through the lens, have someone move the light slowly until it separates the various top surfaces from the dark carpet. If some of the objects are too dark or too light, have your helper angle them for more or less glare (use pieces of wooden clothespins or whatever works best to prop them up) until they glow irresistibly. *Suggestions:* The recorded image will have more contrast than your eyes see, so don't overdo the glare. Use the subject's shadows to help achieve separation and dimension. *Variations:* Add diffusion to soften the glare. Move the light or change its elevation slightly, until only the edge of the glare is reflected on part of the appliance. Add some soft fill light. Add a polarizing filter to the lens and rotate it until the glare is optimal.

Exercise #4

Exercise: Place a bowl overflowing with luscious-looking and colorful pears, peaches, apples, and other fruit, of both dull and shiny varieties, on top of an attractive, not-too-bright, textured piece of material. Add a plate, knife, and fruit peels. Aim the camera down slightly onto the bowl, using either a small soft light or well-diffused broad to light the setup. Mount your fixture onto a short boom or extension so that you can position the light over the bowl. Have your helper swing the light source horizontally and vertically to assume various lighting angles and positions. Alternative subject: Compose some red, yellow, blue, and green shoelaces or socks next to an old pair of boots. *Limitations:* If you need fill light, use only white cards. *Suggestion:* Try back-top light and side light positions, among others.

Exercise #4A

Exercise: Continue one of the setups from Exercise #4 and explore the effects of color changes by trying any of the following: use a gold reflector or card for fill or side kicks; change the color of the background to render it both more and less subtle; use colored gel in front of the key light. *Suggestion:* For video, don't let color-altered light hit the white card while you white balance.

Exercise #4B

Exercise: Continue one of the setups from Exercise #4 and, alternately, place a red, yellow, and green glass filter or Kodak gelatin camera filter over the lens. *Note:* Black-and-white film is necessary for this exercise. *Suggestion:* Unless you are metering through the lens, be sure to compensate for the light you will lose as a result of the filtering media.

Exercise #4C

Exercise: Continue one of the setups from Exercise #4. Position rigid strips of opaque, *non-flammable* material in front of the light to block areas around the subject which are either too light or are near the corners or edges of the frame. These strips can be straight or curved, wide or narrow, single or multiple. See: *Finessing. Suggestion:* Vary the distance between the shadow devices and your light and notice what happens to the shadows.

Exercise #5

Exercise: Create different lighting setups for: 1) a transparent bottle next to a glass full of white wine or cranberry juice; 2) a translucent (frosted) object; and 3) an opaque object. See: *Formula Follows Function. Note:* If, after you have completed this exercise, you still have some wine, a lot of time, and a high threshold for frustration, try lighting all three subjects simultaneously.

Exercise #6

Exercise: Choose an object of any sort which has an unusual shape and place it in front of a simple background or seamless sweep. Using a hard light, project an interesting or dramatic shadow of the subject onto the background or foreground surface. *Suggestion:* Before you settle for second-best, try a lot of angles, including back light. *Limitations:* Use no other lights. Small reflectors or mirrors can be used, however, to create edge separation or accents.

Exercise #4A
Objectives: To explore some ways to distort color and to see if you like the results.

Exercise #4B
Objectives: To see how filters affect the black-and-white rendition of various colors (a craft that is practiced nowadays almost as widely as thatched roofing) and to realize that "lighting" is influenced by more than "mere" light and shadows.

Exercise #4C
Objective: To finesse and enrich your images with carefully placed shadows.

Exercise #5
Objectives: To explore the different approaches necessary when lighting transparent, translucent, and opaque subjects.

Exercise #6
Objectives: To investigate the power of shadows.

Exercise #7

Objectives: To reduce the number of lights that need to be set up, plugged in, and wrapped up; to minimize conflicting sources.

Exercise #8

Objectives: To begin to come to terms with one of the most difficult aspects of video and motion picture lighting: movement; to experiment with motivated lighting.

Exercise #9

Objectives: To become familiar with techniques for controlling hot spots, glare, and excessive contrast; to recognize that the selection of backgrounds is within the realm of lighting.

Exercise #10

Objectives: To compare the look of soft light with bounce light; to compare the effect of various bounce light directions on the subject.

Exercise #7

Exercise: Light two people facing each other (as in an interview situation), using only two hard lights and one or two large, soft reflectors or cards as fill or kickers. *Suggestion:* Try to make each light do two jobs. See: *Two-Light Techniques.*

Exercise #8

Exercise: Light someone who is sitting in a chair. Allow him to stand up, walk across the room, stand in a doorway, and then return to the chair. If you are not happy with the lighting, re-light, but don't strive for even illumination all around the room. Next, have your subject remain seated while you dolly or walk the video or film camera around his chair. Is the lighting still effective during this 360-degree move? What do you need to change? For a third variation, ask your subject to remain in the chair and to hold a flashlight in his hand. Ask him to look anxious. The only light in the room should fall on him. Allow the subject to switch on the flashlight and explore the darkness. Have him illuminate walls and furniture with the flashlight beam. Try this using both a static camera and also one that pans with the circle of light. See: *Method Lighting.*

Exercise #9

Exercise: Pose a man with a bald head, eyeglasses, and a white shirt against a black background. Position a hard light so that it is not reflected in his glasses but still lights his eyes. See: *De-lighting eyeglasses* in *On Face Value.* *Suggestions:* A bald head and white shirt call for a few devices to shade or shadow such areas. Try flags, nets, fingers, or strips positioned between the light and the offending areas. Since bald heads and back light don't mix well, separation from the black background may need to be done in some other way, such as with a kicker.

Exercise #10

Exercise: Continue (or repeat) one of the above setups that involve the use of a soft light. Using several broad or hard lights in place of the soft light, hang a large sheet of diffusion material, such as a piece of frosted gel or a shower curtain (see: *Terms of Enlightenment*) in front of your lights. Be sure not to place the lights too close to the diffuser or to spot the lights excessively. Strike

this setup and then bounce one or two of the broads or hard lights off the ceiling (if the ceiling is not white, carefully attach non-flammable white cards to the ceiling). Next, aim the lights at a white wall or its equivalent. For yet another alternative, bounce the lights off a juncture of two walls and a ceiling. You may wish to compare the lighting when the units are bounced at full spot and full flood. If the units do not focus, move them closer and farther away from the wall or ceiling.

Exercise #11

Exercise: Light an open book or newspaper with a hard source and some professional or homemade non-flammable shadowing devices clipped to a stand. Call attention to a paragraph or area by darkening all else, particularly the brighter outer margins. If the shadows are too dark, add a little fill light. *Tip:* If shooting film or videotape, have someone turn a page slowly after adding a little edge light to the hand, but not to the book.

Exercise #11
Objectives: To explore ways to dramatize a bland subject through shadowing.

Exercise #12

Exercise: Shoot a friend outdoors when the sun is overhead. Repeat in the open shade and, once again, in heavy shade. Pick a particularly flat and dull shade, such as under dense tree cover. Add some subtle side or kicker light to the subject with a reflector or light. Shoot once more in mid-afternoon with front and back light, both with and without fill. Repeat during pre-sunset and, again, at early and late dusk. See: *Superior Exterior Lighting.*

Exercise #12
Objectives: To become attuned to the rich variations in "plain" daylight and some of the ways to control it.

Wrap-up

In addition to these basic exercises, many others will suggest themselves as you peruse the pages of this book or think about the rich realm of lighting options open to you. Part of the value of such exercises lies in the doing. Another part depends upon how well you can analyze your results. For this, a professor, fellow students, or a lighting pro could prove invaluable.

The ultimate objective, as with any profession or sport, is to make the foundations of your understanding so intuitive, so solid, that your mind will be free to concentrate on the creative aspects of your craft.

Lights-off exercises
Examine some of the photos and paintings in this book and decide: 1) how many sources have been used; 2) where they are coming from; and 3) whether they are hard or soft sources. Suggestion: Analyze both the direction and quality of the shadows as well as the highlights.

Helpful books, videotapes, & periodicals on lighting

A † indicates that excerpts from the publication appear in this volume.

† *Adventures in Location Lighting*, Jon Falk
A thorough and thoroughly practical exploration of electronic flash techniques, equipment, and resources, with lots of valuable tips and opinions. The spiral-bound volume supplements Falk's popular lighting seminars. Jon Falk, Westmont, NJ.

† *A Man With a Camera*, Nestor Almendros
The Academy Award-winning cinematographer offers an excellent mix of philosophy, history, and theory about lighting and shooting features and documentaries. Farrar, Straus & Giroux, New York, NY.

American Cinematographer
This venerable periodical explores film lighting techniques, among many other topics. American Society of Cinematographers, Hollywood, CA.

***American Cinematographer Video Manual*, Frank Beacham**
A handy, portable manual covering a range of topics on video production. Does for TV and video craftspeople what the *American Cinematographer Manual* has done for film folks for years. ASC Press, Hollywood, CA.

***The Art of Using Filters*, Harry Mathias**
This 45-minute video also includes a book. First Light Productions, Los Angeles, CA.

† *Cinema Workshop, Fourth Edition*, Anton Wilson
The author demystifies technical topics such as lenses, formats, light, batteries, and video cameras. He does so in a lucid and frequently amusing way. ASC Press, Hollywood, CA.

***Cinematography*, Kris Malkiewicz**
Almost everything you ever wanted to know about film production, including an excellent section on lighting. Deservedly, a standard text in film schools. Prentice-Hall Press/A Division of Simon & Schuster, New York, NY.

***The Complete Film Dictionary*, Ira Konigsberg**
An exhaustive collection of definitions of film terms with mini-essays on film history and aesthetics. The New American Library/A Division of Penguin USA, New York, NY.

Controlling the Image,
Harry Mathias
The 45-minute video also includes
a book. First Light Productions,
Los Angeles, CA.

† *Electronic Cinematography:*
Achieving Photographic Control Over
the Electronic Image,
Harry Mathias and Richard Patterson
This impressive work introduces cine-
matic techniques to video production
and delves into many electronic
mysteries, such as waveform monitors.
Wadsworth Publishing Company,
Belmont, CA.

† *Film Lighting: Talks With Holly-*
wood Cinematographers and Gaffers,
Kris Malkiewicz
A series of interviews with some of
the best feature and commercial film
lighting folk in the business. The
author also explores specific lighting
techniques and equipment. Prentice-
Hall Press/A Division of Simon &
Schuster, New York, NY.

G.T.E. Sylvania Lighting Handbook
Solid technical stuff: lamps, sockets,
charts, formulas, and a glossary of
terms with a heavy tilt toward stage
and concert disciplines. Sylvania
Lighting, Danvers, MA.

Light: Working With Available
and Photographic Lighting,
Michael Freeman
A well-organized, well-written, and
well-illustrated book aimed primarily
at the still photographer.
Amphoto/Watson-Guptill Publishing,
New York, NY.

Light and Color in Nature and Art,
Samuel J. Williamson and
Herman Z. Cummins
Serious investigation of the technical
and scientific fundamentals of light
and color. John Wiley & Sons, Inc.,
New York, NY.

Light and Film
A beautifully illustrated semi-classic
on the physics and optics of light
and the techniques and aesthetics
of lighting. Here "Film" does not refer
to motion pictures. Time-Life Books,
Alexandria, VA.

The Light on Her Face,
Joseph Walker (ASC)
and Juanita Walker
The story of a distinguished
Hollywood cinematographer.
ASC Press, Hollywood, CA.

Lighting for Television,
James DuBois
Some basic theory and technique with
no-nonsense illustrations. CDT Pub-
lications, San Juan Capistrano, CA.

Lighting for Location Motion
Pictures, **Alan J. Ritsko**
A thorough, practical, and excellently
illustrated investigation of the subject
by a filmmaker willing to share his
secrets. Topics include rigging and
electrical distribution on-location.
Van Nostrand Reinhold Company,
New York, NY.

Lighting for Photography,
Walter Nurnberg
This oft-reprinted 1940 classic has
a lot to offer neophyte still photo-
graphers, though some of it may seem
dated. Focal Press, Stoneham, MA.

***Lighting in the Real World,*
Dick Reizner**
This 65-minute video is also available in three shorter versions. Rosco Laboratories, Port Chester, NY.

Lighting Dimensions
A periodical that covers a wide range of lighting disciplines including film, television, and still photography. New York, NY.

LightNews
An Occasional, Casual, Compendium of Illuminating Ideas, Timely Tips, Pertinent Propaganda, and Advice to the Lightlorn. Lowel-Light Mfg., Inc., Brooklyn, NY.

***Lighting Techniques for Video Production: The Art of Casting Shadows,* Tom LeTourneau**
This volume is directed toward beginners and intermediate practitioners by a man who has written extensively on the subject. Knowledge Industry Publications, Inc., White Plains, NY.

**† *Light Years: Confessions of a Cinematographer,*
Tom McDonough**
Not a treatise on lighting, but a candid and insightful look at feature and documentary production. Includes tributes to the likes of Gordon Willis, Vittorio Storaro, Nestor Almendros, and Billy Bitzer. This salty volume by a first-class writer is peppered with revealing and amusing escapades, both professional and personal. Grove Weidenfeld, New York, NY.

***The Location Photographer's Handbook,* Ken Haas**
While aimed at the not-so-immobile still photographer, most of the book's thorough exploration of the physical, psychological, political, meteorological, economic, geographic, and medical aspects of shooting overseas also apply to video and film work. Van Nostrand Reinhold, New York, NY.

***Making Movies from Script to Screen,*
Lee R. Bobker**
A wide-ranging volume on film craft and business. The section on barn-doors versus gobo shadow quality should be taken with a grain of salt. Harcourt Brace Jovanovich, Orlando, FL.

**† *Masters of Light: Conversations with Contemporary Cinematographers,* Dennis Schaefer
and Larry Salvato**
Many of the top feature film cameramen answer the author's questions with an insider's insights on light. University of California Press, Berkeley, CA.

***Motion Picture Camera and Lighting Equipment,* David W. Samuelson**
An extremely useful, equipment-oriented look at lighting technology by one who has rented, sold, and used it. Focal Press, Stoneham, MA.

***On Location Lighting,*
Ralph Metzner**
This 38-minute video covers the basics of lighting techniques. Video Craft Corp., Knowledge Industry Publications Inc., White Plains, NY.

Photo District News
This still photographer's large-format periodical combines technical, aesthetic, and commercial considerations. There are frequent investigations of both flash and "hot-light" subjects. New York, NY.

Photography,
Barbara Upton and John Upton
A handsome distillation from the Life
Library of Photography series which
explores everything from aperture
to the zone system. Little, Brown and
Company, Boston, MA.

The Photographer's Studio Manual,
Michael Freeman.
The techniques and strategies of
shooting stills in fixed and "portable"
studios. Amphoto/Watson-Guptill
Publications, New York, NY.

Professional Lighting Handbook,
Carlson & Carlson
An excellent reference manual full of
valuable information, such as the use
of sperm oil to prevent oxidation of
lamp and socket bases. And don't miss
David Quaid's Foreword. Focal Press,
Stoneham, MA.

*Sight, Sound, Motion/Applied Media
Aesthetics,* **Herbert Zettl**
An analysis of the underpinnings of
film and television that generates some
refreshing light and expressive shadows
. . . and a little smoke. Splendidly illus-
trated and indexed with a bibliography
of serious reading. Wadsworth
Publishing Company, Belmont, CA.

*The Technique of Lighting for
Television and Motion Pictures,*
Gerald Millerson
A comprehensive, well-organized,
and well-illustrated investigation
of lighting technique and theory.
The beginner's Lighting Bible.
Focal Press, Stoneham, MA.

*The Technique of Television
Production,* **Gerald Millerson**
Basics on lighting and many other
aspects of video. Focal Press,
Stoneham, MA.

*The Work of the Motion Picture
Cameraman,* **Freddie Young
and Paul Petzold**
Focal Press, Stoneham, MA.

8

Terms of Enlightenment

Glossary

A glorified glossary of lighting lingo with pertinent tips & impertinent opinions to enlighten the novice & entertain the enlightened.

Terms of En.light'.en. ment

The unexpurgated version

Introduction

This Glossary focuses on the tools, techniques, and theories of lighting in the worlds of video, film, and stills. Most theatrical, scientific, and optical engineering references are glaringly absent, as are most formulas and product names.

Definitions favor the practical aspects of the craft. Entries like Back Light Phobia* and Lighter's Block* I have shamelessly coined to help illuminate a common dilemma or nameless phenomenon. The freewheeling tips, quips, and opinions are meant to open eyes and minds and to enlighten a complex subject. Despite this lexicon's length, many a pro's and region's favorite phrases will be missing or "misdefined." That's light.

Words in Initial Caps can be found as separate entries elsewhere in the Glossary. The source of a quote, such as (*FL*), can be found in *Symbols & Abbreviations* at the beginning of this book.

Sample entry:

Tyranny of Terms*
The tendency of terms to turn into dogma. New pros needn't feel compelled to use "Base Light" or "Back Light," for example, unless they really need them. *Tip:* It matters less what a tool or technique is called than whether it performs the job efficiently and that you know how to use it effectively. However, as Gill McDowell points out, coming to terms with the jargon makes intracraft communication easier.

Absorption of Light
The fate of non-Reflected, non-Scattered light. The reason why black suits are difficult to light (and hot to wear) is that they absorb most of the light and convert it into heat. Surfaces that absorb only parts of the Spectrum appear pink, purple, green, or some other color.

Accent Light
Any Source from almost any direction which is used in addition to more basic lights to call attention to an object or area — not the Lighting.

Achromatic
A subject, scene, or Image without color.

Aims of Lighting
To enhance mood, atmosphere, and drama; to illuminate the story; to separate planes; to suggest depth; to direct attention; to reveal character; to convey time of day; to enrich and, occasionally, bedazzle. *Minimum aim:* to stimulate microchips and silver halides.

Ambient Light
The general (and often undesirable) Illumination surrounding the shooting or projection area; not exactly the same as Available Light or Natural Light. *Tip:* use the term to ward off meddling clients, as in "I can't light it your way because of the ambient light." They are likely to nod sagely.

Amp Calculations
Formula: Amps = watts ÷ volts. *Tip:* When the no-nonsense electrician asks: "How many amps will you need at 120 volts?" just divide the maximum watts you expect to use by 100 (it has a built-in safety factor and you won't have to hunt for a pencil). Need 3,000 watts? 3,000 ÷ 100 = 30 amps. Remember, if you don't know watts what, you'll blow it — with the electrician.

Circles of Confusion

Ambient Light
Artificial Light
Available Light
Motivated Light
Natural Light

Angle of Light
The angle formed between the light/subject axis and camera/subject axis is probably the most important aspect of light in determining mood, modeling, and "message." Both the horizontal and the vertical angle should be indicated. *Examples:* true Rim Light, 180 degrees for both; Key Light, commonly 15 to 45 degrees for both. *Tip:* On the job, pros tend to use less specific designations such as Top, Side, and 3/4-back, which indicate the approximate angle yet allow for fine-tuning based on the subject.

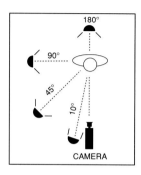

Angle of Reflection *see* Glare Angle

Angle of View
The angle accepted by a lens or meter which depends upon its Focal Length and the camera Aperture (commonly, the horizontal angle).

Answer Print, Trial Print (film)
One of the early lab attempts (typically there are two or three) to combine picture and sound. It is also the time for light and color correction and exploration; the time when all your previous efforts can be spoiled or perfected. Be there. *See:* Timed Print (an earlier stage).

Aperture (light and camera)
The camera, projector, or printer opening that controls the size and proportions of the recorded image — the Frame. *See:* Aspect Ratio. The area from which light is emitted from a Fixture is also an aperture, and the size, among other factors, influences the Quality of the light.

Apple Box
A rectangular wooden box used to support people, props, or equipment at any of three different heights. Thinner half-apples offer other options, alone and in stacked combinations.

Arc Light
A very large, near-daylight, carbon-arc source that was used to shoot Hollywood blockbusters — now rivaled by HMI and MSR Lights.

Artificial Light
An ambiguous term that refers to light produced by electricity as opposed to a Natural source and to illumination introduced to record images.

185

Depending upon how it is used, it looks either artificial or natural.

ASA *see* EI/ASA

Aspect Ratio, Frame Proportions
The proportions of an Image; width divided by height. *Example:* 1:1.33 for 16mm. The ratio changes depending upon the medium of reproduction and the proportions of the monitor or screen on which they are projected, which plays havoc with Composition and the tops of heads. *Tip:* Foreground framing with dark shapes will appear to change the aspect ratio.

Attenuator (optical)
A continuously graduated color or Neutral-Density camera filter used to tame snow, enrich sunsets, and perform Absorption magic more subtly than can be done with a Graduated Filter.

Attributes of Light
Every source has five main attributes that affect the quality of light emitted and the overall lighting-look: 1) Hard or Soft (or in between); 2) Intensity (the amount of light); 3) Direction (in relation to the lens/subject axis); 4) Color (of light emitted); and 5) Beam Pattern (the Beam Angle, shape, and any shadow patterns). All but color are affected by the light's Size and Distance, which may also be considered attributes.

Automatic Exposure
Automatic exposure controls on video cameras, for all their blessings, are subject to rapid, distracting brightness changes. *Alternative:* use it to set exposure, lock it out and make manual Stop changes, or allow the image temporarily to be dark or light. *See:* Through-the-Lens Metering.

Auto White Balance
Some video cameras automatically adjust the relative proportion of red, blue, and green in order to neutralize color variations from one light source to another. *See:* White Balance for more colorful details.

Available Light
Light of almost any sort which exists and has not been introduced to record images. Its use is sometimes fast, cheap, and even beautiful. *Tip:* The more you understand lighting technique, the better prepared you will be to take advantage of the good stuff — when it is available. Before committing, what are the odds that it will last as long as your shooting will and that the mood is appropriate? Keep a few lights available — in case. *Also see:* Natural Light.

Available Light Phobia*
The morbid fear of uncontrolled lighting situations.

Averaging
The light meter's arithmetic mean of all the light it "gathers."

Axial or Axis Lighting
Illumination from the lens axis using light reflected from a partially mirrored glass angled 45 degrees in front of the lens. Used primarily for medical and scientific recording where access or shadows are a problem. *Also see:* Ring Flash.

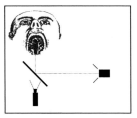

B Lights*, The Two Bs*
Back Light and Background Light are frequently confused. Both begin with "back," both are used to Separate Planes and imply Depth, and both are tricky to Motivate so that they appear realistic. Each, however, points in a different direction. *Tip:* Discretion may dictate that only one or, on occasion, neither is really needed. To paraphrase Shakespeare, in a rather different context: Two B or not two B, that is the question.

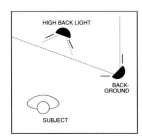

** Not a conventional term but coined by the author. Words with Initial Caps are separate entries elsewhere in the glossary.*

Baby (spot)
A 500-to-1,000w Fresnel light.

Backdrop Lighting
The even illumination of a painted or photographic background or backing, seen through the windows or doors beyond a set.

Background Light, Set Light
Reveals the character of the background and helps separate it from the subject. *Angle:* toward the background, usually from the side and high enough to avoid Glare and subject or microphone shadows. *Tip:* Avoid overlit backgrounds except for High Key, limbo, and special effects.

Back Light
Back Light separates subject from background, saints from sinners, and one pro from another. *Angle:* toward the lens from above and behind the subject, or above, behind, and slightly to the side of it, high enough to cut lens Flare. It is especially helpful for video images that may suffer loss-of-edge contrast. *Sins:* confusing this source with Background Light, and, for Motivation purists, using it at all. *Tip:* Smoke, steam, and other Translucent subjects adore Back Light of almost any color.

Back Light Addiction*
The uncontrollable urge to smother subjects under deadly doses of Back Light.

Back Light Phobia*
The unreasonable fear of violating the Motivation principle by using even tiny quantities of the substance.

Ballast
A device used to start and operate Discharge Lamps. It may include a Dimmer.

Bank
Several lights grouped together to create a larger or more powerful source. *Tip:* use soft lights or heavy Diffusion to avoid Multiple Shadows.

Barndoor
A front-of-the-light device having two or more pivotable black panels used to shape the Beam and shade the camera lens or scene.

Circles
of Confusion

Back Light
Edge Light
Kicker
Rim Light

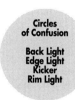

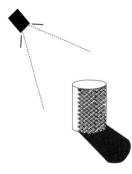

LIGHTS

DIFFUSER

Base Light
Diffuse, overall set Illumination intended to keep video electronics quiet. This characterless illumination has been going out of style thanks to improved camera performance and skillful Lighting Directors — at least on single-camera sets.

Batten
A pipe, pole, or wooden strip used to support lights. *See:* Grid.

Beam
A cone of light emitted by a Luminaire.

Beam Angle
If you're into reading light-performance data, beam angle is the point at which the Intensity of a source drops to 50% of maximum (center reading) measured in degrees of the full angle. *Simply:* How wide?

Beam Pattern
Includes Beam Angle, beam shape, and any realistic or abstract patterns introduced into the beam. *See:* Finesse.

Best Boy
The Gaffer's first assistant on large film crews. *Origin:* may have come from the Merchant Marine, as did many other film terms.

Big Nose/Small Ears Syndrome*
The "comic," and mostly unattractive, appearance of a face shot from extremely close through a wide-angle lens. *See:* Distortion and Perspective.

Black and White (B&W)
B&W film offers opportunities and challenges. Foreground and background may merge in the absence of color separation. *Tips:* use more Back Light or Background Light. View the scene with a B&W viewing glass. *Other differences:* Color Temperature complications disappear and all those long-abandoned filters that turn blue skies black and trees white can be used again. *Last tip:* While many of the black and white Masters aren't around, their masterpieces are. *Quote: The most difficult task for today's director of photography is to "think" in black and white again. He must become mentally color-blind, imagining what each scene will look like on the screen when it loses the colors it has in reality.* — Nestor Almendros [AMWAC]

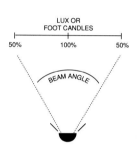

LUX OR
FOOT CANDLES

50% 100% 50%

BEAM ANGLE

187

Black Light *see* Ultraviolet

Blade *see* Finger

Blocking
Setting actor and camera positions and movements which are intimately related to lighting.

Blooming
The spreading of strong Highlights into surrounding areas of the image.

Blue Process (film), Chroma Key (tape)
Shooting action in front of a deep blue or other color Cyc. The result is a separation matte for a background scene that will be added later. *Tips:* Try to see the background scene before you light, avoid any blue — or whatever color is used — elsewhere in the scene, light the Cyc evenly, keep shadows off it, and consult an expert.

Boom
An adjustable arm, usually positioned on top of a stand, that extends a light or microphone over a subject.

Boom or Mike Shadow
A frequent and unwelcome (especially when it moves) part of early television which is still with us on occasion. *Solutions:* a large, soft Key or Bounce Light; a high-angle Key that is sharply Cut with a Flag at the top of the subject's head. The soundman may be able to boom-in from the opposite side or raise the mike slightly without sacrificing sound quality. Other types of microphones can be used which do not create shadow problems — only sound problems. Still photographers, count your technological blessings.

Booster Blue
Various blue gels or rarely, glass, used to increase the Kelvin of a source — such as: 1/8, 1/4, or 1/2 daylight blue.

Booster Light
The fixture or illumination that helps to balance out-of-balance Exterior light.

Bounce Card, Bounce Board
A white reflecting panel used for Fill or subtle Kicks. *See:* Show card.

Bounce Light
A super-soft source produced by reflecting lights off white (or at least color-neutral) panels or walls. Also, the terminal treatment of lighting kits by belligerent or under-tipped baggage handlers.

Bracketing
Photographers shooting tricky jobs may make safety Exposures above and below the "right" one, generally at 1/2- or 2/3-Stop intervals.

Breaking the Motion Barrier*
The challenge still photographers face when they cross over into video and film and deal with time and movement as they affect lighting.
See: Consistency of lighting; Moving Lights; and Moving Subjects.

Brightness, Luminance
A measure of a surface's or subject's reflectivity in a given direction.

Brightness Ratio, Contrast Ratio
The all-too-often awful truth about a subject or scene that has inappropriate or excessive Contrast. *Meter reading procedure:* Take two reflected-light readings: 1) the lightest significant area of the subject or scene and 2) the darkest. Divide 1) by 2). Each medium or method of reproduction has different brightness ratio limits. Movie theaters can project a maximum of about 125:1 (7 stops plus); modern, well-adjusted video cameras 30 or, some pros suggest, 40:1. *Also see:* Lighting Ratio and Contrast.

Broad, Broad Light
Typically, a semi-hard, non-focusing light with a wide Beam Angle. Unlike a true Soft Light, direct illumination from the Lamp is not blocked and the Aperture is usually smaller.

Brute
The 225-amp Hollywood powerhouse carbon Arc Light that kept generators purring and stars glowing, indoors and out.

* *Not a conventional term but coined by the author. Words with Initial Caps are separate entries elsewhere in the glossary.*

Circles
of Confusion

Brightness Ratio
(or Contrast Ratio)
Lighting Ratio

Bulb
The "glass" part only of a photo Lamp.

Burning Up
Overly bright, washed-out parts of a scene or subject, often as a result of subjects moving too close to an intense source. *See:* Moving Subjects, Graduated Scrim, and Floater for remedies.

Butterfly, Overhead
A large frame with a fabric diffuser or net to soften or reduce harsh sun or light. A miracle-worker when you have a calm day, a stand (two for an Overhead), weights, and the crew to Rig it or a studio to hang it.

Butterfly Lighting
A slightly high-angle, slightly Diffused source, centered on a (frequently female) subject's face to minimize nose shadow, skin texture, and double chins and emphasize cheekbones and beauty. *See also:* On-the-nose Key*

Circles
of Confusion

Light
Lamp
Bulb

"C" Clamp
One of several ways to attach a light to a ladder, for example.

MATTHEWS "C" CLAMP

Camera-top Light, On-board Light
The flat-light look of on-board lights for news-type shoots can be improved. *Tips:* Use heavy Diffusion or aim the light at a wall or use a low-wattage lamp in order not to overwhelm any face-saving Available Light.

Candle Power
One of several ways to measure and compare Incident Light levels. *More common photo/video ones:* Foot Candles, Lux, and Lumens.

Carbon Arc Lights *see* Arc Lights

Century Stand, C-Stand
This studio-standard commonly has a Grip Head with articulating arms to position light control devices such as Flags and Nets.

Cheating
If lights cast subject or microphone shadows on the background and your Back Light is only Top Light, it's time to pull people and furniture away from the walls, cyc, or seamless paper. Thanks to the two-dimensional nature of our business, there are many other such ways to cheat, if you have a Cinematic License.

Chiaroscuro
The arrangement of light and dark areas in a Composition. A term infrequently invoked on the job.

Chicken Coop
A six-lamp fixture, with or without Diffusion, hung over a set for broad, down illumination.

Chip Chart (video)
A chart of gray tones ranging from black to white used to set up electronic cameras.

Chroma Key *see* Blue Process

Chromatic Adaptation
The eye's ability to compensate, after a few minutes, for variations — sometimes drastic ones — in the color of light sources so that everything appears normal. *Tip:* Since the film doesn't compensate, you may want to use a Color-Temperature Meter.

CID *see* Discharge Lamp

Cinematic License
Allows holder to use unmotivated Back Light, elevate short actors, and transform day into night.

Close-up, CU (film & video)
A composition in which a subject's head more or less fills the frame. In an extreme or very close shot (ECU, VCU) only part of the subject is included, frequently just eyes, nose, and mouth.

Close-up (stills)
A shot requiring a supplementary lens, bellows, extension tubes, or macro lens to bring the subject into focus.

Clothes Light
Any off-the-face fixture used to lighten dark clothing or emphasize its texture. *Angle:* often from the side or 3/4 back.

Clouds
The sun's not-always-cooperative Reflector and Diffuser.

Coffin Light
A rectangular Soft Light, often with an adjustable black skirt used to control Spill. Like the Chicken Coop and Space Light, it is hung over the set.

Color (moods and emotions)
Color plays a role in affecting viewer's moods and appetites. *Tip:* use a Light Hand.

Color-blind
Some films, copiers, and human eyes are not sensitive to portions of the visible Spectrum.

Color Conversion, Color Correction
Matching the daylight or Tungsten balance of the film and lights through filtration or, with video, White Balance. Color can also be corrected during printing. *Tip:* Neutralizing "off-color" sources, such as dusk, is a technical and aesthetic call — not necessarily appropriate. *See:* Style and Consistency of Lighting.

Color-Correction Filters, CC Filters
A series of camera and printer filters available in gradual steps which can be used to correct color balance or to distort it for special effects. Range 1: red to blue; Range 2: magenta to green. Consult Kodak.

Color Distortion, Coloring Light
Gels not only correct the color of light sources relative to one another or the film, they can also be used to distort light for dramatic or artistic purposes. Thus far, no permit is required. *Video tip, see:* White Balance.

Color Media *see* Gel

Color Reference
The eye/brain shifts an "abnormal" color scene (say blue light) toward "normal" (White Light). To minimize the shift, include a source of contrasting color (amber or red) so the eye has a color reference. *See:* Chromatic Adaptation.

Color Rendering Index (CRI)
A numeric evaluation of the accuracy (in relation to "daylight" at 100) of various types of light sources. *Example:* HMI is about 90.

Color Shift
Color distortion or inaccuracy caused by problems with film or processing, White Balance or transfer, light sources, Reciprocity Failure, projection, or viewing sources, and, painfully, much more.

Color Temperature, Kelvin Scale, K
Briefly: how red, blue and green the "white" light is. Films are "white balanced" by choosing the correct color-temperature source (daylight, about 5,600K; tungsten, usually 3,200K) or by filtering. *Tip:* Exotic, kinky-spectrum light sources are difficult to read accurately with portable color meters. *Options once you determine the problem:* use camera filters, Gel lights and/or windows; White Balance and/or filter a video camera, re-light with photographic sources, or opt for off-color scenes.

Color-Temperature Meter
A device used to measure the color of a source and provide recommendations for correction. Sometimes you should just say no. *See:* Color Temperature.

Comet Tailing
The streaking of small, extremely bright parts of a scene when a pre-CCD video camera moves across them.

Complementary Colors
Yellow, cyan, and magenta, which are complementary to the Primary Colors.

Composition, Mise-en-scene
An arrangement of visual elements in the Frame; the path followed by the eye while viewing an image. Film and video composition exists in time and may change during the shot as well as through the cut or dissolve between shots. Composition and lighting are interdependent. *See:* Framing.

** Not a conventional term but coined by the author. Words with Initial Caps are separate entries elsewhere in the glossary.*

Consistency of Lighting, Matching

With film and video it is important that scenes used together match in Mood and spirit. This can be challenging when parts of a sequence are shot days — or sometimes months — apart, or when exterior light changes in mid-sequence. Also, the relative brightness of the subject, walls, and any windows should be constant unless the angle changes drastically. *Quote: I have the assistant keep a shot-to-shot logbook which gives the f-stop, the filtration, whether there were any [camera] nets, the focal length of the lens, etc. . . . [in case] you have to come back and finish it three weeks later but you want everything to match.*
—John Bailey [ML]

Contrast

The difference between one tone and another or between the darkest and lightest parts of a scene or processed film. High contrast involves not only an extreme Brightness Ratio but also few gray tones. Low contrast has an expanded range of intermediate tones with limited pure blacks and whites. *Tip:* What is too Contrasty for one medium or emulsion may not be so for another.
See: Brightness Ratio; and Fall-off (on a surface).

Contrast (Viewing) Glass

A filter that darkens the scene to help the new and old pro evaluate contrast and shadow areas.

Contrast Phobia*

An occupational hazard for videographers terrified of lighting ratios above 4:1.

Contrast Range (light) *see* Brightness Ratio

Contrasty

A scene or image with high Contrast.

Cookie, Cucoloris, Cucaloris

A device almost as strange as its names. Placed in front of a Hard Light, it throws realistic or abstract shadows, or dappled light, on bland walls or areas of the scene.

Cool

Light, gels, or subjects in the blue-green region of the Spectrum.

Copy Art

Shooting and lighting relatively flat art — artfully, whenever possible. *Tips:* lights must be set beyond the Glare Angle; small focusing lights or Broads are usually preferable to Soft Lights; with reflective subjects, hide the camera, people, and any windows behind a large black cloth. Don't bake the art.

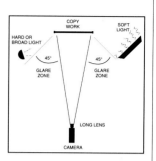

Cove

The gradual, curved transition between adjacent walls of a Cyc.

Coverage

All the shots and angles needed to capture a scene effectively and edit it well. *Quote: Planning scene coverage in advance is the most essential element in an effective lighting design.*
— Kris Malkiewicz [FL]

Creativity

Coming up with the ultimate image, a lot of electricity, or a good cup of coffee on a late night shoot, just when all seems lost. *Quote: "Creativity" describes a state of grace in which commerce, ego, and, lastly, taste, are all sufficiently served.*
— Tom McDonough [LY]

CRI *see* Color Rendering Index

Cross Key *see* Multiple Key

Cross Light

The illumination of a subject from both sides.
Also see: Multiple Key.

CSI *see* Discharge Lamp

Cut

To remove light from the scene, scenes from the film, money from the budget, or terms from an interminable glossary.

Cutter *see* Flag

Cyc, Cyclorama

The ultimate Limbo background, found in many studios. The wall(s) and floor are joined in a gradual curve. *Tip:* simulate it with a Seamless Paper sweep. *See:* Cove and Limbo.

Cyc Strip, Strip Light

A row of connected Broads used to light a Cyclorama or wall.

Dark Adaptation

Optical and chemical changes in the eye which, over a period of about 20 minutes, enable people to "see in the dark." It makes Exposure judgments by eye doubly difficult when light levels change. *Tip:* In the dark, color perception is minimal or non-existent.

Dark Backgrounds

One way to focus attention on the subject is to use a dark background, especially with back-lit and Translucent subjects.

Day-for-Night

Since ours is the Art of Illusion, it doesn't have to be night, it only has to look like it. *Tip:* Shoot late in the day with the sun, if any, as Back Light and use little fill; avoid the sky; underexpose 1 or 2 stops; some subtle blue helps convey the effect. If you want to see the moon, streetlights, or store lights in the scene, shoot during late dusk or real night.

Daylight Film

A film color-balanced for average daylight and flash illumination — approximately 5,500K.

Daylight Filter *see* 85 Filter

Daylight Variations*

The color, direction, and quality of daylight goes through stunning changes between dawn and dusk. Exploring and exploiting those permutations is one of the challenges and rewards of the craft.

Decibels (dB, db)

A unit used to express differences in electrical or acoustical signals including, for example, how noisy a motion picture camera or airplane is, or how much Gain a dark location requires. *Formula:* equal to 10 times the logarithm of the two levels. *Also see:* Gain and White Balance.

Definition, Sharpness

The perception of a well-defined, sharp image depends upon on a complex combination of factors, some of which are: Focus, Depth of Field, Contrast, and maximum potential detail inherent in the recording media or emulsion. The degree of image enlargement, along with viewing distance and how many generations removed from the original the image is, will also affect definition. If you can remember all of that, you'll at least sound sharp. The opposite of . . .

Degradation, Image Quality Loss

Loss of image quality or Definition for any number of reasons, including intentional ones. *Quote: I don't like forced development and flashing. Because I do like a fairly rich negative with good blacks, I'm not keen on the strong use of fog filters, although on occasion I use them. I don't like the effect they produce. [Also] you're going to have to make a dupe negative. So you're into a degradation with the dupe. Then any opticals . . . give you further degradation. Then . . . the projector is not so good; it hasn't got a very sharp lens or there's not enough light. At every stage along the line, the picture's going to deteriorate . . . so I'm very reluctant to have a degraded negative in the first instance. I think you're cheating your audience. They've got a right to see what's on the screen.* — Billy Williams [ML]

Dense

An overexposed negative or portion of it; the opposite of Thin. *See:* Overexposure.

Depth (Apparent)

The illusion of a third dimension on a flat screen or print through various techniques, among them effective lighting that emphasizes planes. *See:* Foreground, Modeling (Relief), and Sculptural Lighting.

Depth of Field

The area in front of and behind the plane of focus in the scene which is acceptably sharp (for intend-

* Not a conventional term but coined by the author. Words with Initial Caps are separate entries elsewhere in the glossary.

ed enlargement). *Tip:* A little more depth requires a lot more light (for a smaller Stop) or a wider angle lens. Don't call it depth of focus, a related but different matter.

Diaphragm, Iris, Aperture (camera lens)

The adjustable opening of a camera lens which controls the quantity of light reaching the film. *See:* Stop. Some lights also have an iris.

Dichroic

A vapor-deposited coating (usually on glass or metal) that reflects unwanted portions of the light spectrum; a filter with such a coating, typically one that converts tungsten light to match daylight sources or films.

Diffusion, Diffuser

A Translucent material placed in front of a Light to soften Highlights and Shadows, reduce Contrast, and increase Beam Angle.

Dimmer

An electric or electronic device that can reduce a fixture's brightness, usually with some loss of Color Temperature. Optical dimming mechanisms maintain Color Temperature.

DIN Standard

The German system (Deutsche Industrie Normal) for rating film sensitivity. Every 3 degrees doubles the film speed. *See:* EI/ASA and ISO.

Direction or Function of a Light

The big four:* Key, Fill, Back Light, and Background Light are the cornerstones of traditional lighting. Used without regard to the needs of the subject and scene, they become millstones. *The small six*:* Kicker, Side Light, Eye Light, Top Light, Rim Light, and Accent Light. *Tip:* Learn to use all 10 effectively, then forget about them and just light.

Directional Light

A loose term for light that is not loose and does not spill. Hard Light is directional, Soft Light can be made fairly directional with an Egg Crate.

Director of Photography, DP, Cinematographer

The individual on a film production responsible for lighting, Composition (except in the UK), and, to a large extent, crew performance. The full list is much longer.

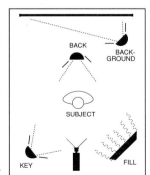

Director's Finder

An optical device that helps you select a lens of appropriate Focal Length and a Frame.

Discharge Lamp, HID (High Intensity Discharger)

CID (Compact Indium Discharge), CSI (Compact Source Iodide), xenon, and most importantly for shooting purposes, HMI (Hydrargyrum Medium Arc-Length Iodide), are lamps containing special gases under pressure (some high, some low pressure) through which an electric arc is discharged to produce a highly efficient light source. They require a Ballast and starter. Their Color Rendering Index and Hot Restrike Time vary. Lamps may require individual Color Correction with gels. *Also see:* HMI.

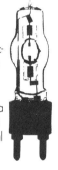

PHILLIPS MSR 250/HR

Discontinuous Spectrum

Fluorescent lights and, to varying degrees, many Discharge Lamps have spectrums with gaps or excessive amounts of some colors such as too much green or too little red. They emit light not suited for precise color reproduction. *See:* Color Temperature and Color Rendering Index.

Dispersion, Light Dispersion

A process whereby White Light is separated into a Spectrum of rainbow-like component wavelengths by, for example, a prism or raindrops.

Distance

The light/subject distance not only controls Fall-off but also shadow quality and the effective Size of the light. *See:* Throw.

Distortion (lens)

An optical aberration of a lens. *Extreme example:* a fish-eye lens. The term is often misused to describe the exaggerated Perspective effect of any lens when used too close to a subject, resulting in Big Nose/Small Ears Syndrome*.

Dolly

A mobile camera platform, whether simple or sophisticated.

Circles of Confusion

Dispersion
Absorption
Reflection
Refraction
Scattering

193

Dollying vs. Trucking

Dolly shots move toward or away from the subject or set (lens 0 degrees to travel); trucking shots are more or less parallel to the subject's line of movement (lens 90 degrees to travel).

Dominance

If several sources are needed, one of them (or one Direction of Light) usually should dominate.

Dot, Target

Round devices used to shadow areas of the scene to control Contrast or improve lighting.

MATTHEWS DOTS

Double, Stuntman or Stuntwoman

The daredevil who, in Tom McDonough's words, saves the star's bones. *Also see:* Stand-in.

Double Exposure

The re-exposing of film, intentionally or not, to a second image.

Dust

A great enhancer of atmosphere with a little wind and Back Light and considerable care to protect the camera.

Ear-side Key*

Occasionally the main source lights a model from the camera-side of his face, sometimes from behind his ear which will leave the front of his face in partial shadow. *Also see:* Far-side Key* and On-the-Nose Key*.

Edge Light

A separation light somewhere between a Kicker and a Rim Light.

EFP

Electronic Field Production as distinguished from ENG video shooting.

Egg Crates

A frame made up of crossed strips; used in front of a soft source to reduce Spill light.

EI/ASA, Exposure Index

A numerical designation of a film's sensitivity to light. The current US standard for film speed. *See:* ISO; and DIN.

18% Assumption*, Middle Gray, Zone 5

Light meters "expect" subjects and scenes to reflect 18% of the Incident Light. Mostly they do. *Tip:* What you do when they don't will affect your image in more ways than one. *See:* Gray Card and Zone System.

85 Filter

A salmon-colored filter that enables standard Tungsten Film stock to take on average daylight without turning blue in the face. Some labs are prepared to compensate for shots made without the 85 filter.

Electromagnetic Spectrum *see* Spectrum

Electronic Flash, Strobe (stills)

An electronic source that produces a burst of light capable of freezing motion. Its Color Temperature approximates daylight. Strictly speaking, the term "strobe" refers to a light or effect consisting of repeated bursts, often used to capture multiple, overlapping images of a moving object.

DYNALITE, INC.

Electronic Flash vs. Hot Lights (for stills)

Quote: In fast action work such as fashion, strobes offer an undeniable combination of advantages. . . . The primary logic of constant source lighting is the combination of control and superior visualization . . . Let's face facts. Modeling lamps are dim, period. — Michael Chiusano [LN]

Ellipsoidal, Focal or Projection Spot Light

A special-purpose light that projects a well-defined, easy-to-shape Beam; often used to project patterns onto backgrounds. A theater staple.

ENG

Electronic News Gathering as distinguished from EFP.

STRAND LEKOLITE

* Not a conventional term but coined by the author. Words with Initial Caps are separate entries elsewhere in the glossary.

Enveloping Light*, Super-soft

A source such as overcast sky; a Soft Light or Bounce Light that is sufficiently large or close to the subject to partially surround or Wrap it.

EV, Exposure Value

A system of light measurement in which each whole number is 1 Stop more or less than its neighbors; used by many meter makers.

Exposure

The result of light that reaches any recording surface through the combination of time (Shutter Speed) and quantity (lens Diaphragm size).

Exposure Latitude

The range above or below optimum exposure within which a given film can reproduce acceptable results. Negative films have the widest latitude for decent exposure.

Exposure Meter, Light Meter *see* Incident Meter, Reflected Meter, and Spot Meter

Exterior Lighting

The use of Natural, Artificial, and Reflected Light, as well as the blocking, diffusing, and manipulation of daylight and night light. If you're stuck with Top Light sun, here are a few *Tips:* Use Reflectors, a Butterfly, or lights. No electricity? Use batteries (even vehicular) with matching-voltage lamps, connectors, and daylight correction. Or shoot in the Shade.

Eyeglasses

One of two serious threats to the new pro's equanimity in portrait matters. The other: noses.

Eye Light, Catch Light

A little Eye Light goes a long way; use a Light Hand. *Tip:* A small, diffused, doored-down Hard Light near the camera gives Kicks in the center of the eyes and teeth (unless your subject is tight-lipped). Placed off to the side, the whites of the eyes glow lovingly, tragically, or threateningly, depending upon the music.

Eye Line

Where the subject looks: Profile, close to the lens, at the lens, up, down or anywhere else, affects the Intensity, Mood, and credibility of the scene and the lighting. An area of considerable Cheating.

f-stop *see* Stop

Fall-off (Light on a surface)

The size of the area on a surface where light and shadows merge. Soft sources produce a gradual transition, a subtle gradation of tones. Hard sources, without Fill Light, change abruptly. *See:* Wrap and Contrast.

Fall-off (source) *see* Inverse Square Law

False Ceiling

A Translucent material stretched above a Set which Transmits light, but which appears solid from below.

Far-side Key *

In relation to the camera, the main light is set on the far side of a model's nose which leaves the camera-side of her face in partial shadow. Far-side Key*, Ear-side Key*, and On-the-Nose Key* are terms which, if they don't exist, should, because they are fast descriptions of dramatically different lighting-looks.

Fast Action, Undercranking *see* Time Lapse and Frame Rate

Fast, High-Speed

A confusingly general term that includes film, lenses that require little light for Exposure, and Shutter Speeds capable of stopping fast action. Also, people who have a reputation for lighting quickly; more highly valued by some producers than "good." *See:* Speed (your lighting).

195

Fay Lamp, Fay Light

A sealed-beam daylight PAR lamp or the fixture that uses several such lamps connected mechanically and electrically.

Feather the Light, Feathering

To reduce the light level to near 0 at the edges of the beam; to pan or tilt the light so that its dim edge is used. Fixtures, such as fresnels, that are feathered by design are easy to overlap. *Tip:* The edge of the Beam on most fixtures produces the sharpest shadows.

Fiber Optics

A flexible bundle of light-transmitting fibers used for medical, scientific, and difficult-access situations.

Fill Light, Filler

Fill is used to lighten shadows and control Contrast and Lighting Ratios. *Tip:* Avoid Hard Light fill and Over-kill Fill*. *Angle:* usually close to the lens, on the side opposite the Key. Time allowing, try a fill-angle better suited to your subject. *Quote: I used to light very strictly by ratios because I wanted consistency. . . . Now I just fill by eye. I"ve had that much more experience.* — John Bailey [ML]

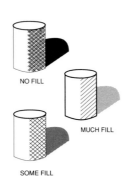

NO FILL

MUCH FILL

SOME FILL

Film

A flexible base supporting an emulsion — light-sensitive in the case of movies and stills and magnetic in the case of video. Also, informally, motion pictures. Erick Sommers insists that since both are film according to physicists, video-taping can technically be referred to as "filming."

Film Fog *see* Fog (on Film — Unintentional)

Film Look

Various claims by video manufacturers and pros that their tape images resemble film quality.

Film Sensitivity (Speed) *see* EI/ASA, ISO and DIN

Filter (camera)

Any light-transmitting medium that absorbs, reflects, or diffuses light when placed in front of or behind a lens.

Filter (for a light)

Any light-transmitting medium that, when placed in front of the fixture, absorbs, reflects, or diffuses part or all of the beam. "Filter" may imply glass as opposed to Gel materials. *Also see:* Dichroic.

Filter Factor

The Exposure correction needed to compensate for light losses due to a filter. Through-the-Lens Metering automatically compensates for most filters.

Finessing Light

The black art of refining White Light by using focusing knobs, Barndoors, fancy Scrims, Butterflies, gels, and anything handy that won't melt.

Finger, Blade

A long, narrow Flag or cutter used to shadow part of the Subject or scene.

Fixture *see* Lights

Flag, Cutter, Gobo

An Opaque panel used to block light and shadow the subject, background, or camera lens. It can also hide lights in the dark recesses of a scene. Which term you use depends upon the device's size and what part of the country you alight in.

MATTHEWS FINGER & FLAG

Flair, Style

Knowing just when (and with whom) to use Flare — among other talents. *See:* Style.

Flare

Flare, unlike Flair, is not in one's head but in one's lens or camera. *Tip:* Keep bright lights, sun, and strong Reflections out of the lens; or turn flare's image-eating tendencies into image-enriching ones by telling your client: ". . . it's artistic." Just don't call it "Glare."

Flash

A term that covers the scarce-but-still-available disposable flash bulb as well as Electronic Flash sources. *See:* Electronic Flash

** Not a conventional term but coined by the author. Words with Initial Caps are separate entries elsewhere in the glossary.*

Flash Duration

The discharge time of an electric flash unit which determines its motion-freezing and Kelvin (the shorter, the Cooler) characteristics.

Flashing Film

Exposing film to low levels of even illumination primarily to decrease Contrast; controlled Fogging.

Flat (sets)

One section of a Set traditionally made of canvas stretched over a wood frame.

Flat Light, Flat

The results of low-Contrast or close-to-the-lens lighting or Over-kill Fill*. *Tip:* While Soft Light is, by its nature, flatter than Hard Light, even a soft source, above or to the subject's side, is not flat. *Proof:* Vermeer.

Flat-Light Syndrome *

Symptom: pale faces drained of life. *Cure:* Modeling.

Flicker (Intentional)

The attempt to suggest sources such as fire. It is easy to overdo the effect and undermine the reality. One reality: TV images don't flicker.

Flicker (Unintentional)

The disastrous effects of a Discharge Lamp that is out of Sync with a film camera — among other causes.

Floater

The mid-shot adjustment of a flag, typically to reduce light when an actor moves too close to a light source.

Flood

To increase the Beam size of a focusing light, which, like it or not, decreases its Intensity.

Floodlight, Flood

A wide, semi-soft source often used for general illumination or to bounce light. *Also see:* Broad.

Fluorescent Filters

Filters designed to compensate for weak red and excessive green wavelengths in typical fluorescent light sources. FLD and FLB filters can tame some of the more commonly used tube types. *Tip:* For the new pro, tests are advisable.

Circles
of Confusion

Flat Light
Low Contrast
Low Key

FLOOD

Fluorescent Phobia *

The paralyzing dread (sometimes justifiable) of using fluorescent ceiling fixtures to shoot with.

Foamcore

4' X 8' panels of white board which are reasonably rigid and reusable if not too abused. They are often used to reflect light onto a Subject without casting new shadows.

Focal Length (camera lens)

The lens-to-focal-plane distance at the infinity setting. Focal length affects shooting distance, which affects Perspective. *See:* Angle of View.

Focus (camera)

To adjust the Distance setting on a lens or let an automatic focus device do it for you.

Focus (light)

To vary a Spot Light's Beam size and Intensity. *See:* Flood, Spot, Focus Range, and Beam Angle.

Focus (yours)

To ignore the pandemonium around you while you light.

Focus Range

The ratio of Spot to Flood for a given light. *Example:* 800 fc to 100 fc = 8:1. The more the better, if it's also smooth.

Fog (on Film — Unintentional)

An accidental "image veiling" through light leaks or chemical action. One of the more serious technical nightmares that help to make film insurance nearly prohibitive.

Fog, Mist, Haze, Steam, Smoke

Translucent vapors add a little magic to images. *Tip:* Use some Back Light.

Fog Filter

One of many special camera filters that introduce image Diffusion, smearing of Highlights, and lightening of dark areas. The "fog," however, neither moves nor increases with distance. For those, use a . . .

Fog Machine, Fog Maker

For the right scene, rolling fog is easily one of the most beautiful effects available. Portable fog machines generally require electricity, dry-ice (for low-lying effects) and chemicals (non-toxic types, please!). They are, otherwise, fairly easy to use — in small areas with little or no wind — but experience helps. Large areas typically require several machines and operators.

Foot Candle (fc)

A unit of incident illumination, theoretically unaffected by subject Brightness. *Also see:* Lux.

Foreground

Dark foregrounds help hold the eye within the Frame and increase the illusion of Depth. Bright foreground objects, especially out-of-focus or moving ones, can be distracting. *Tip:* Back- or Side-Light the foreground using little or no Fill. *Also see:* Frame.

Formula (of sorts)

For uncontrollable or 360-degree action in a room (weddings, for example) try mounting three Broad Lights high up, in two different corners, and on the opposite wall. Favor Motivated positions. Resist the temptation to use a fourth source, but not the one to Bounce or Diffuse — light level allowing.

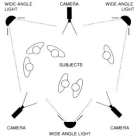

Formula Lighting

A sensitive eye and a little imagination are worth far more than a lot of lighting formulas, since every formula fails to acknowledge that every scene is different.

Frame

Any one of the series of pictures that make up exposed rolls of still or movie film. Also, the outer limits of an image, especially when it sits on a piano. *See:* Framing and Aspect Ratio.

Frame Rate, Frames Per Second, FPS (film and stills)

The speed with which film moves past the gate. For movies, 24 is normal in the USA. Higher rates produce Slow Motion (by providing more frames during projection). Slowing down the rate speeds up the action. *Tip:* Don't forget to compensate for Exposure changes caused by altered Shutter Speed. For stills, motorized cameras offer rates of several frames per second; if Flash is used, Synchronization is critical.

Framing, To Frame a Shot

To adjust the size or position of the outer limits of the image before or during shooting. An aspect of Composition. A term loosely used, instead of composition, to refer to the arrangement of visual elements. Also, to use Foreground shapes (such as arches and tree branches) to suggest Depth, to direct the viewer's eye, or to soften the edges of the picture.

French Flag

A small black panel on an adjustable arm used on a camera to block Flare from lights.

MATTHEWS FRENCH FLAG

Fresnel

A thinner, lighter, "stepped" version of a Plano-convex Lens. Also, a Spot Light with such a lens. *Tip:* silent "s," s'il vous plait.

FRESNEL LENS
FILAMENT
BEAM
SPHERICAL REFLECTOR

Frost Gel *see* Diffusion

Gaffer

The chief electrician on a motion picture production, responsible, ideally, to the Director of Photography.

Gaffer's Tape, Gaffer Tape

Introduced by author in 1959 to support Lowel-lights on vertical surfaces.

Gain, Gain Control (video)

The boosting of a video camera's sensitivity to light when light levels are low (at the cost of some increased electronic Noise); also, changing its color balance. The amount of gain is measured in Decibels. *See:* White Balance.

** Not a conventional term but coined by the author. Words with Initial Caps are separate entries elsewhere in the glossary.*

Gel, Gelatin, Media
As used with photographic lights, a strong, flexible, fade-resistant material that changes the color, amount, or quality of light. *Tip:* Some colors, like blue, fade fairly fast and need to be checked.

Generator, Jenny
A device that converts liquid fuel into electricity so you can operate lights and Wind and Fog Machines on-Location — all at once if it's a big one. *Tip:* For sound, you want a "silent" one.

Gilding the Lighting *
Using more lights, effects, or color than the lily needs.

Glare
Light reflected toward the camera from shiny or even relatively Matte surfaces. In moderation, it is one of the most useful ways to add life to drab subjects. If excessive, tame it by: moving the glaring object, the light, or camera angle; using softer light, a polarizing camera Filter (not on bare metal), or dulling-type spray (not on bald heads). *Also see:* Kicks and . . .

Glare Angle, Angle of Reflection
The law-of-the-light states: "The angle of reflection is equal to the angle of incidence." *Simply:* Light is reflected at the same angle it came from, but in the opposite direction. Pool players understand. *Tip:* As soon as this law becomes intuitive, lighting will be easier.

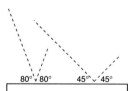

Glare Zone *
The angle within which lights will produce glare on a surface; beyond which, the Glare-free Zone*, it will be absent. *See:* Glare and Copy Art.

Gobo
A Flag; also a disk with a cutout pattern that casts shadows when used in an Ellipsoidal Spot Light.

Good Eye
Useful for good lighting results, essential for outstanding ones. *Tips:* To help develop sensitivity to light and Composition: study good films, paintings, and photographs; keep an image file; and observe the subtleties of light and shadow all around you when you're not shooting.

Graduated Filter, Grad
A filter with modulated-color or gray areas which can be oriented in front of the camera to control Contrast or add color to part of a scene. *Also see:* Attenuator.

Graduated Scrim
A Hard Light scrim with a degree of subtlety in modulating the brightness of areas of the subject or scene. A fast fix for subjects Burning Up as they approach a strong light. *See:* Moving Subjects.

Grain
Silver particles that remain on the film after processing to form an image. Usually, the faster the film, the coarser the grain, the less the Definition.

Gray Card
A Matte 18% reflectance card used instead of a subject for a Reflected Light Meter reading. *Tips:* Exposure corrections for unusually light or dark subjects are the same as for an ILM — not an RLM. Angle the card for typical but glare-free light. *See:* 18% Assumption*.

Gray Scale (film)
A chart of gray tones ranging from black to white used to help conscientious lab technicians print the scene accurately. *Tip:* Shoot a couple of feet of film with the chart in the Foreground, at the beginning of scenes or sequences.

Grease Paint *see* Makeup

Grid
An overhead system of pipes or tracks used to support lights and cables, sometimes with side, front, and back adjustability of fixtures.

Grip
Traditionally, the crew member who hangs lights, pushes dollies, hefts cases, and, on the West Coast, handles Reflectors. Also, a clamp to mount lights.

Grip Head
A clamping and positioning mechanism usually mounted on a Century Stand. It holds Flags, Nets, Diffusers, and Butterflies.

MATTHEWS GRIP

199

Guide Number (Flash)

Guide numbers proclaim the light output of Electronic Flash units more realistically than Watt/seconds do, but still ignore such essentials as reflector design. The guide number divided by subject Distance represents the theoretical f-stop, but since you spent so much for that meter — exercise it.

Hair

A lighting opportunity when it's on someone's head; a disaster when it's in the camera Aperture.

Hair light

An Accent Light presumably limited to the top of the head. Sometimes only a Back Light with delusions of grandeur and fancy-colored gels.

Hand-holding

An operation likely to complicate your life whether performed with a light, camera, client, or model.

Hanger

A light-support device that you attach to a Grid.

Hard Light

A relatively small, direct, usually focusable source, with or without lens, that produces strong Highlights and dark shadows. The quality is more dramatic and controllable, but generally less flattering, than Soft Light. *Tip:* Cheapest hard source with least Fall-off: the sun. *See:* Spot Light.

Haze, Ultraviolet, UV, Skylight Filters

Film, unlike the human eye, is sensitive to some UV which adds blue and reduces visibility on distant landscapes. These filters should not be confused with Fog Filters, which are supposed to *add* "Fog." A Polarizing Filter can also cut haze. For B&W films, orange or red filters are effective.

HDTV, High-Definition Television

A poor definition of high definition: the pending improvement in image quality (sharper) and Aspect Ratio (wider).

Heat Filter (lights)

A Transparent filter that removes much of the Infrared (heat) from a light source.

Heat Waves

Extreme heat eventually causes some surfaces to radiate "shimmering" waves that are emphasized by long lenses. They decrease Definition but increase drama — as in *Lawrence of Arabia*, brilliantly lit by Freddie Young.

HID *see* Discharge Lamps.

High Key

Lighting that results in predominantly middle-gray to white tones. *Tip:* Use white or light sets, wardrobe, and Makeup; also, soft Flat Light, Back Light, and possibly camera-lens Diffusion.

Highlights

The bright areas of a subject or scene, often the result of gentle Reflections of lights. Strong reflections are called "Kicks" or "hot spots." The size and intensity of highlights are determined in part by the hard or soft nature of the light and the subject texture. *Tip:* Diffusion enlarges and softens highlights. *See:* Fall-off (light on a surface).

High-speed, Overcranking (film)

see Frame Rate and Slow Motion

HMI, Metal Halogen

HMI (hydrargyrum medium-arc-length plus iodide) lamps are at this time one of the best of the Discharge Lamps for shooting. They are daylight-balanced, 5,600-to-6,000K, with a 3,200K option, relatively low pressure and short Hot Restrike Time with high output and high CRI. HMI (still sometimes called "Metal Halogen") performs minor miracles, especially when balancing strong daylight for color shooting. *Tip:* Test Color Temperature at frequent intervals and keep Color-Correction gels handy.

ARRI LIGHTS

** Not a conventional term but coined by the author. Words with Initial Caps are separate entries elsewhere in the glossary.*

Hot Lights

Still photographer's lingo for constant-source as opposed to Electronic Flash.

Hot Restrike Time

The time required after turning off a Discharge Lamp such as an HMI before it can be turned on again. Slow restrike does not mix well with quick tempers.

Hot Spots *see* Kicks

Hue

The perception of a color as the result of the miraculous combination of optical, physical, chemical, neural, and psychological phenomena. *See:* Spectrum, White Light, and Absorption.

Idle-fixture Phobia *

The obsessive fear, most commonly suffered by producers on distant locations, of being surrounded by unused lights. Also rampant among camera-persons who see virtue in quantity rather than quality.

Igniter

A component that provides high-voltage electric current needed to start a Discharge Lamp.

Illuminant *see* Source

Illumination

Lighting minus craft. Also, someone else's setup.

ILM *see* Incident Light Meter

Image

A representation of a subject or scene, often through optical, chemical, and electronic means.

Incandescent Lamp or Light

A lamp that produces White Light when electric current excites the filament. *See:* Tungsten Filament and Tungsten Halogen Lamp.

Incident Light

The light that "makes it to the scene" before roughly 82% of it is Absorbed and Scattered.

Incident Light Meter (ILM)

A meter designed to read Incident Light. Compensation is needed for unusually dark or light subjects, Back Light, silhouettes, and special Exposure effects. The tool for measuring Lighting Ratio. The Translucent, light-averaging, usually hemispheric part of this meter is aimed toward the camera, or, on occasion, between the camera and the Key, from the subject.

Indecent Exposure * (film and stills)

The result of any number of miscalculations and minor errors that do not cancel each other out. *See:* Exposure and Exposure Latitude.

"Indoor" Film

A term guaranteed to trip up the new pro and the literal-minded when they're loading the camera for window-light shots. *Tip:* Call it Tungsten or 3,200K film.

Infrared

A portion of the Electromagnetic Spectrum to which the human eye is not sensitive but which can be used with infrared film and Filter to record images of unusual tonal balance. Infrared rays produce heat when they strike objects. *See:* Heat Filter.

Inky, Inky-dink

A small Fresnel Spot Light.

Inner-Light

What effective outer lights can reveal about a subject's character, especially if the eyes are well lit.

Insert Stage

A small studio, generally without soundproofing, designed to light and shoot close-ups or product shots.

Instrument

One of many terms for a Light, heard mostly in the theater. *See:* Lights.

Intensity, Light Level, Light Output

The "strength" of the Incident Light independent of subject reflectivity, commonly measured in Foot Candles or Lux. High levels allow for increased Depth of Field (not always desirable) or faster shutter speeds (stills or high-speed filming).

MINOLTA METER

Optimum levels are what one strives for. Realistic levels are what one settles for.

Interiors

Indoor sets and locations or where you shoot when it rains on your Exterior parade.

Internal Reflector

A Lamp with an integral reflector, such as the MR-16 and R-40.

Interpretive Exposure *

Intervention in the meter/diaphragm/shutter conspiracy in order to achieve a special look such as High Key, Low Key, and Silhouette.

Inverse Square Law, Fall-off

Light from a point source falls off inversely to the square of the distance. Move the light from 10-to-20-feet away and you have only 1/4 of the intensity; 40-feet, 1/16th. Reflectors and lenses reduce fall-off; Diffusion increases it. *Tip:* To minimize fall-off within a scene, use hard lights as far away as practical.

Iris *see* Diaphragm

ISO (International Standards Organization)

A European rating of film sensitivity to light.

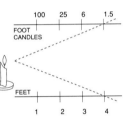

Joule *see* Watt/second

Juice

The popular way to refer to electricity and eliminate four syllables.

Junior, Deuce, 2kW

A 2,000-watt focusing Fresnel Spot. Junior can also refer to (ah, the utter confusion) a 1,000-watt Spot.

Kelvin *see* Color Temperature

Key Light, Main Light

The key may determine the character of the lighting, but often a strong Back Light for example, sets the Mood. The key should usually be Motivated by a source like the sun or a window. *Tips:* Several key lights may be needed when lighting Moving Subjects or several people facing in different directions. A former Kicker or Back Light may become the key when the camera angle changes.

Keystoning

The apparent "unparalleling" of parallel lines as a result of not shooting a building or framed picture at a perpendicular (90°) angle. The same phenomenon can occur with projected images.

Kicker, Liner, Glow Light

A low-angle, side-back light that adds honest glare (the kind that helps elect Presidents) to the side of faces. *Tip:* Try a white card or small reflector when you run out of lights or crave subtlety. *Also see:* Glare.

Kicks, Hot Spots, Specular Reflections

Small, bright, light reflections that add sparkle (and, with a Star Filter, radiating lines of light). However, if too bright, they are likely to add Flare. *See:* Glare Angle for control. Use Hard Light — just for kicks.

Kill

To turn off one or more of your lights. Or clients.

Kilowatt (kW)

Electricity equivalent to 1,000 watts; thus a 10kW light = 10,000 watts. *Tip:* use kW not K, which is also the abbreviation for Kelvin.

Circles of Confusion

Glare, Flare Highlights Hot Spots Kicks, Kickers

* Not a conventional term but coined by the author. Words with Initial Caps are separate entries elsewhere in the glossary.

Lab, Laboratory

The place your precious film goes to be developed, printed, and heaven knows what else. *Tip:* Don't be shy about telling the technicians what you want (High Key, Low Key, Silhouette, or a sunset-look) because they are in the dark. *Lowell Law:* Labs only botch irreplaceable film.

Lamp

Fits in a light and glows white-hot when turned on. *Cautions:* If anyone calls it a Bulb his or her Cinematic License will be revoked, but not his theatrical one. If anyone touches it (bare-fingered) when cold, the lamp will be damaged. If anyone touches it when hot, her fingers will be damaged.

Lamp-life

The number of hours at which half of the test lamps fail. *Tip:* Shock, vibration, frequent on-off cycles, overvolting, power surges, obstructed ventilation, defective lamps, and other longevity-threats are not factored in.

Lens Shade, Sun Shade

A minimal flare-control device. For more effective ways to prevent light rays from reaching the lens and filter, *see:* Matte Box and French Flag.

Light *see* Spectrum; and *Introduction*

to this book, for starters.

Light, Fixture, Luminaire, Instrument, Fitting (UK)

The contraption, regardless of name and shape, that surrounds a Lamp. "Instrument" has theatrical overtones.

Light Change

To dim, Kill, or turn on your Lights while shooting.

Light Control *see* Finessing

Light Grid *see* Grid

LOWEL FREN-L

Light Hand

Its use is recommended for most lighting, color choices, and effects.

Light Level *see* Intensity

Light Meter, Exposure Meter *see* Incident Meter, Reflected Meter, and Spot Meter

Light Plan, Light Plot

A plan view of the Set or location showing some or all of the following: the position, height, type, and Size of the lights, their intensities, accessories, gels, beam shapes, etc.

Light Quality *see* Attributes of Light (though not synonymous)

Light Reading, Meter Reading

Gathering Exposure and Contrast information with a light meter requires a light reading; learning to use the meter effectively requires heavy reading. Skillful meter use will tell you everything you want to know about the lighting, except whether it's any good.

Light Surgery*

Delicate operations performed on subjects to improve faulty or out-of-fashion features using a little light, a little shadow, and a lot of Finesse.

Lighter's Block*

The frightful sensation of facing an unlit Set with no notion where to start. The paralysis can be conquered by Plane Lighting and Motivated Lighting methods. *Quote from an Academy Award-winning Cinematographer: "The first day I come on a set, I usually don't know what I want to do; I feel like I've just graduated from USC [film school] . . . It takes me a little while to get my courage and spirit up." —* Conrad Hall *[ML]*

Lighting (for Image Recording)

The subject is so large it could fill several books.

Lighting Director, LD

The person responsible for lighting video productions. *Also see:* Director of Photography.

Lighting Planes

Visualize your subject, or the entire scene, as a series of planes at various angles to the lens. Position lights to reveal or conceal those planes effectively.

Lighting Ratio

The ratio of Key Light plus Fill vs. Fill Light only, using an Incident Light Meter. If the first is 200 Foot Candles and the second 50, the ratio is 4:1, or a 2-stop difference. Optimum and maximum lighting ratios depend upon Subject, Mood, medium, and type of reproduction, as well as on personal taste. In television, a timid ratio is 2:1, a dramatic one 8:1 or more. Film and slides can handle higher ratios than video and printed photos. *Also see:* Brightness Ratio. *Consolation:* if it were less confusing, imagine how crowded our craft would be. *Tip:* Many experienced pros use their eye in addition to, or instead of, a meter.

2:1 32:1

Lighting With Paint*

A pail of oil paint on a drab Location and an ounce of grease paint on a pale face (*see:* Makeup) may work better and faster than Painting with Light. Also, what some artists do on canvas.

Light-struck

Film that has been exposed to stray light prior to processing. *See:* Film Fog. Also, this craft's equivalent of stage-struck.

Lily

A series of color chips sometimes recorded at the head of a film scene or on the edge of a transparency when accurate color reproduction is crucial.

Limbo

A photographic background that appears to disappear, usually accomplished with a white or black Cyc or a Seamless Paper sweep, plus Limbo Lighting. Also, the period between freelance jobs which tests your confidence and credit.

Limbo Lighting*

The illumination of a background, such as two walls and a ceiling, so that they appear seamless or single-planed.

Liner *see* Kicker

Location

An area used for shooting, or considered for use, other than a studio. And other than a place previously used by an inconsiderate crew.

Long (Focal Length) Lens, Telephoto

A lens with an Angle of View narrower than that of the human eye and a "normal" lens. (Normal, Long, and Wide Angle are relative terms and depend on film or Aperture size. 50mm is wide for a 4 x 5 view camera, normal for a 35mm still camera, and long for a video camera. Telephotos are long lenses in the optical sense, but are by design shorter in the physical sense. *See:* Perspective.

Low Contrast *see* Contrast

Low-Contrast Filter

A camera filter that reduces contrast by adding subtle fog in dark areas.

Low-angle Light

The ideal Key, especially when Motivated, for villains, monsters and nymphs bathed by sun reflected from limpid pools.

Low Key

Lighting that results in predominantly gray to middle-black tones with few light areas. *Tip:* Use dark sets and wardrobes, hard lights, lots of flags, and don't let the lab or video engineer "save" you.

Lumen

A unit of measurement of Incident light. Lumens, like Lux, flux, candela, Foot Candles, foot lamberts, and Watt/seconds, were created by scientists and engineers to confuse artists.

Luminaire *see* Lights.

Lux

A unit of measure of Incident Light. The video and European version of Foot Candles. *Conversion Formula:* fc x 10.8 = Lux.

** Not a conventional term but coined by the author. Words with Initial Caps are separate entries elsewhere in the glossary.*

Magic Hour

That supremely beautiful time of day (dusk or dawn) when almost everyone would shoot almost everything, if only it lasted longer. *Tip:* Use little or no Fill, underexpose 1 or 2 stops, "drop" the 85 Filter if you like blue or need more exposure.

Main Light *see* Key Light

Makeup, Grease Paint

A little makeup may do what a lot of lights can't; too much, especially on close-ups, is worse than none. *Tip:* Examine makeup under your lights.

Marks

Positions where actors pause as determined during Blocking. Marks are often indicated on the floor with chalk or bits of tape and are helpful for controlled lighting and focusing. They can be distracting for actors, hopeless for non-actors.

Matching *see* Consistency of Lighting

Matte

A non-reflective, dull subject or surface. *Tip:* Even black, semi-matte surfaces will glow, given some soft glare-light, but there's little hope for totally dull subjects. *See:* Scattering. The term also refers to various optical and printing effects beyond the scope of this book.

Matte Box

A fancy Lens Shade that disposes of all but the most determined rays of potential Flare and holds one or more filters of various sizes. The best ones also allow Graduated Filters to be rotated and positioned precisely.

Metal Halogen *see* HMI

Meter Reading *see* Light Reading

Middle Gray *see* Gray Card and 18% Assumption*

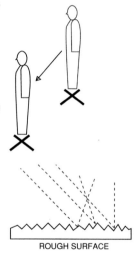

ROUGH SURFACE

Mid-light Crisis*

The stage between Lighter's Block* and Terminal Trauma* when you would turn everything off and start all over again if the producer were not staring at his watch and muttering.

Mired

A variation on Color Temperature measurements which is proportional throughout the two scales. Currently used mostly with filters. *Conversion Formula:* divide 1,000,000 by the Kelvin degrees. Also, mired is that feeling of walking into a dingy, cavernous "No-Problem Location" with one tiny light.

Mirror (for lighting)

An ancient and honorable way to stretch your lighting resources and the sun's reach. For tabletop shots keep a few shaving mirrors handy for accents and Kicks. A little tape applied to the mirror can shape the reflected light beam; dulling-type spray can diffuse it.

Mirror (for shooting) *see* Reflections

Mise-en-scene *see* Composition

Modeling, Relief

The hint of three-dimensionality resulting from light placed well away from the lens/subject axis — the opposite of Flat Light. *Also see:* Sculptural Lighting and Texture.

Modeling Light (Flash)

The Hot Light in many Electronic Flash units which helps you to "see" the lighting. *Tip:* Modeling lights are not universally proportional to the Intensity of the flash tube. A truly "proportional" halogen modeling light must be centered, diffused, and modulated to the various power levels of the flash. Even so, it is not proportional to daylight and other Ambient sources, so Polaroid Test Shots may be required.

Money Matters

The engine that propels the craft, and on occasion, even the art. *Quote 1: . . . the principal movie-making tool is not lenses or lights or stars or words or even Winnebagos. The principle moviemaking tool is money — the dispersal of expensive materials in a manner so grand as to be matched only by the military.* — Tom McDonough *[LY]; Quote 2: The*

schedule is always hanging over your head and it is a constant battle for the creative person to try to do the best he can under the restrictions of time. — Mario Tosi *[ML]; Quote 3: The trick you have to turn in this business is, given the time, to light the set and light it beautifully. It takes twice the effort to make it just a little bit better. . . . It doesn't get twice as good.* — Bill Butler *[ML]*

Monochromatic
A subject or image consisting of only one color in addition to any black, white, and gray tones. *Tip:* The subtlety of the effect can be surprisingly powerful.

Mood, Atmosphere
Stereotypically: romance, comedy, mystery, fantasy, or horror. Mood is one of the prime considerations in determining the lighting-look; another is . . .

Motivated Lighting, Source Lighting
When the lighting appears to come from actual sources established in the scene or sequence, such as a window or desk lamp, you can increase audience allegiance and "artistic integrity." Fantasy images? Anything goes. *Quote: Shadows falling toward a lit desk lamp are a sure sign of the novice or student.* — Eric Somers

Movement
One of the keys to movie/video magic is subject and camera movement, as well as the movement potential inherent in editing. It is intimately related to Composition and lighting. *See:* Breaking the Motion Barrier.*

Moving Image Media
The convenient, if not yet familiar, term that includes both film and video.

Moving Lights (video/film)
Effective when justified by the action, baffling most other times. *Exceptions:* diffused sources moving with the talent and camera, outdoors, or where background shadows are not a problem. Or when used symbolically.

Moving Subjects (video/film)
Lighting moving subjects is one of the most challenging aspects of the craft, especially for still photographers Breaking the Motion Barrier*. *Tips:* If you can rehearse the action, do it before you light, and note where people pause. Don't attempt to light large areas totally evenly since movement is enhanced by light Intensity changes. (Eric Somers points out that absolutely even illumination is the sin of Televangelist shows; perhaps they will see the light.) It may be necessary to use several Key Lights, one for each area. If movements are not predictable, set the lights far away and high, with half scrims or Graduated Scrims on the bottom to prevent subjects' Burning-up as they approach lights.

MSR *see* Discharge Lamps

Multiple (Double) Key, X lighting, Cross Key
The use of more than one Key Light, such as when two people face each other and each needs to be lit from a different direction. *Tip:* Each key can provide the Back Light for the other subject, after a little Finessing.

Multiple Shadows
Few things expose the novice and the artifice of our craft faster than multiple shadows of a subject — unless they are Motivated or done with a lot of Style.

N

Nanometer
A measure of Wavelength. *Formula:* Nanometer = a millionth mm.

Natural Light
Nature's illumination: daylight, even on interiors. The term implies that the source is not artificial.

** Not a conventional term but coined by the author. Words with Initial Caps are separate entries elsewhere in the glossary.*

Net, Open Net, Scrim
A flaglike device used to reduce light locally; the open net has one side without a frame to avoid a hard shadow.

MATTHEWS OPEN END

Neutral Density, ND (Gel)
Those .3, .6, and .9 ND gels reduce light Intensity by 1, 2, or 3 stops respectively, without a change in color or quality of the light. Camera filters are also available when you want to shoot wider open than high-speed film and high light levels allow.

New Pro *
Someone who is more than a serious amateur but less than an experienced professional; someone attempting the transition from Stills to Video or Film, or the reverse.

Night-for-Night
Shooting night scenes during real night. *Alternatives:* Day-for-Night and dusk-for-night.

Noise (video image)
The Degradation of image quality and Definition as a result of such problems as low light levels and what David Eisendrath liked to call "gremlins."

"No Problem Location"*
The producer's term for a location he couldn't afford to have you Scout. Too often synonymous with a no-Amps, no-access, no-cooperation location.

Normal Lens
A lens that, for a specific camera Aperture, produces an Angle of View approximating that of the human eye, or about 25 degrees. *See:* Angle of View and Perspective.

Nose Lighting, Nose Shadow
Where you want, or don't want, the nose shadow largely determines where you put your Key Light. *Tip:* off the lips, when possible.

Obie Light, Basher (UK)
A special Camera-top source first used, it is said, on Merle Oberon, which lightens otherwise dark eyes and faces, especially as the camera dollies-in for a Close-up. A good obie can be Dimmed without a Color Temperature change.

1kW, Ace
A 1,000-watt Spot Light.

One-Light, Untimed Workprint
Less expensive and usually preferable to a Timed Print in that your carefully underexposed scenes are more likely to stay that way. The best way to appraise your work is to keep the printing lights constant from day to day.

On-the-Nose Key *
When the subject's nose is aimed at the main light source, his nose shadow will be minimized. This Key position is part of Butterfly Lighting. *Also see:* Far-side Key* and Ear-side Key.*

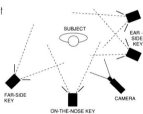

Opaque
An object or material that does not transmit light. Also, a dense client.

Open-face Light
A vague term that seems to refer to a Hard Light (perhaps others) without a focusing lens, although (*Safety Tip*) not necessarily without a protective glass or screen in the front.

Open Up
To enlarge the lens Diaphragm in order to increase Exposure or decrease Depth of Field.

Optical Axis, Lens Axis
The imaginary line that extends straight out from a lens.

Overexposure, Overexpose
Overexposed images have Highlights without details. *Causes:* faulty meters, readings, or interpretations, or the conviction that if a little light is good, a lot is better. Intentional, controlled overexposure, sometimes with underdevelopment, may be used to try to desaturate color or for other effects.

207

Overhead *see* Butterfly

Overhead-sun Syndrome *
Symptoms: Subjects lose their eyes and develop noses that need Light Surgery.

Over-kill Fill *
Wishy-washy lighting as a result of the tendency to play it safe in the Contrast and Lighting Ratio departments. *Also see:* Flat Light.

Painting With Light (Film)
A phrase implying that the fine art of film needs Fine Art to refine it.

Painting With Light (Stills)
The use of "light hose" systems to caress the scene selectively. Also, swinging any constant-source light (or swinging a Flash while firing it frequently) to illuminate vast dark areas economically. *Tips:* Use time exposure and a steady tripod; dress in black, keep light and cables moving; block all daylight and pray. Burr Lee suggests: Using Figure 8 and vertical movements of the light with 2/3 of the light coming from one side of the camera and 1/3 coming from the other side; always using the same Stop; and never wearing white shoes – unless you like to retouch. [LN] *Another secret:* lots of practice.

Pan
To arc a light or camera horizontally. Also, to re-view the results unfavorably.

Pan-itis *
An aggravated condition of viewer's eyes caused by relentless, rapid video and film camera swings.

Pantograph
A scissors-like mechanism used for raising and lowering studio lights. Other devices can also perform the same function, sometimes better.

PAR (parabolic aluminized reflector)
An automobile headlight-like Lamp that is used in special, non-focusing fixtures.

Parabolic Reflector
A reflector shape used with some focusing fixtures to provide efficient output, especially in Spot setting.

Parallax
The disparity between viewing and imaging angles when they are not identical, as with sports finders or twin-lens cameras.

Persistence of Vision (Movies)
The seventh-of-a-second image retention of the human eye without which motion pictures wouldn't work. Also, the Orson Wellesian compulsion to create Art in an industry that mistrusts it.

Perspective (lens)
The effect of Focal Length and distance on spatial relationships or relative size of objects at varying distances; apparent depth and any movement toward or away from the lens.

Photo Flood
Primarily 3,400K, short-life, Incandescent, medium-screw-base lamps; good for extremely well-ventilated Practicals.

Pipe Clamp
A light support that attaches to a Grid or pipe.

Pitting
Surface irregularities that may develop on Lamp pins, bases, and sockets which affect Lamp-life and socket operation. *Tip:* Replace pitted lamps and sockets ASAP.

CLANCY CLAMP

Plano-convex Lens
A lens used to focus light rays. It is flat one side, convex (curved outward) on the other. *Also see:* Fresnel.

** Not a conventional term but coined by the author. Words with Initial Caps are separate entries elsewhere in the glossary.*

Plug Ground Pin (on a light)

Quote: Your childhood education warns that you'll probably burn in hell for cutting off that third prong. — Tom Sadowski *[LN]*

Polarizing Filter (Camera)

Polarizing camera filters can be set to reduce most non-metallic Glare as well as to darken blue skies. *Most effective angle:* 90 degrees to the source. *Light loss:* a little over 2 stops.

Polarizing Filter (Fixture)

Polarizing gels can cut Glare, but will be damaged if used too close to high-wattage tungsten lamps. *Light loss:* a little over 2 stops.

Polaroid Test Shots (for stills)

The standard way to appraise lighting, especially with Flash when Modeling Lights are not proportional.

Practical Light

A prop light seen in the shot which can be operated by the talent; sometimes doctored to control brightness, color, or coverage.

Primary Colors

The Additive Colors: red, blue, and green; Subtractive Colors: yellow, magenta, and cyan.

Profile (Portraits)

A one-eye-only sideview of a person.

Props

Objects used to "dress" a set or still life.

Pushing, Forced Development, Upgrading (UK)

Compensating through overdevelopment for intentional or unavoidable Underexposure. *Cost:* a little money and a lot of Grain gain.

Quality of Light *see* Attributes

Quantity Versus Quality

Like so much in life, lighting is often compromised when you must, or imagine you must, go for the most instead of the best. *Also see:* Style.

Quartz Lamp

The original, and still commonly used, name for the renamed Tungsten-Halogen Lamp.

Radio Remote (Flash)

A wireless device used to trigger Flash or motor-driven cameras. Jon Falk cautions: *"They can be made inoperative by random communication frequencies, certain phases of the moon, and a negative cash flow; best powered by AC, not batteries."* *[AL]*

Reciprocity Law (Exposure)

Exposure = Intensity x Time. When you cut either the intensity or the time (shutter speed) in half you have only to double the other to keep your meter happy, up and down the exposure scale, except at the far ends, where the law is not enforced.

Reciprocity Law Failure (mostly stills)

The lack of reciprocity at both extremes (very long and very short exposures). *Solution:* increased Exposure and, if necessary, additional compensation for the reciprocity failure of the first compensation. Video/film folk normally need not fret.

Red-eye
The red-retina reflection seen in the center of the eyes when portraits are lit by a flash positioned too close to the lens axis.

Reflected Light
Various surfaces in a scene reflect between 1% and 95% of the Incident Light. Specular surfaces will reflect it narrowly. Diffuse (rough, irregular, or Matte) surfaces Scatter it. *Also see:* Glare and Bounce Light for further reflections.

Reflected Light Meter (RLM)
An RLM reads Light that is reflected from a scene. Aim these meters at the subject or scene or a Gray Card from the direction of the camera. *Also See:* Spot Meter and 18% Assumption*.

Reflections
Out-of-control reflections can hurt your image; controlled ones can enrich it. *Tips:* Keep the subject in full sun, the reflecting surface, such as water, in shade. Reflections on water are most pronounced when the lens is at a low angle. Most mirrors add a greenish cast to the image. Normal mirrors add a "ghost reflection" to the main reflection; use a first surface mirror for critical images.

Reflections (unwanted color)
Avoid large brightly lit areas that will reflect their color onto the subject unless the effect is desired and Motivated.

Reflector Flood
An incandescent, Internal-reflector Lamp (Flood, Spot, or medium Beam). The diameter is indicated in 1/8-inch units, thus an R-40 = 5 inches across the front.

Reflectors (inside Lights)
Variously shaped "bowls" (Parabolic, ellipsoidal, spherical, etc.) that shape and intensify a lamp's Beam.

Reflectors (to redirect light)
Flat devices, mostly white, silver, or gold, that redirect the sun's and other source's rays. Lighting with reflectors is like lighting with lights — except no cables. Just cloud and wind worries.

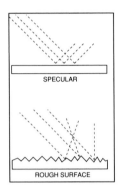

SPECULAR

ROUGH SURFACE

HARD LIGHT
SUBJECT
REFLECTOR

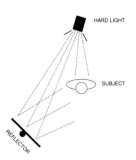

Refraction
The directional shift or "bending" of light rays as they leave one density medium and enter a different one. Or why your legs are short in water when viewed from the air.

Rembrandt Lighting
The dramatic emphasis of a few planes or features of the subject by using Accent Lights or shadowing devices that keep the rest of the scene very dark.

Rigging
Positioning lights without stands, often from overhead Grids.

Rigs
Improvised or official assemblies that support lights, backgrounds, and paraphernalia of all persuasions.

Rim Light, Rimmer
Subjects appear to have seen the light, then turned their back on it. *Angle:* The source looks down the barrel of your lens when the subject moves; sometimes several sources are aimed at the subject from wherever they can be hidden, more or less behind the subject.

Ring Flash
The ring-around-the-lens electronic flash that provides an image without shadows or Modeling — if that's what you want. A light saver with deeply recessed subjects. *Also see:* Axial Lighting.

Riser
A pole that can be added to the top of a substantial stand to extend its height. *Safety tip:* weight the Stand and check its stability.

RLM *see* Reflected Light Meter

Rules
The cumulative craft wisdom that beginners need to learn so they can anticipate the consequences of breaking them when appropriate. Not the same as Formulas. *Quote: Lighting is really common sense and personal observation. This is applied to a few rules of photography which cannot be broken and to others which I tend to bend a little. . .* — Paul Beeson [TL]

REFRACTION

* Not a conventional term but coined by the author. Words with Initial Caps are separate entries elsewhere in the glossary.

S

Safety
The dangers of our craft range from "mere" finger-scorching to electrocution. Don't take chances with your epidermis, or anyone else's.

Sandbag
A weight used to stabilize unstable Stands, Rigs, and much else. *Substitutes:* heavy cables, cases, or rocks.

Saturation
The degree of intensity of a Hue. Also, the result of hanging a hot light under an automatic sprinkler head.

Scattering (of Light)
The effect an irregular or Matte surface has upon Incident Light — broadly Reflecting it.

Scissor Clamp, Scissor Mount
Supports a light from a dropped ceiling Grid. *Caution:* Beware of automatic sprinklers.

Scoop
A large, semi-soft studio unit used for general set Illumination.

Scouting
Searching for a Location. Also, checking one out prior to shooting to determine equipment, noise, electrical and lighting needs, and problems. *Tip:* Saving money by not scouting can be expensive; and finding someone who is knowledgeable and reliable and who lives near the location can be challenging. *Quote: Three rules apply to filming on-location: 1) Scout before shooting to help save time and money; 2) Expect the unexpected — it is sure to happen; 3) Trust no one, especially the weather forecaster.* — Jon Fauer [LN]

Scrim
Commonly, a screen-like metal mesh used in front of a light to reduce intensity, not to diffuse it. But thanks to the mystery and magic of show biz, other devices

that do diffuse are sometimes called scrims, especially in the world of theater. *Tip:* If you can see a clear image through the material, there's no Diffusion and no confusion. *Also see:* Net.

Sculptural Lighting *
Modeling with lights to emphasize planes and Texture. Consider using the term to describe a subject/background relationship in which the bright edge of the subject (key side) stands out against a dark part of the background, and the shadow side of the subject separates from a light area of the background. The result is about as close as 2D can get to looking like 3D.

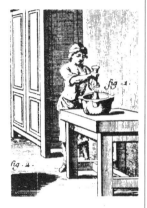

Seamless Paper
Wide rolls of background paper used to make Sweeps. These add background color and create Limbo.

Senior, 5kW
A 5,000-watt Fresnel Spot Light.

Separation of Planes
The craft of suggesting a non-existent third dimension through the use of lights positioned to emphasize Modeling. *Tips:* Keep subjects well away from backgrounds; Back Light, Rim Light, and Background Light will usually do the job; so will a good Dolly shot. *Quote: I like to rely on tonal separation rather than just relying on the color to separate it . . . if you can incorporate the right use of color with tonal separation, you get a greater perspective in composition, a greater depth.* — Billy Williams [ML]

Set
A construction or arrangement of walls, scenery, and Props designed for the convenient lighting and shooting of scenes and, except for stills, sound recording.

Set Light
The term some Lighting Directors use to refer to Background Light, and others may use instead of "Base Light." Obviously, part of a vast conspiracy to confound beginners.

Set Up

All the activities of placing lights, accessories, cameras, and, if needed, microphones, prior to shooting.

Shade (exterior)

Consider all the subtleties of shade: wide-open, dappled, flat, side, kicker, and back-lit varieties. Keep eyes and options open, Reflectors handy.

Shadow Detail

Extremely dark areas (either in actual shadows or in unlit and underlit parts of the scene) in which some texture or detail has been captured. *Tip:* Careful Exposure readings, a Good Eye, and experience help with such details.

Shadows

The power of shadows is in their potential to reveal as well as to conceal. *Tip:* Back Lights and Low-angle Lights can exaggerate shadows for dramatic or stylistic purposes. Poorly placed or Multiple Shadows usually add unwelcome clutter and confusion to the Composition.

Sharp (image) *see* Definition

Sharp (shadows)

Shadows that have a hard, clean edge. *Tip:* The farther away subjects, Snoots, and Flags are from a Light, and the closer they are to the background, the sharper their shadows will be. The edge of a spot beam produces sharper shadows than the center; the sun, ellipsoidal Spot Light, and, to a lesser degree, Fresnel lights, cast sharp shadows.

Show Card

A large sheet of cardboard, Matte-white on one side, preferably black on the other, used to reflect or block light, to add or subtract Highlights.

Shower Curtain

A large, Translucent plastic sheet used to diffuse lights. *See:* Bank.

Shutter (Light)

A venetian blind-like device attached to a light to adjust Intensity without affecting Color Temperature; a mechanical Dimmer.

Shutter Speed

Half of an Exposure equation; the time that light is permitted to strike the light-sensitive surface within a camera. Motion picture shutter speed is approximately 1/50 of a second when the camera runs at 24 fps.

Side Light

This half key/half kicker hits subjects at an angle of about 90 degrees. *Also see:* Cross Light.

Silhouette

Dark shapes and figures that are set against a light background. Silhouettes have both simplicity and impact, even on small screens. *Tips:* Keep the subject dark, the background light; underexpose 2-to-3 stops from the Incident Light Meter's "recommendation"; and don't let the lab or Video Engineer "save" you.

Silk

Diffusers of various sizes which scatter and soften artificial light or sunlight. Synthetics (which don't yellow as fast or blow the budget) have tended to replace the labor of silkworms. But large silks on exteriors (see: Butterfly) allow some air to escape, reducing the fabric's tendency to become a sail on windy days.

Simplicity

Don't use more Directions of Light, lights, or colors than needed for a subject or mood. *Quote: . . . We are not shooting at a space, but at part of it, a sense which is rather subtle and easily distorted by resorting to queer angles, exaggerated composition, forced perspective, and overly dramatic lighting.* —Ezra Stoller *[LN]*

Size and Distance of a Source

The larger the light, the softer its Quality. However, the effective size of a source also depends upon subject size and distance. A large, distant source is, in effect, small and hard (behold the sun). A 4-square-foot Soft Light covering a car is small, but if lighting a watch, it's enormous.

* *Not a conventional term but coined by the author. Words with Initial Caps are separate entries elsewhere in the glossary.*

Skypan
A large, high-wattage studio light used to flood Cycs and such.

Slave Unit (Electronic Flash)
A unit that, like a perfect assistant, responds in a flash to the Master.

Slow Motion (video and film)
The stretching of real time for technical or lyrical reasons. *See:* Frame Rate.

Snoot
Snoots are front-of-the-light "tubes" that project a circle of light on a subject or background. They also reduce Spill. *Tip:* To turn the circle into an ellipse, decrease the light-background angle.

SNOOT

Soft Light
Diffused, Bounced, indirect light; the opposite of Hard Light. The soft shadows and subtle highlights produced are so luscious one wonders why this light isn't used for everything. At times it seems to be. The difficulty of hiding and controlling a soft source, however, especially when shooting reverse angles, and its reluctance to "go the distance," limits its use. So does fickle fashion. *Tip:* The largest, cheapest soft source is an overcast sky.

Source, Illuminant
Anything that produces light, whether Natural, Artificial, Incandescent, Discharge, Flash, Constant-Source, lightning, or a firefly.

Source Lighting *see* Motivated Lighting

Space Blanket
A camping item, sometimes attached to Location walls or ceilings to reflect light. *Caution:* Check for flammability.

Space Light
A large cylinder containing several broad lights that is hung from ceilings to provide soft top light. A black "skirt" can be lowered to limit Spill on surrounding walls. Used mostly on features and commercials.

Spectrum (Visible & Electromagnetic)
The full range of electromagnetic wavelengths extends from the shortest gamma rays of 1 millionth mm to radio waves of 6 miles. Buried in the middle is the visible spectrum, the tiny portion to which the human eye is sensitive. The spectrum can be "seen" when White Light is intercepted by a prism or raindrops. *Tip:* It does not fully match what film "sees" and therein lie occasional surprises. *See:* Ultraviolet and Infrared.

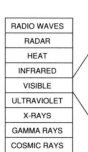

RADIO WAVES
RADAR
HEAT
INFRARED
VISIBLE
ULTRAVIOLET
X-RAYS
GAMMA RAYS
COSMIC RAYS

RED
ORANGE
YELLOW
GREEN
BLUE
INDIGO
VIOLET

Specular (subject)
A highly reflective, mirror-like surface. *Tip:* If your subject is specular and small, stick it in a Translucent tent, cut a hole for your lens, and douse it with light. Or surround it with white panels.

SPECULAR

Speed (Film Sensitivity)
The higher the ISO/ASA number, the more sensitive (faster) and usually the grainier the film. *See:* Gain, for the video equivalent of sensitivity and Background Noise as the parallel to grain.

Speed (lens)
The largest Stop (smallest number!) a lens can provide. *Tip:* High-speed lenses are great for low-level illumination but limited in terms of Depth of Field when wide open.

Speed (light)
186,000 miles per second.

Speed (your lighting)
Slower than Light. Often lighting speed is the critical element in whether you capture the shot, the spirit of the performance or, despite even a dazzlingly successful image, the next job.

Spider Box, Junction Box
An electrical distribution box used for plugging in lights, fans, and such.

Spill
Spill, like glare and weeds, suggests something unwelcome and unloved. But spill does cut contrast — if that's what you need. *Tip:* Flags, Snoots, and Barndoors provide a little relief with Hard lights, little relief with Soft Lights. *See:* Egg Crates.

Spot

To adjust a focusing light toward maximum Intensity and minimum Beam Angle.

Spot Light

A focusing Hard Light. *Traditional types:* Inky — up to 250 watts; Baby — 500-to-1,000 watts; Junior, Deuce or 2kW — 2,000 watts; Senior, 5K — 5,000 watts; Tenner or 10kW — 10,000 watts. *See:* Hard Light.

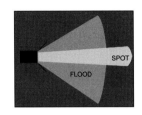

Spot Meter

Spot meters let you select and see the area they read — typically about 1 degree. They are indispensable for distant, unapproachable, and tricky (inside-furnace-type) metering and can be used to determine Brightness Ratio; not appropriate for Averaging.

Squinting (subject)

Usually the result of lights or Reflectors placed too close to the subject's line-of-sight, especially if surrounding areas are much darker. *Tip:* Add light to the walls and objects your Subject looks at and/or increase the angle of the key.

Stage plug

A large, heavy-duty electrical connector requiring caution in use.

Stand, Light Stand

While lights may find themselves mounted on a camera or Grid, Hand-held, or clamped virtually anywhere, commonly they are supported, elevated, and positioned by stands. *Tip:* Only amateurs call stands "Tripods." *Quote: I am always surprised at the large number of TV studios that do not have light stands in their inventory. Stands are extremely valuable when you need to add a source quickly — like at one minute to air. —* E. Carlton Winckler

Stand-in

The look-alike who stands in for the principal actor/actress during lighting sessions and, rarely, during Blocking. Not a Double.

Star Filter

A clear glass filter with engraved lines that turn tiny Kicks into star-like streaks. There are many options and sizes when you wish upon a star filter.

TIFFEN FILTERS

Stop, Lens Stop, f-stop, T-stop

An adjustable iris Diaphragm that controls, in part, how much light reaches the film or video tube. Once you grasp the logarithmic progression, and the idea that the larger the number the smaller the opening (therefore less light) — it's a piece of cake. F-stops are the theoretical amount of light transmitted by the lens; T-stops, the actual amount. The difference is about 1/3 stop, often more with zooms.

Stop Down

To reduce the size of the Diaphragm in order to decrease Exposure or increase Depth of Field. The opposite of Open Up.

Stop Pull

A manual, therefore potentially subtle, change of stop as the camera moves or pans from bright to dark areas; or the reverse. *See:* Automatic Exposure.

Strobe Light (film)

Special strobes can be used with motion pictures to freeze action frame by frame for scientific and other purposes. The lack-of-motion blur in each frame produces an unusual effect when the film is projected.

Strobe Light (stills)

Flash used sequentially for Edgerton-like effects; otherwise, as Ben Sobin, among others, reminds us, it should be called Electronic Flash.

Stud, spud

The projection at the top of a stand or on a clamp which allows a light to be attached and rotated.

Studio, Stage

An area dedicated to convenient lighting, shooting, and often set-building and recording of films, videos, and stills. Large, soundproof ones with Grids and Cycs tend to be popular on high-budget shoots. "Studio" also refers to a large production company that may or may not have its own stages.

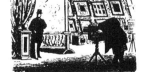

** Not a conventional term but coined by the author. Words with Initial Caps are separate entries elsewhere in the glossary.*

Style

That hard-to-define quality that may distinguish the work of two equally good lighters — or equally bad ones. *Quote: ". . . you have to keep the whole movie in your head all the time. . . . You can see stylistically if you are not dealing with it appropriately. Directors can't always see that because they become overburdened with the major problem of dealing with actors and telling the story."* —Gordon Willis [ML]; *Also see:* Flair.

Subject

A wonderfully vague term that covers: an entire film, the things and people lenses are aimed at, and this author's need for a genderless word to avoid countless "he or she" constructions.

Sun Shade *see* Lens Shade

Sweep

A continuous Seamless Paper background with a gradual curve where wall and floor join. The Poor Man's Cyc. Well-equipped photographic studios have a mechanism for raising and lowering rolls of seamless paper.

Symmetrical Lighting

Lights placed at more or less equal heights and equal-but-opposite angles and set at equal intensities. Because such lighting violates the principal of Dominance, it looks unnatural, confusing, or boring.

Sync, Synchronization

Having things happen at precisely the same time: your Electronic Flash and Shutter, or a desirable job and available time.

Sync Voltage

The camera flash contact voltage at the time it is fired.

Tabletop

A waist-level platform useful so that you don't waste your energy bending over while lighting and composing small objects. Also, the type of shooting associated with such subjects.

Take (film and video)

An uninterrupted recording of a scene, as in "Take 1" or, with some commercials, "Take 101." When you shoot a lot of takes the one that looks the best is always the last one, or the first one, or they all look the same.

Talent, Actor, Performer, Cast, Star

The professional who may or may not be talented. *Also see:* Subject, which may or may not be an actor and may or may not be an object.

Target

A round Gobo or a large Dot used to reduce or block light.

Teaser

An extremely large Flag.

Tenner, 10kW

A 10,000-watt Fresnel Spot Light.

Tent, Tenting

Translucent contraptions of various sizes, shapes, and materials which help to hide lights, cameras, and crews when you're shooting highly reflective objects.

Terminal Trauma *

Not knowing when to stop adding "just one more light."

Texture

Skillful lighting from an off-lens-axis angle can make texture appear to be so real, so 3D, it seems like you can touch it. *See:* Modeling and Sculptural Lighting*.

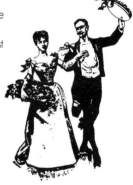

215

Thin
An underexposed image or area; the opposite of Dense.

Through-the-Lens Meter (TTLM)
An in-the-camera meter that can, in the case of video, adjust the iris as you shoot. It performs sophisticated readings of virtually everything except your mind. *See:* Automatic Exposure.

Throw
The distance light travels from Source to Subject, as in "a long throw." *See:* Distance.

Tieing-in
Connecting electrical cables directly to a live circuit box, dangerous even for an experienced, licensed electrician; illegal and suicidal for others. *Quote: Deep down in your heart you know that someday you'll meet face to face with the Grim Gaffer while you are doing a solo tie-in at a fuse box in some old lady's damp basement. — Tom Sadowski [LN]*

Tilt
Vertical arcing of the light or camera on an axis as close as possible to the lens. The opposite of Pan.

Time Lapse (film)
When a very slow Frame Rate is used, flowers appear to open in seconds and buildings seem to be constructed in minutes. *Tip:* Since time-lapse shots may span hours, days, or even months, unchanging or gradually changing lighting is important. Systems for reducing or killing the light between frames should be considered. *Another requirement:* careful calculation of exposure (slow shutter speeds mean low levels of light) and tests so there won't be unpleasant surprises at the end of a three-week shot.

Timed Print
A motion picture workprint that has received Timing to compensate for Exposure and color variations.

Timing, Grading (UK)
Adjustments of the motion picture printing lights to compensate for exposure and color variations, or to achieve special effects. *Tip:* Good timing makes champions.

216

Titan Arc
The granddaddy, 350-amp carbon arc that provided "sunlight," fill, and lots of jobs on countless feature films.

TLC, Tender Lighting Care
Something every Subject wants, most deserve, few get.

Top Light
Angle: directly over the subject. *Tip:* If you want to light eyes, not nose-tops, save this one for non-human subjects or horizontal ones. However, soft top-front light is ideal for some faces; top-back light for some food shots.

Translucent
An object, material or vapor that transmits and diffuses light but not clear images. *Examples:* Frost Gel and dense smoke. *Tip:* Use some Rim Light or Back Light.

Transmitted Light
Light that has passed through a Transparent or Translucent material.

Transparencies
Slides or other images that are viewed by Transmitted Light or are projected.

Transparent
An object or material that transmits both light and undiffused images. *Tip:* Try lighting a plain background directly behind the object, not the object.

Tripod
The three-legged device that is almost always topped with a tripod head (for panning and tilting) which supports cameras of various types. *Tips:* A tripod or Dolly is recommended not only to steady and move the camera (especially with long lenses and long shooting sessions) but also to make Framing and composing the shot simpler. *Tip:* Never lean a closed tripod against the wall: gravity always wins and heads will roll. *See:* Hand-holding.

** Not a conventional term but coined by the author. Words with Initial Caps are separate entries elsewhere in the glossary.*

Truck *see* Dolly

T-stop *see* Stop

Tungsten Filament

A lamp coil that emits light (and heat) when electricity flows through it. *See:* Incandescent Lamp and Tungsten-Halogen Lamp.

Tungsten Film

Film balanced for 3,200K lamps and requiring color correction when shot with other sources unless Color Distortion is desired.

Tungsten-Halogen Lamp

A tungsten filament coil set in a regenerative halogen gas atmosphere that eliminates premature lamp blackening. Useful lamp-life is extended, lamp size decreased. *Earlier name:* Quartz Iodine.

Two-dimensional Translation *

Part of developing a Good Eye involves anticipating what surprises await you when the three-dimensional world ends up on a flat screen, tube or print, minus one dimension. *Tips:* View the scene with one eye closed or through the lens of a camera; images on a ground-glass seem more 2D-ish than aerial images. Polaroid Test Shots can also help.

Tyranny of Terms *

The tendency of terms to turn into dogma. New pros needn't use "Base Light" or "Back Light," for example, unless they really need them. *Tip:* It matters less what a tool or technique is called than whether it performs the job efficiently and that you know how to use it effectively. However, as Gill McDowell points out, coming to terms with the jargon makes intracraft communication easier.

U

Ultraviolet (UV)

A portion of the Spectrum to which film and bees' eyes are sensitive, but not human eyes.

Ultraviolet (UV) or Skylight Filter

see Haze Filter

Umbra Penumbra Phenomenon

The black center shadow and gray outside shadow(s) produced by an eclipse and most hard lights. The phrase of choice when you need approval to rent or buy a budget-busting light: "...but it's the only one that won't create a penumbra."

Umbrella (for Lights)

Appropriate umbrellas convert hard or broad lights into large soft sources.

Umbrella (for subjects)

Instant shade for immobile subjects like growing flowers and perspiring ones, like camera crews in the desert. Don't forget a stand, clamp, and weight.

Underexposure, Prints of Darkness *

The result of too little light or too small an f-stop. *See:* Thin. Underexposure may also occur if you have a lazy agent.

Upstage

Away from the audience or camera.

V

Vanity Ploy *
The art of getting VIP subjects, by exploiting their insecurity, to "talk you into" one more take long after they said they absolutely had to leave.

Video Engineer
The person who can expand or compress your creative horizons as well as your contrast range. The more you understand the technical aspects of Waveform Monitors, vectascopes, video recording, and broadcast, the more likely the video engineer can become your partner rather than your censor.

Video Monitor
The experts disagree whether or not lighting should be appraised on a studio monitor, since many are of poor quality or are poorly adjusted. Regardless of quality, video monitors are used to judge performance and camera moves during setup, shooting, and playback, whether for video or film cameras that have a . . .

Video Tap, Video Assist
A motion picture camera "tapped" to provide an electronic image for viewing and sometimes recording. It allows instant playback of scenes in order to judge performances and cinematography. For some, the video tap is indispensable; for others, about as welcome as a spinal tap.

Viewing Glass *see* Contrast Glass
Visible Spectrum *see* Spectrum
Volts (v)
A measure of electrical "pressure." *Formula:* volts = watts ÷ amps. *Tip:* To save bucks and save face, check lamp-voltages before plugging in; and check overseas voltages before grabbing your passport.

W

Warm
Light, gels, or subjects in the red/orange/yellow region of the Spectrum.

Warming Filter
Subtracts excess blue or adds sunset-candlelight-like glow to a shot.

Watt (w)
A measurement of power or the rate at which electrons move along a wire. *Tip:* Different types and makes of fixtures using the same wattage lamps when tested at the same distance will have considerable variations in light output. Performance charts may be helpful; an Incident Light Meter definitely will be.

Watt/seconds, W/s, Joule, J (flash)
The electrical current stored within the capacitors of electronic flash units, only part of which reaches the flash tube and none of which can be compared with the real or claimed watt/second ratings of other units. Joule is the British equivalent. Flash maven Jon Falk suggests that skepticism and flash meters are in order.

Waveform Monitor
The box that provides the electronically literate with a beam-by-beam evaluation of the lighting while they set up, but does not, as Harry Mathias reminds us, replace a trusty light meter.

Wavelength
The distance between "waves" in the electromagnetic field, specified as angstroms or Nanometers.

** Not a conventional term but coined by the author. Words with Initial Caps are separate entries elsewhere in the glossary.*

White Balance

The process of adjusting the video camera's red, blue, and green Gain controls in order to balance the color of prevailing sources (sunlight, sky light, fluorescent, etc.). White Balance is performed instead of, or in addition to, using internal or external camera filters or colored gels on the lights. *Tips:* For normal results, balance is done on a pure white card using the same light that falls on the Subject. In order to achieve abnormal color you can trick the camera by white balancing on a card or paper exactly opposite from the color desired. Some pros keep an assortment of colored cards handy for this off-white-balance operation. *Also see:* Auto White Balance and Color Distortion.

White Light

The 1,000 or so colors humans who are not Color-blind can discern have their origin in white light. The Hues we attribute to any object depend upon how the surface reflects and absorbs light and how the eye interprets it. *See:* Spectrum and Absorption.

White Reference (Video & Film)

The best way to outwit TV automatic gain control. *Tip:* Compose and light so that about 10% of the Frame is white. Even with film, large areas of black tend to look muddy unless there is sufficient white reference.

Wild Wall

An easily removable Flat or section of a Set which facilitates camera positioning, dollying, and lighting.

Wind Machine

An excellent way to introduce atmosphere and drama — power and budget permitting.

Window Gel

Gels for color conversion (such as 5,500K to 3,200K) are available in wide rolls to cover windows. *Tip:* If the camera angle includes the windows, wrinkles and Reflections in the gel can cause problems.

Wrap (finish)

To pack up equipment. Also, to complete a shoot — or an almost endless Glossary.

Wrap (light)

Large, close, soft sources tend to envelop small subjects with light that Falls off gradually on the curves.

Wrap Party

End-of-the-shoot celebration to reward the crew for their past efforts and future silence regarding what really happened on location.

Z

Zone System

A series of ten zones (or tones) from 0 (black) to 9 (white) with 5 being middle gray and reflecting 18% of the light. Each zone reflects double or half of the light (1 Stop) of the adjacent one. Specific subject tones can be placed in predetermined zones that best suit a particular subject, contrast range, and stylistic intent. Developed by Ansel Adams, the system is widely taught and is detailed in books by Minor White and others.

Zoom

Used instead of collections of fixed-focal-length lenses and, unfortunately, instead of a dolly.

Zoomitis *

A serious nervous disorder. *Cause:* uncontrollable lunging. *Symptoms:* extreme dizziness and disorientation. *Cure:* Zoomenders.

Contributors

We are indebted to many experts whose words and images enrich the pages of Matters of Light & Depth. *While some contributions substantiate my views, others I chose because they introduce contrasting opinions and techniques.*

Nestor Almendros, ASC, cinematographer: *Sophie's Choice, Days of Heaven*

John Bailey, ASC, cinematographer: *American Gigolo, Ordinary People*

Paul Beeson, British lighting director

Bill Butler, ASC, cinematographer: *The Rain People, Jaws*

Michael Chiusano, commercial photographer, author

Dean Collins, photographer, lecturer

James Crabe, ASC, cinematographer: *Rocky, The China Syndrome*

Caleb Deschanel, ASC, cinematographer: *The Black Stallion, The Right Stuff*

George Spiro Dibie, cinematographer

Randy Duchaine, location photographer

Jon Falk, photographer, author, lighting lecturer (see *Acknowledgments*)

Jon Fauer, cinematographer, writer

Ernst Haas, photo essayist, teacher

Conrad Hall, ASC, cinematographer: *Butch Cassidy and the Sundance Kid, In Cold Blood*

Bill Hayward, NY photographer

Bill Holshevnikoff, photographer, lighting lecturer

Bill Klages, television lighting director

Kris Malkiewicz, author of two books on film, teacher, video/filmmaker

Dale Marks, photographer

Harry Mathias, cinematographer, engineer, author

Tom McDonough, cinematographer, author who, in *Light Years*, discusses some of the film folk on this page (see *Acknowledgments*)

Gill McDowell, lighting director/gaffer and founding partner of *Liberty Lighting Limited* (see *Acknowledgments*)

Charles Merzbacher, professor of film, filmmaker (see *Acknowledgments*)

Richard Patterson, co-author with Harry Mathias

David Quaid, "retired" cinematographer: *The Swimmer, Cops & Robbers;* producer/director

Tom Sadowski, a very independent filmmaker, photographer, author/humorist

Joe Seamans, cameraman

Tom Seawell, photographer

Ben Sobin, sound specialist

Eric Somers, head of Department of Performing and Visual Arts, Dutchess Community College (see *Acknowledgments*)

Ezra Stoller, venerated architectural photographer

Vittorio Storaro, ASC, cinematographer: *The Conformist, Apocalypse Now, The Last Emperor*

Struan, Canadian fashion photographer

Mario Tosi, ASC, cinematographer: *Six Pack, The Stunt Man*

Burk Uzzle, photographer

Slavko Vorkapich, the moving-image-as-montage-and-graphic-art grand guru

Haskell Wexler, ASC, cinematographer: *In the Heat of the Night;* director: *Medium Cool*

William Whitehurst, studio photographer, teaches advanced lighting at *Parsons School of Design*

Billy Williams, ASC, BSC, cinematographer: *Women in Love, Ghandi, On Golden Pond*

Gordon Willis, ASC, cinematographer: *The Godfather* (and sequels), *All the President's Men*

Anton Wilson, cameraman, inventor, entrepreneur, author

E. Carlton Winckler, retired lighting director, formerly senior production consultant for *Imero Fiorentino Associates* (see *Acknowledgments*)

Vilmos Zsigmond, ASC, cinematographer: *McCabe and Mrs. Miller, Close Encounters of the Third Kind*